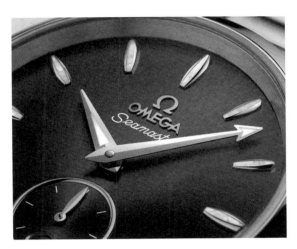
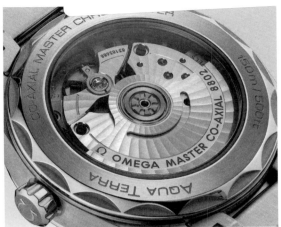

SEAMASTER AQUA TERRA

As its name suggests, the Aqua Terra crosses many boundaries. Descended from a long line of ocean-watches and built to withstand Earth's ever-present magnetic forces, it shares DNA with our most rugged sports chronometers, yet it is infused with the design sensibility of a classic dress watch.

Worn on deck or in the boardroom, its clean look is created by a symmetrical stainless steel case surrounding a sun-brushed dark green dial. The style is enhanced even further with a subtle Small Seconds subdial and sailboat-shaped indexes that each feature an iridescent mother-of-pearl inlay.

The supreme adaptability goes deeper than looks though, because behind the elegance of this Aqua Terra is one of our next-generation movements, which have raised the standards of watchmaking quality.

As a Co-Axial Master Chronometer, the Aqua Terra will require less servicing throughout its lifetime, while also guaranteeing the industry's highest standard of precision, performance and magnetic resistance up to 15,000 gauss, as certified by the Swiss Federal Institute of Metrology (METAS).

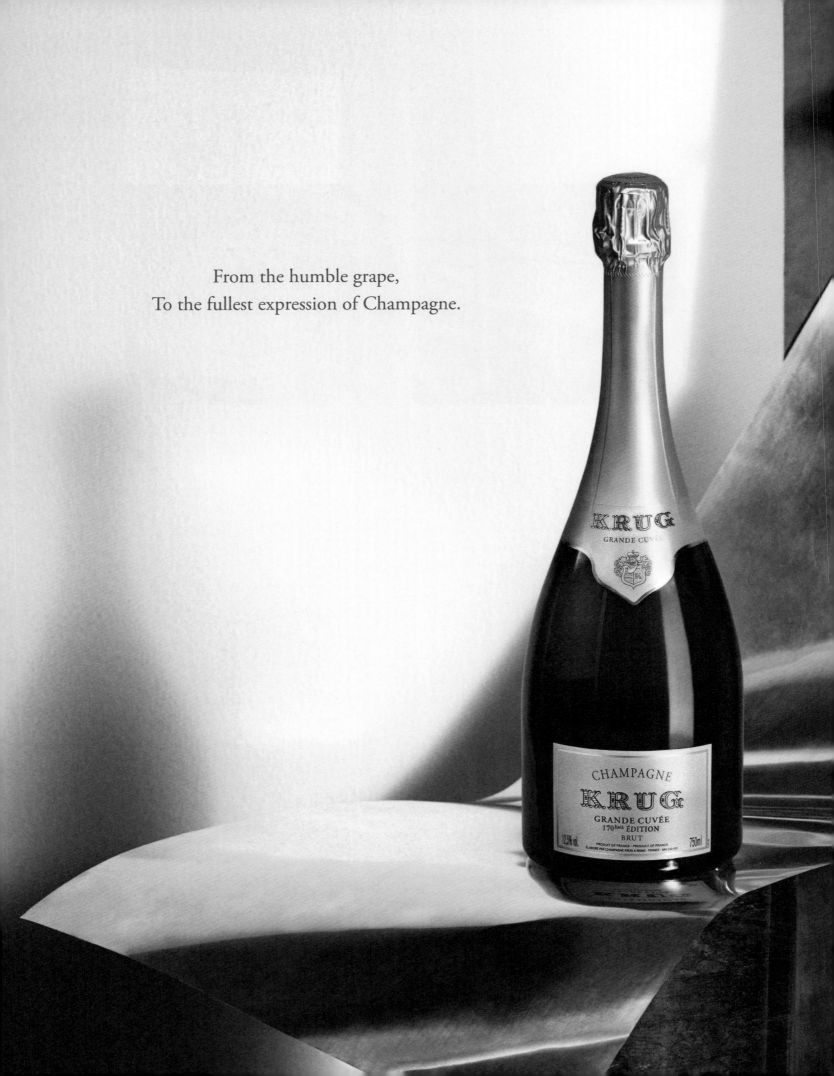

From the humble grape,
To the fullest expression of Champagne.

KRUG

CHAMPAGNE

KINFOLK

MAGAZINE
—

EDITOR IN CHIEF	John Clifford Burns
EDITOR	Harriet Fitch Little
ART DIRECTOR	Christian Møller Andersen
DESIGN DIRECTOR	Alex Hunting
COPY EDITOR	Rachel Holzman
DESIGN ASSISTANT	Abbie Lilley

STUDIO
—

ADVERTISING, SALES & DISTRIBUTION DIRECTOR	Edward Mannering
STUDIO & PROJECT MANAGER	Susanne Buch Petersen
DESIGNER & ART DIRECTOR	Staffan Sundström
DIGITAL MANAGER	Cecilie Jegsen

CROSSWORD	Mark Halpin
PUBLICATION DESIGN	Alex Hunting Studio
COVER PHOTOGRAPH	Zhong Lin

WORDS
—

Precious Adesina
Allyssia Alleyne
Alex Anderson
Poppy Beale-Collins
Ed Cumming
Stephanie d'Arc Taylor
Daphnée Denis
Tom Faber
Bella Gladman
Robert Ito
Rosalind Jana
Rebecca Liu
Moya Lothian-McLean
Jenna Mahale
Okechukwu Nzelu
Hettie O'Brien
Sala Elise Patterson
Stephanie Phillips
Kasia Redzisz
Asher Ross
Baya Simons
George Upton
Salome Wagaine
Anna Winston

STYLING, SET DESIGN, HAIR & MAKEUP
—

Suyane Abreu
Gemma Bedini
Josephine Cho
Carlos Ferraz
Flower Bar
Henrik Haue
Mark Jen Hsu
Sunny Hsu
Katsuya Kachi
Jinny Kim
Camilla Larsson
Maika Mano
David Martins
Danilo Micke
Victoria Salomoni
Stefany Silva
Trine Skjøth
James Sleaford
Sandy Suffield
Kingsley Tao
Christian Trust

ARTWORK & PHOTOGRAPHY
—

Paulo Abreu
Simon Bajada
Stella Berkofsky
Jonas Bjerre-Poulsen
Jordan Bourke
Henrik Bülow
Justin Chung
Marina Denisova
Phil Dunlop
Lasse Fløde
Gavin Goodman
Derek Henderson
Todd Hido
Marsý Hild Þórsdóttir
Annie Lai
Charlotte Lapalus
Matthieu Lavanchy
Jean-Philippe Lebée
Ziqian Liu
Mar+Vin
Luca Marianaccio
Kristen Meyer
Christian Møller Andersen
Lady Adelaide Osafo
Clément Pascal
Roberto Ruspoli
Victor Schrager
Dominique Shepherd
Lamberto Teotino
Aaron Tilley
Dillon Versprille
Charlotte Wales
Zhong Lin

PUBLISHER
—

Chul-Joon Park

The views expressed in *Kinfolk* magazine are those of the respective contributors and are not necessarily shared by the company or its staff. *Kinfolk* (ISSN 2596-6154) is published quarterly by Ouur ApS, Amagertorv 14B, 2, 1160 Copenhagen, Denmark. Printed by Park Communications Ltd in London, United Kingdom. Color reproduction by Park Communications Ltd in London, United Kingdom. All rights reserved. No part of this publication may be reproduced, distributed or transmitted in any form or by any means, including photocopying or other electronic or mechanical methods, without prior written permission of the editor in chief, except in the case of brief quotations embodied in critical reviews and certain other noncommercial uses permitted by copyright law. The US annual subscription price is $75 USD. Airfreight and mailing in the USA by WN Shipping USA, 156-15, 146th Avenue, 2nd Floor, Jamaica, NY 11434, USA. Application to mail at periodicals postage prices is pending at Jamaica NY 11431. US Postmaster: Send address changes to Kinfolk, WN Shipping USA, 156-15, 146th Avenue, 2nd Floor, Jamaica, NY 11434, USA. Subscription records are maintained at Ouur ApS, Amagertorv 14B, 2, 1160 Copenhagen, Denmark.

Born in 1949. Thousands of new combinations yet to be discovered.

≡string®

String Shelving System configured by interior designer Lotta Agaton. Discovered in 2021.

WELCOME
The Mind Issue

For a long time, psychedelic drugs were associated with specific subcultures: hippies, ravers and—most recently—Silicon Valley entrepreneurs looking to fast-track their way to the next lightbulb moment. Like so much of what we know about the mind, this perception is changing fast. New research is revealing the mind-bending potential of psychedelics to treat depression and other mental illnesses. "Psychedelics dive deeply into the psyche, loosening it up, changing perspectives and allowing deep material to be dealt with in a fascinating way," says psychiatrist David Erritzoe, whose interview on page 114 leads a special section that explores the modern mind in all of its complexity.

The mind, as we discover throughout the issue, cannot be separated easily into science versus abstraction—our hopes, dreams and fears are all the result of synapses firing. On page 168, we're looking at tricks the brain plays that affect how we experience the world: the cognitive processing errors that lead people to think everyone has noticed their mismatched socks, or to accidentally call their boss "mommy." In essays, we examine how contemporary culture intersects with consciousness by looking at the links between wellness influencers and the alt-right, and consider what the rise in televised therapy programs such as *Couples Therapy* can teach the rest of us. We also meet the Oxford University philosopher Amia Srinivasan, who talks about her belief that all of us can comprehend difficult ideas, harkening back to the golden age of the public intellectual. "There was a relentless insistence on complexity and difficulty, and the expectation that a non-philosophically trained audience could keep up, which I think it often can," she says.

Elsewhere in the issue, we're invited inside two designers' homes we've long hoped to visit: that of Rose Uniacke in London and Vincent Van Duysen in Antwerp. Their warm, tactile styles have attracted celebrity clients (the Beckhams and Kanye, respectively) and even a mutual admiration: Van Duysen collaborated on the design of Uniacke's home. We've also got some of our most ambitious fashion shoots to date: a floral extravaganza shot by Mar+Vin in São Paulo and, on the other side of the world, photographer Zhong Lin brings her psychedelic vision to a shoot in Taiwan.

In a way, every issue of *Kinfolk* is dedicated to the mind, in that we hope to spark new ways of thinking (although perhaps not quite on the level that Erritzoe's research subjects experience in his psychedelics trials). This spring, that includes thought-starters on the benefits of being absolutely average, the conundrum of why we believe in personalized prophecies and the enigma of what constitutes a sellout.

WORDS
JOHN CLIFFORD BURNS
HARRIET FITCH LITTLE

HOUSE OF
FINN JUHL

finnjuhl.com

14 — 44

STARTERS
Complex questions, concise answers.

14	Happy Medium	28	Small Wonder
16	Word: Knolling	29	Stone Cold
18	The Science of Fiction	30	Signal Boost
19	Behind the Shed	34	One and a Million
20	Rejina Pyo	36	Ahlem Manai-Platt
22	Plane Jane	38	Cold Comfort
24	Out of the Blue	39	Eyes on the Prize
26	Ita O'Brien	40	Brendan Yates

46 — 112

FEATURES
From Belgium, Britain and Brazil.

46	Vincent Van Duysen	82	Paapa Essiedu
56	Follow Me!	94	Space Invaders
60	Hermès: In the Making	102	Rose Uniacke
70	Fresh Stems	—	—

"I thought acting was fun: You do a play and people clap for you at the end." (Paapa Essiedu – P. 82)

Photograph: Phil Dunlop

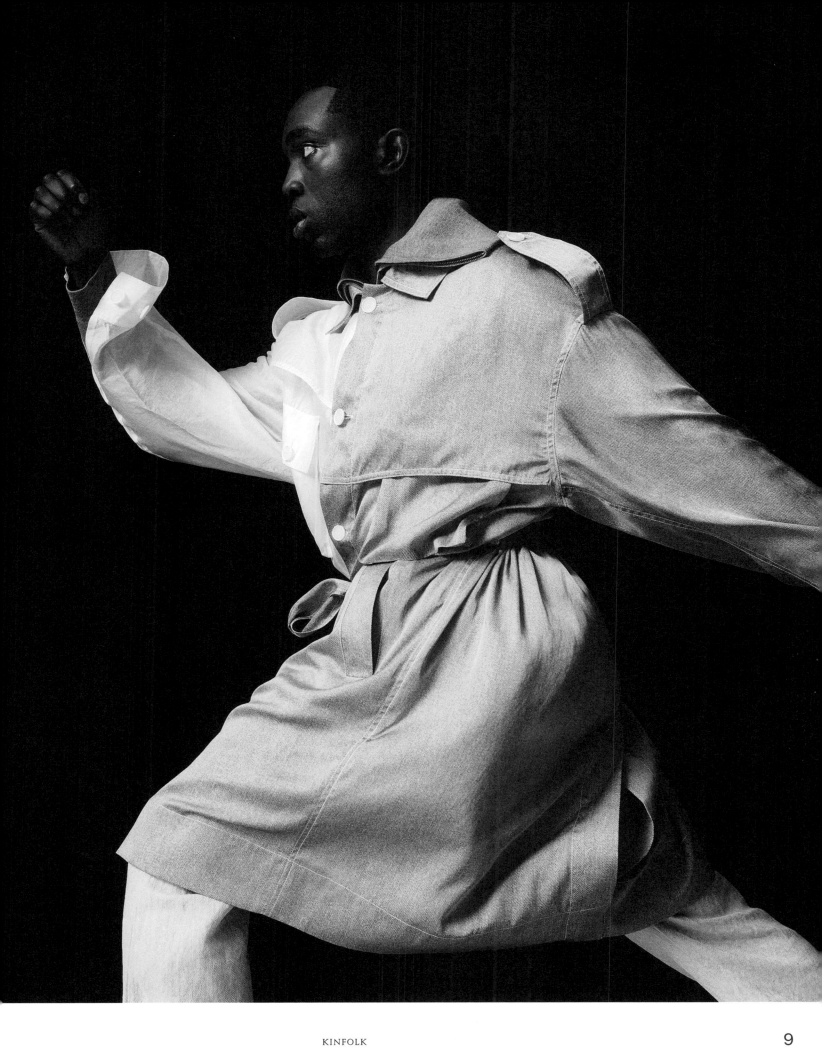

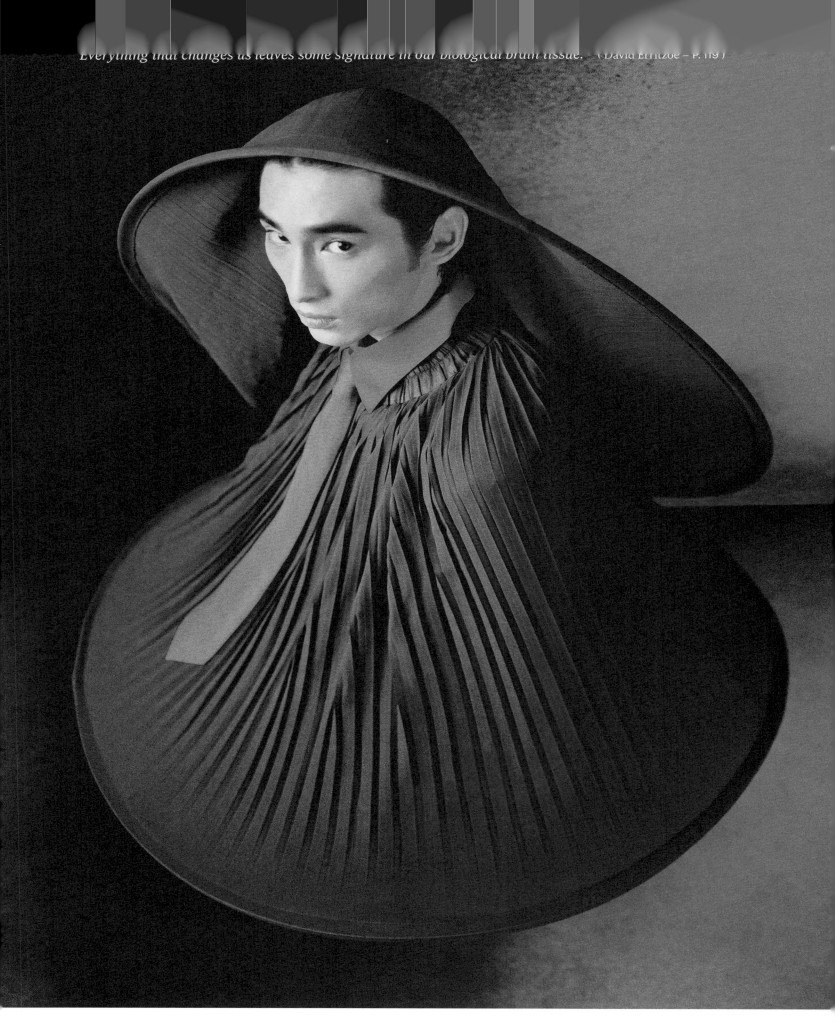

CONTENTS

114 — 176

THE MIND
A guide to the world within.

114 David Erritzoe
122 Spring Trance
134 Amia Srinivasan
144 The Alt-Right Wellness Loop

148 Open Relationships
158 Mind Games
168 Tricks of the Mind
—

178 — 192

DIRECTORY
Cultural odds and ends.

178 Peer Review
179 Object Matters
180 Cult Rooms
182 Chan Marshall
184 Crossword
185 Correction

187 Last Night
188 Bad Idea
189 Good Idea
190 Credits
191 Stockists
192 My Favorite Thing

Photograph: Zhong Lin

marset

Taking care of light

Part 1.
STARTERS
On status, garden sheds and hardcore punk.
18 — 48

14	Happy Medium	30	Signal Boost
16	Word: Knolling	34	One and a Million
18	The Science of Fiction	36	Ahlem Manai-Platt
19	Behind the Shed	38	Cold Comfort
20	Rejina Pyo	39	Eyes on the Prize
26	Ita O'Brien	40	Brendan Yates
29	Stone Cold	44	The Sellout

HAPPY MEDIUM
In praise of average.

Nobody wants to be average. The word itself comes with a chill. Average food is not worth eating, nor is an average film worth watching. An average doctor is to be avoided at all costs. An average lover? Perish the thought! And how much worse, how much terribly worse, to be an average *person*.

The alternative, preferred by almost everyone, is to be exceptional. To prove that something special inside us has finally found its place of honor in the real world, either through one stunning achievement, or through a series of them that mount like stairs to an imagined, extraordinary self. Laying awake on stressful nights, we often contemplate this distant self, and treat our living, breathing self as if it were some embarrassing memory-in-waiting.

Most of us will never be exceptional. The math is unfortunately quite clear on the matter. So why all this self-criticism over a condition that almost everyone shares? The first and oldest reason is not likely to bring much cheer: death. There's nothing we can do to avoid it, but if we accomplish great things in life, a part of us will live on. Take Achilles, whose reputation as the greatest of all Greek warriors has lasted some 3,000 years. When he was a child, Achilles' mother told him that he would one day choose between two competing fates: Either die young and gloriously in battle, gaining everlasting fame, or return home safely from Troy to live out a long and anonymous life. He made his choice, and true to prophesy, his name lived on.

Few of us would choose to fulfill our imagined destinies in such a costly manner. After all, there are more practical reasons to want to be exceptional. Status can bring a host of benefits: economic security, the praise of friends, the envy of rivals, something to say when we're asked at parties what we do. The philosopher Alain de Botton, in a TED talk on the subject of success, noted that "never before in history have expectations been so high about what human beings can achieve within their lifespan."

Online, in bookstores, in talks with friends, we are pressured constantly to develop "side hustles" and to cultivate the artists, billionaires and tiger mothers that lie hidden within us. De Botton thinks this game is rigged, and encourages us to find a gentler philosophy of success, one that is founded on our own authentic desires, rather than what we presume others will respect. It is a wise and humane lecture, but don't linger too long. The next two pieces of recommended content on the TED site are "Your Elusive Creative Genius" and "8 Secrets of Success."

The need to be exceptional can come from deeper, more personal origins. Parents have a unique capacity to shape a child's sense of being good enough as they are. The rarest parents provide this gift continually and unconditionally. But very often a child is left with a sense that they must do something special in order to be truly loved. In adulthood, to turn the tables on this unfulfilled need, they may attempt to win the love of the world, or at least part of it, instead.

Achilles, whose mother was not the rarest kind, died at Troy. But that is not the last time we hear from him. Years later another hero, Odysseus, descends to the underworld, where he speaks with a number of famous ghosts before encountering the great warrior himself. Odysseus praises Achilles, telling him that he must be very happy in the afterlife after achieving more worldly glory than any other person. But Achilles' reply shakes Odysseus to the core: He would gladly become the lowliest, least remembered of men, if only he could feel the sun on his back once more.

It's a hard lesson to remember. Our brains, our societies, our smartphones, are hardwired to redirect us away from the pursuit of simple happiness and toward the pursuit of status. We forget that the rich seldom say their wealth has brought them contentment, we forget the personal misery of the authors, musicians and artists who kindle our dreams.[1] We get the equation wrong.

So, if we can quiet our need to be exceptional, what is worth doing instead? It is when we feel loved—when we *trust* that we are genuinely loved by the people closest to us—that we find what we are looking for when we chase success: A sense of safety and calm; an ease within ourselves; a gentle washing away of anxiety and emergence into the present. The ability to truly love and be loved is not always easy to maintain, but it is an experience that is available to the many. Quite an average thing, really, though always special.

(1) Research shows there is only a minimal "happiness bonus" that comes with being wealthy. However, it is a patronizing cliché to assume that it is easy to be "poor but happy." Going from earning under $20,000 a year to making more than $50,000 cuts out a level of extreme material concern, making people twice as happy.

WORDS
ASHER ROSS
PHOTO
PAULO ABREU

16

WORD: KNOLLING
The fascinating history of the flat lay.

WORDS
SALA ELISE PATTERSON
PHOTO
KRISTEN MEYER

Etymology: In 1987, in the quiet after-hours at Frank Gehry's furniture shop, a janitor named Andrew Kromelow invented what has become one of the most ubiquitous aesthetics on Instagram today. As Kromelow cleaned Gehry's shop, he would gather stray tools and experiment with arranging them in a grid-like pattern. He called the practice "knolling," after the hard angles of Knoll furniture, a popular brand that Gehry was designing for at the time. Today, knolling more often refers to the art of spacing out objects on a flat surface at tidy angles to one another and photographing the arrangement from above.

Meaning: By the 2000s, Kromelow's recreational passion had found its way onto the radar of fellow aesthetes. In 2009, sculptor Tom Sachs declared it the mantra of his studio ("Always Be Knolling") and a 2010 feature on Sachs by influential blogger Todd Selby introduced the term to an even broader audience.[1] Then, in 2013, Andrew Kim wrote *90 Degrees: An Experience About Knolling*, a book extolling "the beauty and functionality of knolling."

Soon, social media influencers, graphic designers, art directors and advertisers everywhere were turning to knolling for visual punch. When placed in a knolling layout, even the most mundane objects are rendered significant, perhaps even beautiful: food items, beauty products, the contents of a celebrity's purse.

Although today some knollers opt for a less angular flow to their flat lays, the method has changed little since 1987. Knolling allows creators to influence people's thinking or behavior. Designers use it to create tapestries of pattern, shape and color that lull readers into lingering on the page or pausing briefly in the infinite scroll of their social feed. And advertisers can imply an association by grouping items within a frame: Showing a brand's entire range—whether skincare products or mountaineering equipment—encourages consumers to view them as a set that should be purchased in its entirety. And thus, a design tool for one janitor became a marketing ploy for us all.

(1) Sachs even produced a manual instructing his staff on how to knoll. At this point, the emphasis was still on knolling as a practical solution to tidying a working space. Step two of the manual was "Put away everything not in use. If you aren't sure, leave it out."

WORDS
REBECCA LIU
PHOTO
VICTOR SCHRAGER

Five years ago, Mark McGurl was opening yet another Amazon box when he started thinking about the corporate behemoth's impact on the novel. Amazon's impact on bookselling was already widely acknowledged—anywhere from 50% to 80% of book purchases in the US are now made via the company—less considered was its effect on the very form of the novel.

McGurl, a literature professor at Stanford University and the author of *Everything and Less: The Novel in the Age of Amazon*, dove into Amazon's most read (and unread) list. Through self-publishing programs like Kindle Direct Publishing, Amazon has allowed thousands of writers to bypass traditional gatekeepers. The result is an unfathomable volume of books. "If we're talking about the numbers published, then we are in a golden age of the novel," McGurl tells me over video call. "Traditional literary culture has been eclipsed by a thoroughly popular and populist one, much of which is sponsored by Amazon." Self-publishing has also tapped into niche online communities and brought hyperspecific genres into being: McGurl names "adult baby diaper lover erotica" and "litRPG" (in which novels take the form of an immersive video game, like Ready Player One) as examples.

Amazon's influence has also extended into the traditional publishing houses, leading to a rise in stories about being obsessed with wealth and power—or feeling caught up in its shadow. The bestselling *Fifty Shades of Grey* by E L James, initially a self-published ebook, has spawned a genre that McGurl calls the "alpha billionaire romance." Like its inspiration, these books feature protagonists drawn to a powerful and wealthy male figure. And as the literary world sees its power decrease at the hands of commerce, so too do the protagonists in its prestige fiction.

Reading literary fiction from traditional publishing houses, McGurl kept coming upon a male figure who seemed "almost a direct response" to the Amazon-backed billionaire. These men—of the "beta intellectual romance"—are ponderous, neurotic, and tortured by their declining social power. (They are, however, as invested as their alpha counterparts in wasting women's time.)

McGurl is as clear-eyed as anyone about Amazon's rising power. But he couldn't help but be touched when he was browsing through the many books that have been brought out into the world. "There's a way in which novel writing hasn't been, and almost can't be, assimilated to the life of the corporate drone, where we're always working for somebody else. When you sit down at your laptop and start to write your novel, it's *your* novel." That so many people still do it, despite all the rising demands of work, feels nothing short of miraculous.

THE SCIENCE OF FICTION
How Amazon is rewriting the novel.

It is easy to make fun of sheds. Traditionally they have been places where men—mainly men—can indulge their more esoteric hobbies. Follies for follies. For some they are artistic or creative spaces, for writing or music or ceramics. But most are for whiling away an afternoon, for pottering rather than pottery. The architectural identity of a garden shed—liminal and impermanent, separate from the main residence—echoes its use. To go to your shed is to liberate yourself from the general bustle, and not always to play with your model train set. In the words of the author Michael Pollan, who wrote a book about building his own writing shed, it is a "temple of solitude off the beaten track of everyday life." If a garden is a fantasy for many, a shed is a fantasy within a fantasy.

The British have a particular affinity with garden sheds: Philip Pullman, Roald Dahl and Virginia Woolf—all shed enthusiasts. Since 2007, the annual Shed of the Year competition has been a showcase of ingenuity and dedication that puts professional architects to shame. There have been sheds done up like bomb shelters, or hobbit houses, or churches. Some are practical: workshops or businesses or galleries; others are havens of tranquility and meditation. Inevitably, many are bars. In recent years sheds have sloughed off some of their fusty reputation and become more aspirational. In cramped cities, where development is heavily restricted by regulation, sheds can add square footage without planning permission. The most recent winner of Shed of the Year, Danielle Zarb-Cousin, is a model and Instagram influencer. Hardly fusty.

As working from home has become more common, so has the dream of a space to work in peace.[1] Sheds are a way to preserve boundaries as the physical nature of employment evolves. If you can go to a shed to work, you can also leave work by exiting it. Alternatively, it can be a place for digital as well as physical solitude. At a time of ever-encroaching digital communications, a shed can be a space without Wi-Fi or phone signal. The man alone in his cave might be a figure of mockery, but the need to find a space of one's own has never been more serious.

(1) The boom in shed conversions during lockdown had unforeseen consequences. Fires in sheds, garages and conservatories rose by 16% in 2020 compared with the previous year.

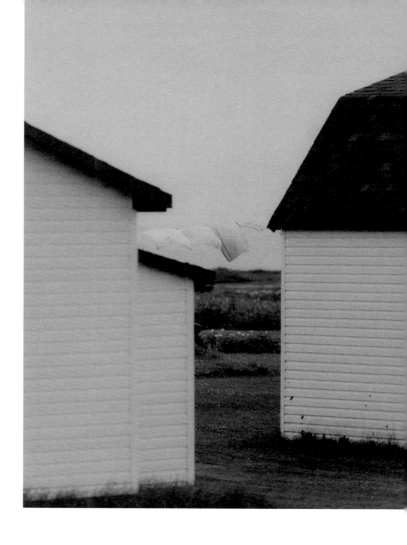

WORDS
ED CUMMING
PHOTO
CHARLOTTE LAPALUS

BEHIND THE SHED
The allure of a garden retreat.

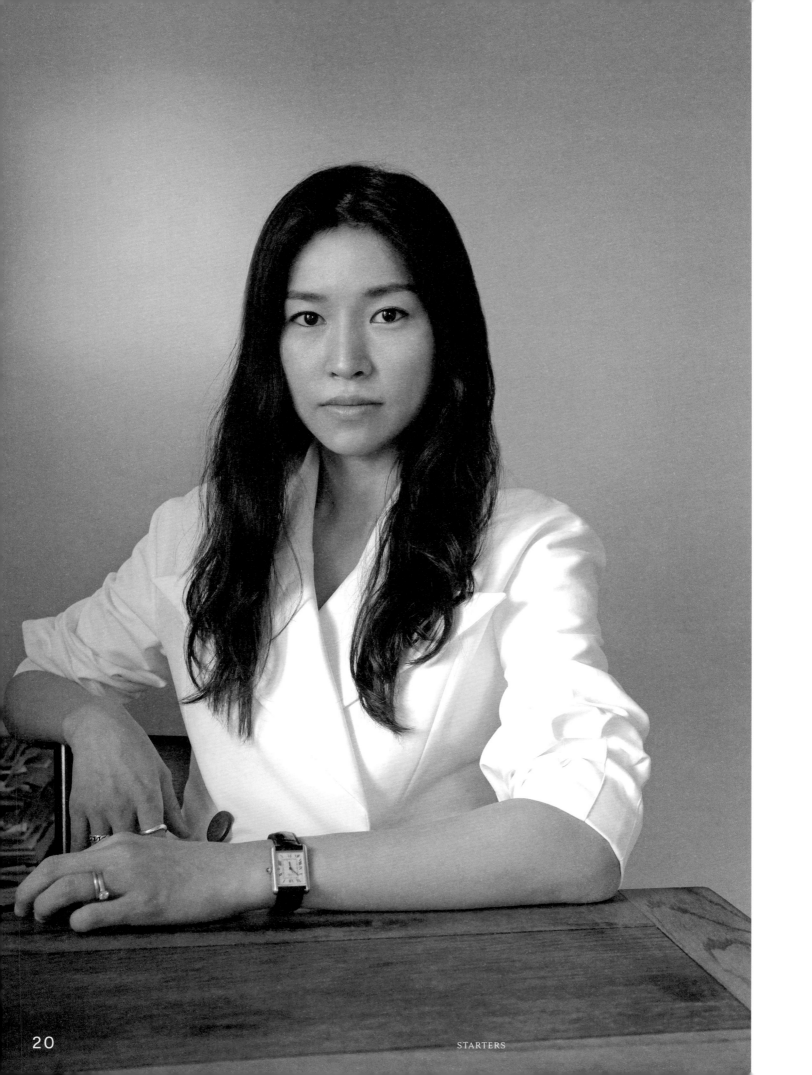

REJINA PYO

WORDS
ROSALIND JANA
PHOTO
JORDAN BOURKE

On making clothes for a street side catwalk.

Rejina Pyo makes clothes that she wants people to live their lives in. The London-based fashion designer grew up in Seoul and began her career working for a large South Korean retailer before moving in 2008 to London, where she enrolled at Central Saint Martins. In 2014 she launched her eponymous label. Over the past eight years, her unique blend of pragmatism and playfulness has acquired a devoted following. Her clothes are sculptural, elegant and designed to be worn again and again. They're also, put simply, really fun—full of punchy color contrasts and sly signature details like mismatched buttons.

ROSALIND JANA: How do you want people to feel when they wear your clothes?

REJINA PYO: I really want them to feel themselves. There's nothing worse than looking like the clothes are wearing you, rather than you wearing the clothes. The clothes are there to enhance, and give you strong armor.

RJ: Tell me about a fashion memory from your childhood that left a lasting impression.

RP: My mom was a fashion designer. I was fascinated by her sketchbook. I tried to draw like her—these beautiful pencil drawings—but she didn't want me to do anything fashion-related, so she used to hide them. We had lots of fabrics in the house because she was making cushions or clothes. I would wrap those fabrics around me and walk up and down the living room as if it was an haute couture dress. My mum dressed me in vintage clothes, never the same as other kids. Imagine wearing a brown linen dress that comes to the ankle with knee-high boots, when other children are wearing cartoon character jerseys or sweatpants.

RJ: When it comes to a new collection, some designers begin with color or structure or mood. What's your starting point?

RP: Usually, I start with a mood: what I'm trying to communicate, or a feeling. I think it's better to start this way rather than being like, "*this* collection is inspired by *this* architect." It's vague in my head, so then I research more and try to articulate those feelings and transfer them into visual images. That's when the color and details and silhouettes come in. People ask me a lot about color palettes, but I've never used industry forecasts. It's usually a very personal, inventive process. I need to get excited. There are like 50 shades of orange, for example. They need to speak to each other between the colors, and then the harmonies come.

RJ: Your work often references different art forms. Are there any artists that you find yourself frequently returning to?

RP: Recently I went to see Isamu Noguchi's exhibition at the Barbican. He was my main inspiration for a long time, especially for my graduation project at Central Saint Martins. Seeing his work in person made my heart beat again. I just love the simplicity and timelessness of his sculptures, and how they developed into lighting: things like that, which bleed through into people's lives. I also love Angela de la Cruz's work. She does amazing things with canvas, which is considered a 2D form, but then she would make sculptures out of it.

RJ: You showed your Spring/Summer 22 collection at the London Aquatics Centre. Are you happier on land or water?

RP: Definitely water, no hesitation. I dream of living by the sea, watching the sea, swimming in the sea. I feel so happy there.

—

—

PLANE JANE
The evolution of (mile) high fashion.

The clothes a person wears to catch a plane can tell a story. Is our fellow passenger carefully casual, as if going to meet a long-lost loved one? Overdressed and hoping to get bumped up to first class? Where are they going with that fedora? Do they ski professionally?

The celebrity airport outfit has long been a source of fascination for the same reason. "A good celebrity airport photo should offer style and hints of mystery and mood," writes journalist Jason Gay in his introduction to *Come Fly With Me*, a visual chronicle of celebrity airport style published in 2021 by Rizzoli. The photographs prompt us to ponder: What's in the bag? Are they happy? Are they devastated? Are they fresh off a scandal, a breakup or a bender? (Maybe the bender is still happening... hence the sunglasses.)

What we glean from the pictures, selected and edited by long-time *Rolling Stone* photo editor Jodi Peckman, is that the way we dress for air travel has changed over the years. Heels and formfitting outfits are out; importance is now signaled instead by a certain luxe slovenliness: Sharon Stone arriving at LAX in 1997 in a pair of gold satin pajamas; Kim Kardashian wearing a hot pink velour tracksuit and blowing the paparazzi a kiss; Rihanna, shielding her face with a water bottle but wearing a puffer jacket so enormous that it becomes ostentatious in its anonymity.

Come Fly With Me documents the historical shift from the suits and high heels of the mid-20th century through the minimal casualwear of the '90s, to the onesies and athleisure wear of the noughties and finally the more recent emergence of cozy-luxe (Mary-Kate and Ashley Olsen swaddled in black knitwear). "The general affordability of travel with the advent of budget airlines in the 1990s meant that flying and airports became less of an event and more of a regular part of people's lives, so naturally there was a more relaxed way of dressing," explains Oriole Cullen, curator of Modern Textiles and Fashion at London's Victoria and Albert Museum.

Our taste for tailored travel wear may have waned, but look closely and the urge to impress in the air is consistent. Smartness was the original status symbol, followed by monograms from brands that had sartorial cachet, and now it's the cashmere sweatpants: We've swapped tailoring for logos for luxury textiles. Perhaps we never lost our nervous excitement at the heady adventure of international travel, after all.

WORDS
BAYA SIMONS
PHOTO
CHARLOTTE WALES

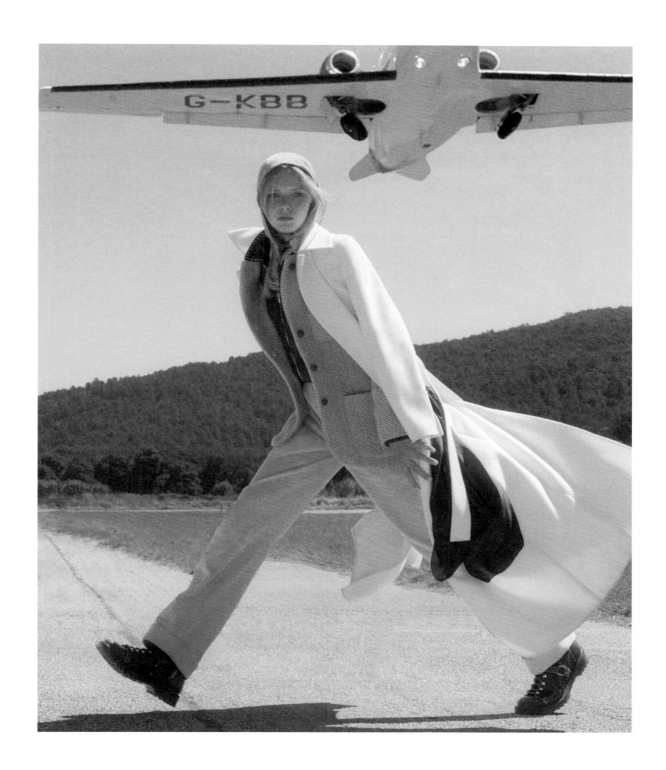

23

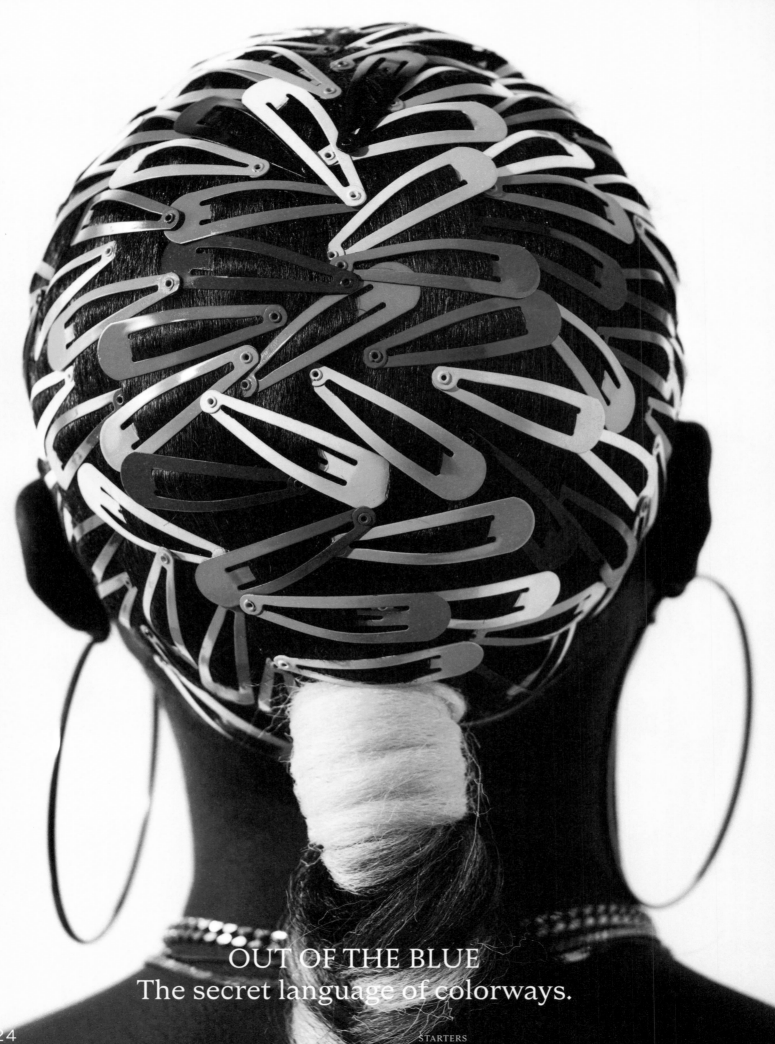

OUT OF THE BLUE
The secret language of colorways.

STARTERS

We all perceive colors slightly differently—what one person might think is red, for example, appears orange to someone else. Color association, however, is widely shared within a society: A red road sign conveys a warning, regardless of how you see the color red.

In fashion, this instinctive response to color has become an integral part of a brand's aesthetic considerations. Each season, new collections are presented at runway shows that appear to articulate a designer's singular creative vision. Behind the scenes in the fashion world, however, color is a science rather than an art. It's a phenomenon that Andy, the fledgling personal assistant played by Anne Hathaway in *The Devil Wears Prada*, discovers the hard way. Her apparently innocuous blue sweater actually represents—in the withering words of Meryl Streep's terrifying fashion editor—millions of dollars and the work of countless designers. Nowhere is this more notable than with sneakers. Sportswear companies invest heavily into developing striking colorways that evoke a particular emotion or spark an association with a style or period: the bright contrasting colors of the 1990s, say, or yellows and oranges that create a sense of energy. As *The New York Times* reported in 2021, so important is color to sportswear brands that some even have dedicated color experts to find the exact hue that will come to define a collection or even, in some cases, the era.

Even if, like Andy, you choose not to engage with fashion, it is the decisions of designers and color forecasters that come to inform what we buy and how we dress. *It's not blue, it's cerulean!*

WORDS
GEORGE UPTON

ITA O'BRIEN

WORDS
BELLA GLADMAN
PHOTO
MATTHIEU LAVANCHY

On the urgency of intimacy coordinators on set.

Ita O'Brien choreographs the bodily tango of intimate scenes in film, television and theater. Having worked on *Sex Education* and *Normal People*—two TV series that garnered critical acclaim for their depictions of sex—O'Brien is now the go-to intimacy coordinator for directors wanting to ensure actors' safety, alongside the purity of their vision. Indeed, upon winning her Bafta for Best Actress for her self-directed and -produced show, *I May Destroy You*, Michaela Coel dedicated her award to O'Brien's work, for allowing people to "make work about exploitation, loss of respect, about abuse of power, without being exploited or abused in the process."

BELLA GLADMAN: Your job is a relatively new one. What does it involve?

ITA O'BRIEN: In the past, intimate scenes were an elephant in the room: They weren't talked about or interrogated. Since 2017, I have been developing, teaching and putting into practice a framework to bring rigor and professionalism to intimate scenes. You wouldn't dream of filming a stunt—handing someone a sword and saying, "Off you go!"—without preparation; stunts are discussed, choreographed and rehearsed, with consent and safety being practiced. I often say, "All I have done is help to bring a bog-standard actor-director process to intimate content."

BG: How do you build trust on set?

IO: I'll check out an actor's journey, such as what training they've had, and see if they'd benefit from certain techniques like a full-on physical warm-up. Then it's putting in time and space for rehearsal and talking to the wardrobe department. In rehearsal, I'll do an icebreaker, such as asking for a hug. If that's okay, then we move onto agreeing what body parts are in play—e.g., where are your hands going to go when you kiss someone?

BG: So it's all about communication?

IO: It's about inviting a positive no: Tell us what your boundaries are, take responsibility for them and say what's a "no" so that we can work freely, openly and professionally where you have said "yes." This means requirements can be made up front and as a matter of course, rather than risking disruption on set. Take modesty garments—a person of color might need a particular shade, so you need to let wardrobe know ahead of time. For a heterosexual sex scene, you might end up with one woman actor surrounded by a male counterpart and an all-male crew, if you haven't mentioned that to the production when they're hiring their team.

BG: Who else benefits, apart from the actors?

IO: I worked with a highly acclaimed director of photography who said he'd been able to bring his full skill as a DOP to an intimate scene for the first time, because instead of having to be a fly on the wall, he could treat it like any other scene. Intimate content affects everybody, not just the actors: the gaffer, a lighting person, the wardrobe crew.

BG: How could your work on set translate to everyday scenarios?

IO: First, don't think intimacy will "just happen." If you want to be more intimate with someone, you have to make time and space to be present. With my children over lockdown, I had to remember to switch off my work self at mealtimes, so I could be present for them as their mom. I learned from researching couples counseling that you shouldn't "end-game" intimacy—spending time with your partner doesn't have to end in sex, intimacy is the goal. Kelly Oliver, in her book *Hunting Girls*, wrote that "consent is a process, not a moment." It's really important to trust that fluidity.

—

SMALL WONDER
The outsized joy of model villages.

WORDS
STEPHANIE D'ARC TAYLOR
PHOTO
CLÉMENT PASCAL

Benjamin Franklin, take note. There are actually *three* things that are inevitable in life: death, taxes and the universal adorableness of tiny objects. From babies and puppies to mini jars of Bonne Maman preserves, it's only the most incorrigible grump that doesn't squeal (at least silently) at the sight of all things small.

This inescapable truth is part—but not all—of the reason behind the appeal of the model village, a phenomenon that started in England in 1929 with Bekonscot Model Village and spread throughout Europe and the world. Out-of-context miniature monuments—like the Blue Mosque and Temple of Artemis at Istanbul's Miniatürk—may be faithful renditions. But model villages depict not just mini buildings and people, they also show a model way of life.

Apart from the punny village shop names and working replicas of old-timey public transit, it's an idealized nostalgia that draws people to model villages. A world in miniature depicts the way we wish things had been rather than the way they actually were. The worst you'll see at Bekonscot is a policeman chasing a genial-looking rascal across a field.

For a while, the Bekonscot staff concerned themselves with updating the model village for the modern era. Brutalist-style buildings were erected alongside mock Tudors, and an airfield was added with mini Concorde jets. They gave up when they realized the speed of technological advances easily outpaced the slow-and-steady approach of the craftspeople working there.

And it turned out that no one wanted to visit a model village where their own problems were recognizable, anyway. When escapism is the meal ticket, it pays for things to feel as far away as possible. Making them as tiny as possible helps too.

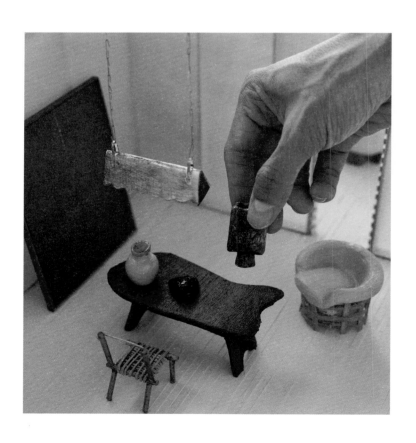

STONE COLD
A history of spite architecture.

Although we usually associate architecture with positive attributes such as beauty and grandeur, it is surprising how often built environments express less benign sensibilities. Dominance, hostility and control are also endemic to architecture. Ancient military fortifications solidified mortal political enmities. Heraldic lions warned away unwanted visitors to walled towns and private estates. Today, our cities are full of aggressive armatures devised to repel squatters, skateboarders and pigeons.

In "spite architecture," these hostilities manifest themselves so boldly that passersby might stop and stare. It's architecture that's devised to annoy others: a building maliciously sited to block another's view, a wall planted to protest a property dispute or a garish application of neon house paint in an area known for tradition and refinement. These dubious works of architecture display deeply personal fights. The Grudge in Beirut, for example, is a thin slice of structural fury—a 13-foot-wide, 4-story modernist house built by one brother to block his sibling's view of the sea. Another fraternal battle, arising from a similar fight over lot lines,

festers in Boston in the form of a tiny colonial house built to deprive an older brother's abode of light and air. Each recalls, for enthralled tourists, an acrid feud between rivals. Their anger has outlived them.

Architectural critic Edwin Heathcote points out that there are worthwhile lessons in these works of bad blood, proclaiming recently in *The Financial Times* that "spite architecture throws up the irresistible stories of humanity's capacity for bad neighborliness." They also show, he says, how architecture might "be used by the relatively powerless as a lever." About 15 years ago, for instance, Edith Macefield's tiny Seattle house forced the redesign of looming condominiums, as she held out against developers' efforts to push her out. The 19th-century Inat Kuca, "Spite House," in Sarajevo, tells a similar tale of defiance. Its unyielding owner compelled the Austro-Hungarian government to move his house slowly and at great cost, piece by piece, to make space for a new and unwanted city hall. These bold obstructions against callous development show that architecture as a poke in the eye or a punch in the nose isn't always a bad thing.

WORDS
ALEX ANDERSON
PHOTO
DILLON VERSPRILLE

Why are people drawn to particular visual trends and cultural preferences, only to abandon them and adopt alternatives for no apparent reason? The writer David Marx, author of a forthcoming book about culture and status, has a theory that people gravitate toward certain behaviors and aesthetic styles because of the status such choices convey to others.

Social groups abide by particular conventions; adopting these conventions is a way of signaling one's affiliation. A newly minted millionaire can prove their status to other millionaires by whipping out an American Express black card, and a successful businessperson might display their university diplomas, communicating to their colleagues the belief that they got there on merit.

Marx argues that these behaviors and choices form the thing we call culture. "In almost all instances," he writes, "new behaviours begin as an exclusive practice of smaller social groups—whether elites or outsiders—and then eventually spread to the wider population." This idea owes much to the German sociologist Max Weber, who observed that status groups were "specifically responsible for all 'conventions': all stylisation of ways of life... either originates with a status group or is preserved by one."

The internet has a weird effect on traditional status signals and, by extension, visual trends. Elite-tier credit cards and framed diplomas are effective because they are resources that not everyone possesses and their meaning is obvious. But in an age where infinity pools are ubiquitous on social media and you can pay to take Instagram photos on a private jet, these old signifiers of class status or cultural affiliation are no longer so reliable. Online, there are fewer barriers to the acquisition of objects or cultural behaviors that were previously scarce.

In this context, products that are hard to get hold of have a fresh appeal.[1] When we spoke, Marx told me about a *New York Times* story that identified a particular Pakistani brand of white and green high-tops worn by Taliban soldiers. Shortly after the story was published, "People were like, 'Oh, I gotta get my hands on them!'" Marx says. Weeks later, Pakistani e-tailers had sprung up promising to ship the sneakers worldwide. The shoes were unremarkable and had blood-soaked origins; what made them momentarily desirable was the fact of their inaccessibility, lending them a cachet that most products—which can be bought on Amazon or copied in an instant—have ceased to possess. On the internet, there are innumerable products, but few of them seem new or original. And there is often no deeper meaning beyond the fleeting popularity of those that do.

You might think the internet's limitless nature would lead to infinite permutations of different cultural trends, but the visual landscape of dominant platforms such as Instagram can feel inherently conservative, and the stylistic conventions of today seem to lack the weight or specificity of those in a pre-internet age. It's easy to picture—or remember, for those of a certain age—how the 1970s looked, but the 21st century conjures few distinct visual sensibilities of its own.

(1) Professor Elizabeth Currid-Halkett has coined the term "inconspicuous consumption" to describe another way the rich spend money now that ostentatious luxury is less of an obvious divider. This encompasses services, education and quality (buying from the farmers market rather than a superstore) and is a more subtle form of exclusion.

WORDS
HETTIE O'BRIEN
PHOTO
ZIQIAN LIU

30

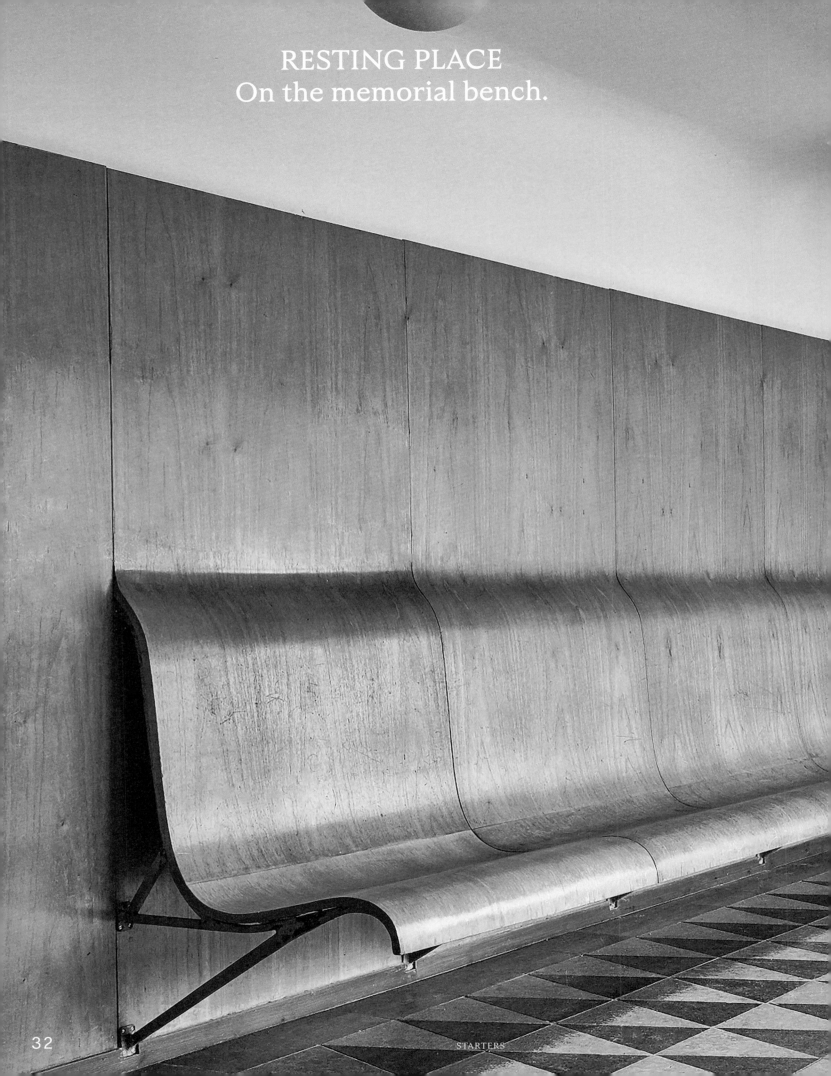

RESTING PLACE
On the memorial bench.

There are more than 7,000 memorial benches in Central Park, each bearing a plaque dedicated to a loved one dearly departed. These small, discreet public memorials have been a feature of New York's most famous park since 1986, and reflect our changing relationship with death.

In the 18th century, when mortality rates were high, the dead were remembered with austere gravestones decorated with skulls and hourglasses—*memento mori*—to symbolize how much death was a part of everyday life. Today, as life spans increase, these morbid Victorian totems have decreased; there is more emphasis on celebrating someone's life and achievements, rather than just marking the fact they are gone.

Perhaps this is why benches have become such a popular form of remembrance. More than trees planted in someone's memory or the place where you scatter a loved one's ashes, benches offer a focal point for grief while often also evoking a memory of the person when they were alive: how they would walk through this park or admire that view. They also satisfy the very human fear of being forgotten: As the saying goes, you die twice—once when you stop breathing and again when your name is spoken for the last time. For those of us without the means to endow a hospital with a new wing or build a library, benches offer a way to live on, even if only for a moment as a passerby stops and wonders who you were.

WORDS
GEORGE UPTON
PHOTO
SIMON BAJADA

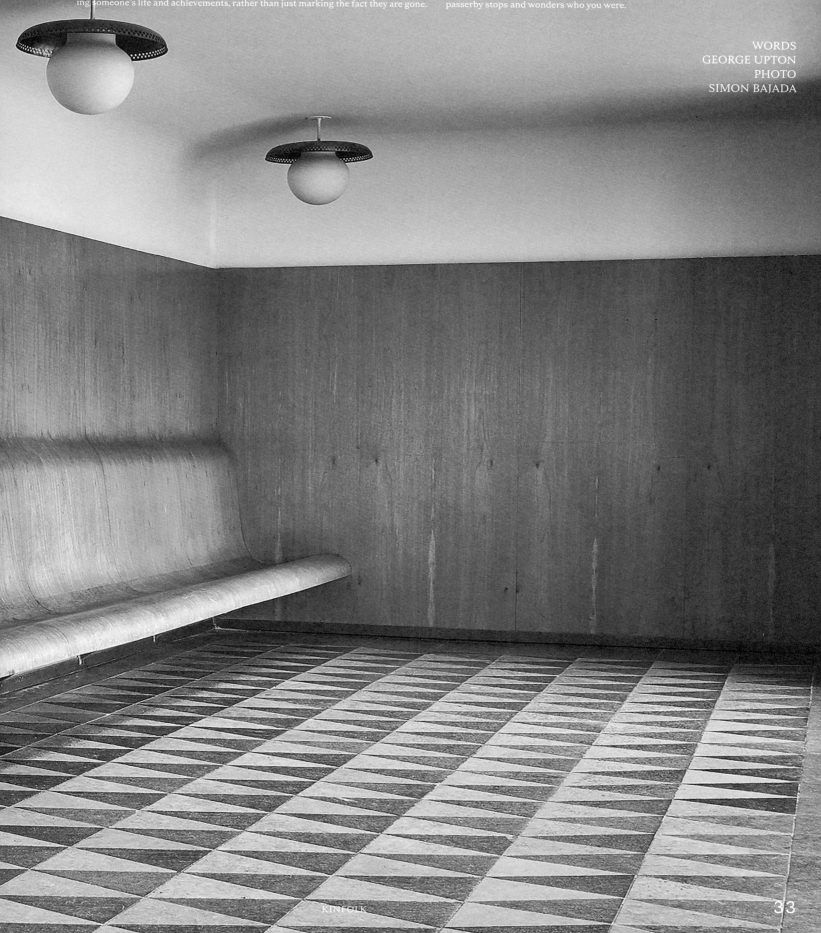

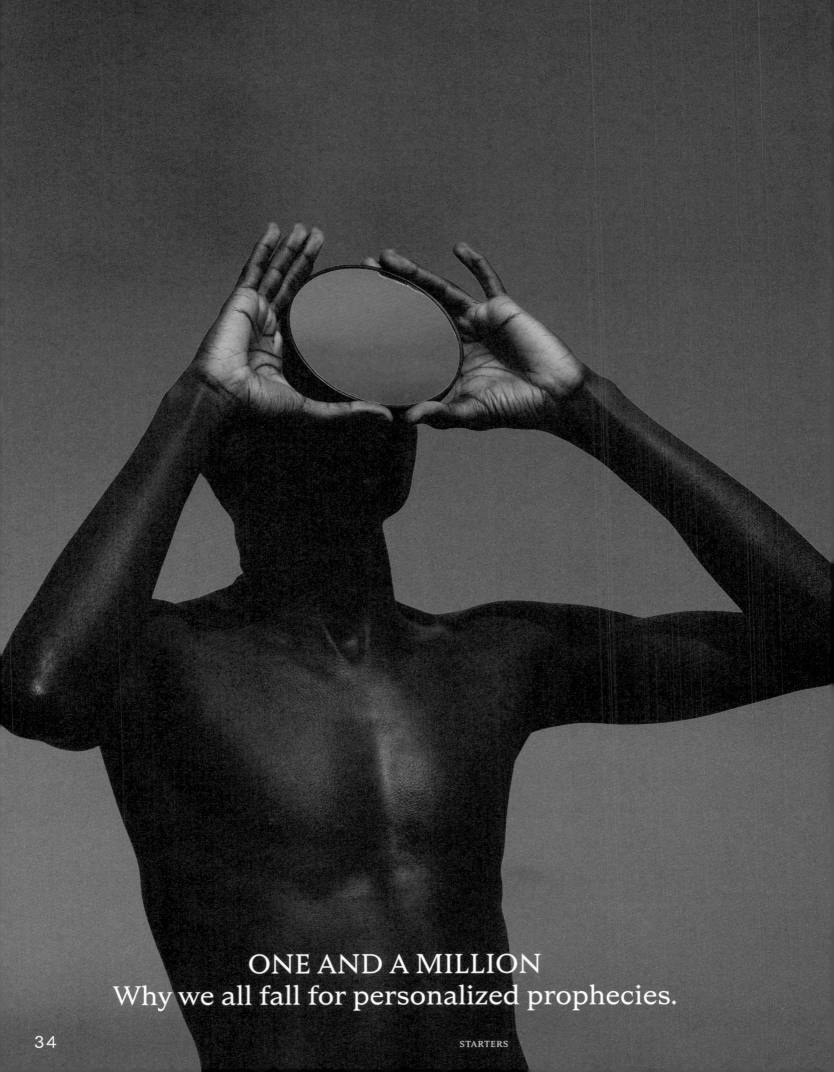

ONE AND A MILLION
Why we all fall for personalized prophecies.

WORDS
OKECHUKWU NZELU
PHOTO
LUCA MARIANACCIO

Astrology is experiencing a resurgence, particularly among Gen Z: Co-star, an app which offers detailed and personalized forecasts, has been downloaded by 25% of women aged 18 to 25 in the US. The app requests information including the location and precise minute of the user's birth, runs it through an algorithm and produces "hyper-personalized" advice about various aspects of life, as well as an extensive personality analysis. Despite Co-star touting its use of NASA data, it is widely accepted that there is no scientific basis for astrology. So what is the appeal?

It may well be a classic example of the Barnum Effect, a phenomenon whereby people identify strongly with even the vaguest descriptions of their personalities. In 1949, the psychologist Bertram R. Forer administered a personality test to his students, and then gave everyone in the class a set of broad statements supposedly produced by this test ("You have a need for other people to like and admire you, and yet you tend to be critical of yourself," for example). Afterward, he asked his students to rate the accuracy of the statements: The average rating was 4.25; 5 was the highest. In fact, Forer had disregarded the personality test responses entirely and had given every student the same statements. The phenomenon became known as the Barnum Effect, named after the infamous 19th-century hoaxer and showman P.T. Barnum.[1]

Viewed through this lens, the appeal of astrology is not surprising. When categorized based on our individual data, we get the impression that every secret nuance of our personality deserves attention. There is something bewitching in identifying with a label, especially when that label does not appear too broad, too negative or too problematic. After all, horoscopes usually couch even the most negative feedback in gentle— or seductive—language: "You march to the beat of your own drum." It gives us a sense that we are all unique, but never alone.

There is a market for this. Although the Myers-Briggs personality test was developed by a mother-daughter team with no formal psychological education, it is now used by millions each year. People are eager to learn about their place in the workforce and in society, and are often willing to pay to do so. The questions posed by personality tests—and the advice provided by astrology apps—can be useful for any self-aware adult. But if Forer's scientific experiment is anything to go by, the key to finding answers may lie not in broad descriptions of personalities, but in an understanding of universal human nature.

(1) It was P.T. Barnum who famously declared "There's a sucker born every minute" and made a fortune showing Americans improbable miracles, like a mermaid that turned out to be a monkey and fish sewn together.

AHLEM MANAI-PLATT

WORDS
BELLA GLADMAN
PHOTOS
JEAN-PHILIPPE LEBÉE

On intuition and eyewear.

Forget the age-old polarity between commerce and creativity. For Ahlem Manai-Platt, founder of the eponymous luxury eyewear brand AHLEM, "there's no distinction"—it's all about trusting your intuition, be that when hiring, designing or making business decisions. Manai-Platt is confidence incarnate—as she says herself, "I never questioned whether I'd succeed. When you're at the core of what you're proposing, how can it fail?" It's this curiosity and confidence that's taken AHLEM from strength to strength since she launched it in 2014. When we speak, Manai-Platt is enjoying a morning coffee in the LA sun, after dropping her son off at school. It's curiously domestic compared to her usual routine of regular transatlantic flights to Paris and back. She makes the most of those trips: "Flights give me the possibility to draw. It's an in-between time, like a theater interval."

BELLA GLADMAN: Did you always want to work in fashion?

AHLEM MANAI-PLATT: Actually, I studied history and photography, to be a war reporter, having been interested in geopolitics since I was a child. I got a job on the photo desk of a documentary production company in Paris, digitizing journalists' films. I was consuming raw documentaries day and night, until I got the chance to do it myself. Although, when my time came, it wasn't a war I was reporting on: I was on camera for a documentary about the difficult life of being an artist in France. I ended up working at Acne, then at Prada Group, then I started my own company helping designers. After less than a year, I decided to start my own brand. Everybody wants to start a brand—a T-shirt brand, pants line, whatever! It was eyewear for me.

BG: Why eyewear?

AMP: I don't need to wear glasses, but I've always had my sunglasses with me. If they aren't on my eyes, they're hanging on a headphone cord or hooked on my T-shirt. I'm an only child, and I grew up between Paris and Tunisia. My mother was extremely busy, and every holiday she would send me to Tunisia to stay with her older sister. I would always go with a new watch, a new camera and a new pair of sunglasses: Those were my essentials.

BG: Talk me through your design principles.

AMP: I liked the Bauhaus ethos before I could even name it or knew what it was. When I was three or four, I was so fascinated by object design. Marbles, fountain pens—the proportion, the line, simplicity, functionality. When I discovered the Bauhaus, its principles of form following functionality, and how that can be applied to a cup, a building, a shirt or a bed, I realized it really was an emotion I had already been feeling.

BG: What's Ahlem's *je ne sais quoi*?

AMP: My design process begins with intuition. I approach each frame as a sculpture, improvising and refining until my idea comes to life. AHLEM glasses are made to make you look good—to give you that instant feeling of confidence and cool—and they're the best quality they can possibly be. Recently, I was in New York at our flagship store, and my friend came by. He tried a pair on and just said, "Whoa, that's insane." You can feel it when you wear them. I'm a true advocate of artisanal craftsmanship. We place such importance on the love, care and savoir-faire put into our glasses because it's the little details that take them to heirloom status and elevate the wearer's mood and experience.

BG: How are you planning to last?

AMP: I don't look to recreate the past for design inspiration, it's about designing for a contemporary moment. I always tell people that I don't have "inspirations"—and it's true that I avoid mood boards, nostalgia trips, and devotion to any specific icon. My influences are democratic: they're everywhere. For me, inspiration is diffuse rather than anchored. It's always moving. Every single design choice I make is about longevity. My belief is that simple, elegant silhouettes paired with superior materials will produce objects that can last a lifetime.

BG: What's running your own brand like?

AMP: My leadership style is intuitive—I run AHLEM the way I want it to be run. I saw what was wrong with the corporate world—the inefficiency, the coming in at 8 and finishing late. I don't need anybody to text or email me at 9 p.m., it's unnecessary! I've also learned that you need to take on the best idea, wherever it comes from, whoever says it. I'm learning on the fly, from experts in their fields, and realistically, if tomorrow I can't work for six months, I want to have created a brand that can carry on without me. You can only do that by hiring people you trust, and who trust in you.

Produced in partnership with AHLEM.

Styling: Gemma Bedini. Ahlem wears a jacket by Maison Rabih Kayrouz and rings by MM6 Maison Margiela and Vibe Harsløf.

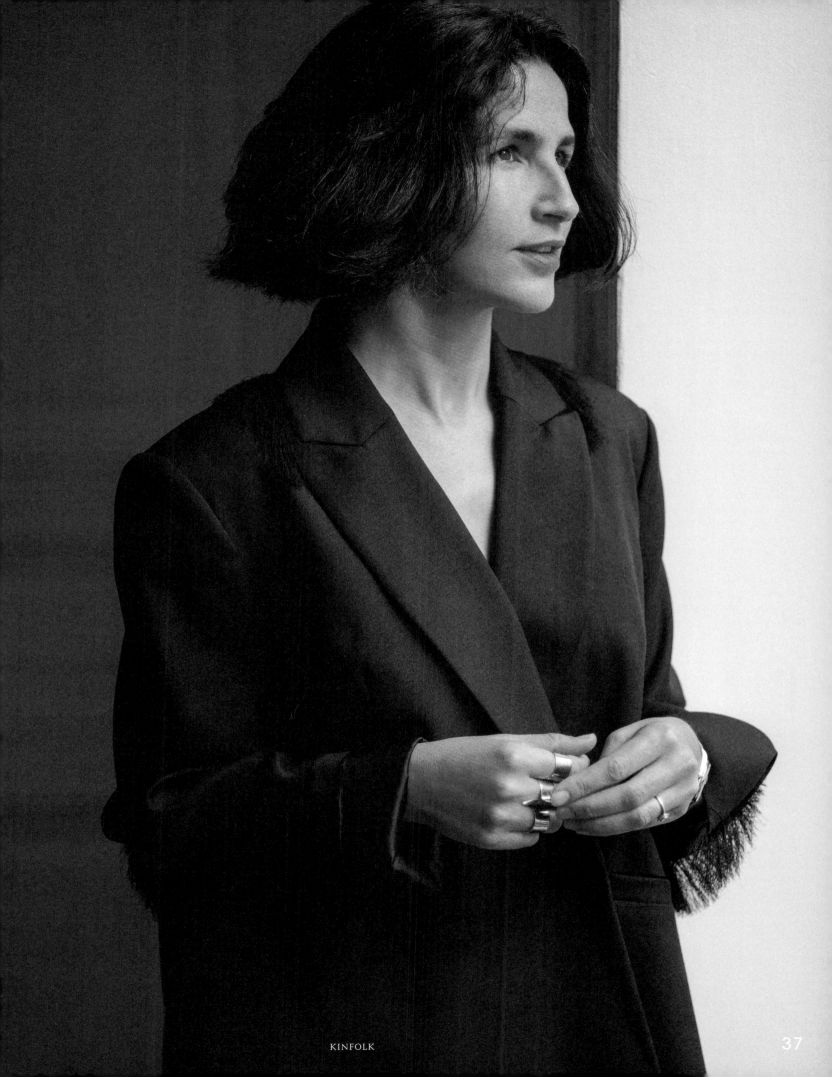

It's become a trope in American movies: A concerned friend will turn up on the doorstep of the grieving or recently heartbroken protagonist with a homemade casserole. Often you won't see the food being cooked or eaten. It is enough just to see the foil-covered rectangular glass or ceramic baking dish, a universally recognizable symbol (at least in the US) of compassion and community.

The history of how casseroles became the definitive American comfort food is also the history of the country in the first half of the 20th century. The dish—which was originally defined as a combination of vegetables, starch and meat—became a useful way of stretching limited resources during the privations of two world wars and the Great Depression. But it is also a story of American technical innovation and industrialization: Pyrex, the heat-resistant glass, was first used for cooking in 1908 when a glass battery jar was converted into a baking dish. And canned soup—that great turn-of-the-century invention—formed the base of many early casseroles.

By the boom years of the '60s and '70s, casseroles—featuring tuna, green beans, or ziti, for example—were being eaten by choice rather than necessity. Evoking a nostalgia for simple family dinners, the dish took on a newfound significance as a uniquely reassuring (not to mention portable) meal; something easy and nutritious to throw together for someone who is going through a tough time. With American casseroles often understood as anything that can be cooked in one dish—as opposed to the more rigid French definition of casserole dishes such as *boeuf bourguignon* and *cassoulet*—it's an approach that is both universal and intimate.

By accident rather than design, the American casserole comes closest to the Medieval origins of the term. Deriving from the Latin *cattia*, meaning ladle, it is thought that initially "casserole" simply referred to a communal pot from which everyone shared. It's a tradition that remains alive and well, both on-screen and off.

WORDS
GEORGE UPTON
PHOTO
DEREK HENDERSON

COLD COMFORT
The plain decency of a doorstep casserole.

EYES ON THE PRIZE
Who are arts awards really for?

Debut novelist Patricia Lockwood has a theory about her 2021 Booker nomination: that the esteemed British literary prize put her book on their shortlist for, well, clout. *No One Is Talking About This*—written in the ultra-specific parlance of the internet-obsessed—is no doubt an edgy choice for the historic award. "Do you think it's to be cool?" Lockwood asked one interviewer, who remarked on the "so not Booker" quality of the freewheeling, experimental novel.

The Booker has always had to maintain a fine balance of elite acclaim and popular support in its nomination choices. "If winners are seen as too obscure, there is a risk the public blows cool and the book-trade becomes testy," Charlotte Higgins wrote in an essay about the prize for *The Guardian*. "If the prize veers too mainstream, though, that is also a problem, since the Booker is supposed to be decided on loftier criteria than mere commercial appeal."

Perhaps the Booker organizers are keen to cover all bases because they're watching their backs. Time and again in the arts, new prizes have been created to correct the oversights of existing offerings. Higgins writes that the Prix Goncourt—the most prestigious literary award in France—was "set up in the wake of the Nobel," while the Booker arose "to rival the Goncourt," and in turn, Higgins continues, "the Turner to imitate the Booker." The Turner, a conceptual art prize that has often caused controversy in its choices, of course inspired the Anti-Turner Prize: £40,000 award for the "worst artist in Britain," along with the Turnip Prize and the Art Clown of the Year Award.[1] Both the Women's Prize and the French Prix Femina were established in response to the sexism of the aforementioned literary awards, and numerous, though monetarily tamer, efforts have been made toward the recognition of exceptional non-white writers—the Jhalak, Caine and Morley prizes, to name a few.

When prizes seem to appear as a corrective action to a perceived oversight, they become an inadvertent guide to exactly who the industry has failed. Discussing the role of marginalized identity in writing and media in *Gawker*, Jenny G. Zhang explains how affirmative actions can be cynical, rooted in self-interest and ultimately siding with the system of the ruling power. "It's hard not to feel that much of the endeavor, while perhaps worthwhile in some regards, ultimately rings hollow," writes Zhang.

As the facade of critical objectivity has worn away over the years, the true nature of these sorts of awards has become clear: that they are more reactive than we realize, often rising as a response to a particular set of circumstances. The late Ursula Le Guin, a hugely influential science-fiction author, held a famous disdain for prizes. "To accept an award from an institution is to be co-opted by, embodied as, the institution," she wrote in a 2017 *Paris Review* piece. Five years later, her estate is planning to launch an £18,000 prize for fiction in her name.

(1) The logic of prizes risks breaking down entirely in the case of the Turner, as artists increasingly question the hierarchy it imposes. In 2019, the four finalists split the £40,000 prize money between them. In 2021, as a response, the shortlist was made up entirely of artists' collectives.

WORDS
JENNA MAHALE
PHOTO
GAVIN GOODMAN

BRENDAN YATES

WORDS
STEPHANIE PHILLIPS
PHOTOS
JUSTIN CHUNG

The Turnstile frontman on hardcore's sweet side.

Life in a touring band brings with it a particular set of hazards. Brendan Yates, lead singer of the Baltimore hardcore band Turnstile, has just experienced the big one: The tour van broke down. "I had a rough morning," he confesses over the phone, speaking from the recently repaired van as the five-piece band races toward their next show in Phoenix.

Judging by the reaction to their new album, *Glow On*, this won't be the last time the band will be faced with battling the vagaries of life on tour. Their eclectic sound, which merges everything from R&B and samba music to noughties rap rock and funk, has lured in fans beyond the US hardcore scene: They've even played Coachella. The band's ascent toward the mainstream has also been spurred along by their collaborations with producer and artist Blood Orange, a major label deal with Roadrunner Records and their unswerving commitment to having fun with it all.

STEPHANIE PHILLIPS: What was your first entry point into hardcore music?

BRENDAN YATES: We started going to hardcore shows when we were super young. We would go to neighborhood shows where our friends' bands would play. Once we started going to high school, we found our way to hardcore shows in the city and met older friends who started taking us to more shows. When you become a teenager, you realize you can actually be a part of the music that you're hearing and it's not just like this distant mysterious thing that only exists in your headphones.

SP: The sense of community that you find in those kinds of spaces can be as important as the music.

BY: Yes, it's important. Growing up, I loved music so much, but it wasn't really anything that existed outside of me in my bedroom. My first experience of being able to go to a show and meet people that like similar music, it started to become real.

SP: What do you think people get wrong about the hardcore and punk scene?

BY: People being excited and dancing can come off as people trying to hurt each other. When there are shows, at least the ones that we're familiar with, people are going and looking out for each other. It's a way to let people express themselves and throw their bodies around, but we're also picking each other up. No one's trying to hurt each other.

SP: There isn't the kind of violence that people assume there is in those spaces.

BY: And that's not to say it doesn't exist. The cool thing is, when there is a community, it's something that's regulated within itself. If there's someone causing trouble at a show, then that's not cool.

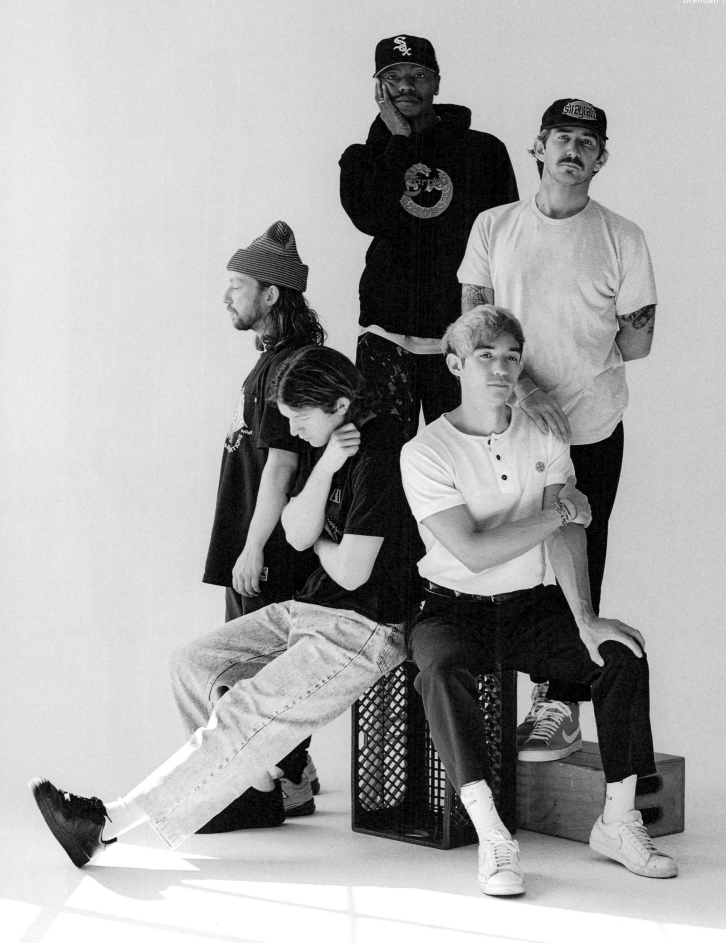

Clockwise (from left): Brady Ebert, Franz Lyons, Pat McCrory, Daniel Fang and Brendan Yates.

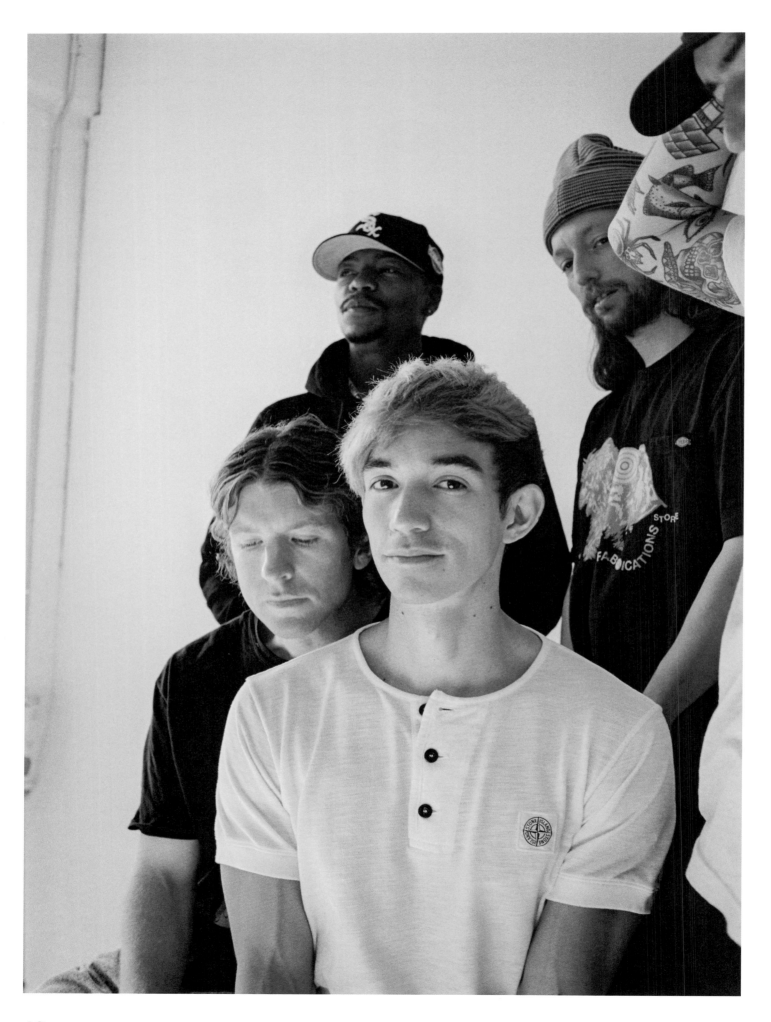

Yates and Ebert had formed their first band as teenagers living on the same street. Lyons was the merch guy for their previous band, Trapped Under Ice, and Fang was a friend from college. McCrory joined from the Baltimore band Angel Du$t.

SP: I read that you wrote most of your songs in your bedroom. I always write on the sofa. Do you feel it's important to have a place you go to spark creativity?

BY: The bedroom is the place where I can pace back and forth for hours straight, thinking about a thing. If you go somewhere else outside there's maybe subconscious pressures on time. [The bedroom] is the most comfortable place where you can fully turn your brain off and submerse yourself in your own thoughts.

SP: While on tour, do you have any pre-show rituals?

BY: I'll try to do things, breathing exercises, to feel more connected with the moment. I physically prepare as well so I don't hurt myself if I'm jumping around or acting silly. I do little vocal exercises too because I don't really know what I'm doing when I'm singing. I just get excited and yell and lose my voice so I try to do anything to be more conscious of stretching that part of my body out. Once we're playing I totally don't think about it. I definitely lose my voice way more than I would like to.

SP: There's been a resurgence in hardcore and heavy rock which has seen bands like yours, as well as IDLES and Chubby and the Gang, rise in popularity. Why do you think people are leaning toward it?

BY: Maybe it's just the way that life naturally circulates. People want something that feels different. It is exciting though, because there's so many great bands. I don't think visibility or accessibility ever determines the greatness of a band, but it is cool when those two things overlap.

SP: Hardcore fans have often bristled against bands that move beyond the scene. Is the idea of selling out something you and rest of the band ever worry about?

BY: No, I don't think that's ever a concern for us. The only way that happens is when you're changing yourself for some reason. I look at the band as an outlet to reflect our growth as humans as well, so it's always going to be reflective of where we're at and our influences and things we're excited about. To ever keep that in one place is essentially stunting your own personal growth. I try to be open—to always be learning and challenging my perspective.

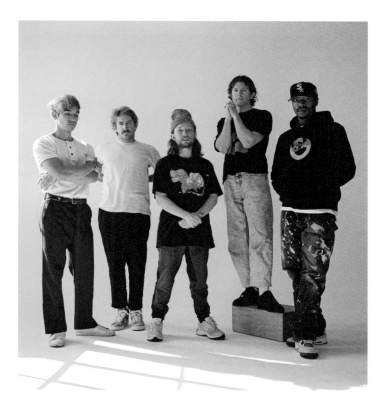

THE SELLOUT
On the moral maze of art and money.

Before he received the 2016 Nobel Prize in Literature "for having created new poetic expressions within the great American song tradition," Bob Dylan, famed musical icon of the 1960s countercultural movement, worked on a campaign with lingerie brand Victoria's Secret. The collaboration surprised many at the time, even prompting news features and articles. Could a folk-rocker walk among the angels and still retain his integrity?

Selling out is an accusation that is only leveled at certain artists. One Direction, Cher and Stephen King are immune from such critique. The notion of a sellout relies on the belief that particular artists owe something to their audiences or wider community; something that is incompatible with certain forms of commercial success. A change in style could be considered selling out, by switching your self-penned confessional folksy ballads for a synth-heavy pop sound, for instance, or by eschewing the art house cinema that built your reputation to direct a superhero movie.

The most serious accusations are political: consider the band Queen performing in apartheid-era South Africa. Of all the musical acts who played the Sun City resort in the 1980s, including Dolly Parton, Elton John and Liza Minnelli, the group faced more lasting criticism for their decision. This was at least in part because of frontman Freddie Mercury's heritage. Born in Zanzibar to a Parsi family, he had somewhat closer ties to Black South Africans than the other acts performing. That the scrutiny rested on an ethnic identity Mercury did not refer to often in public made the double standard appear particularly unfair.

Scrolling through Instagram, where paid partnerships sit alongside calls to action, the concept of selling out can feel distinctly 20th century. When even activists have sponsorship deals, commercial partnerships don't carry the stigma they once did. Yet audiences demand authenticity like never before. To denigrate a popular figure's legitimacy—whether a cook or an author—you need only call their work "inauthentic." Artists succeed by representing their personal brand and the companies with whom they work. Nowadays, they lose legitimacy less through political inconsistency and proximity to wealth, than by failing to portray a genuine version of themselves.

WORDS
SALOME WAGAINE

Photograph: Picture Kitchen / Alamy

Part 2.
FEATURES
Activism, dreamy homes and Brazilian blooms.
50 — 112

46 Vincent Van Duysen
56 Follow Me!
60 Hermès: In the Making
70 Fresh Stems
82 Paapa Essiedu
94 Space Invaders
102 Home Tour: Rose Uniacke

Words
ANNA WINSTON

Vincent VAN DUYSEN:

Photography
LASSE FLØDE

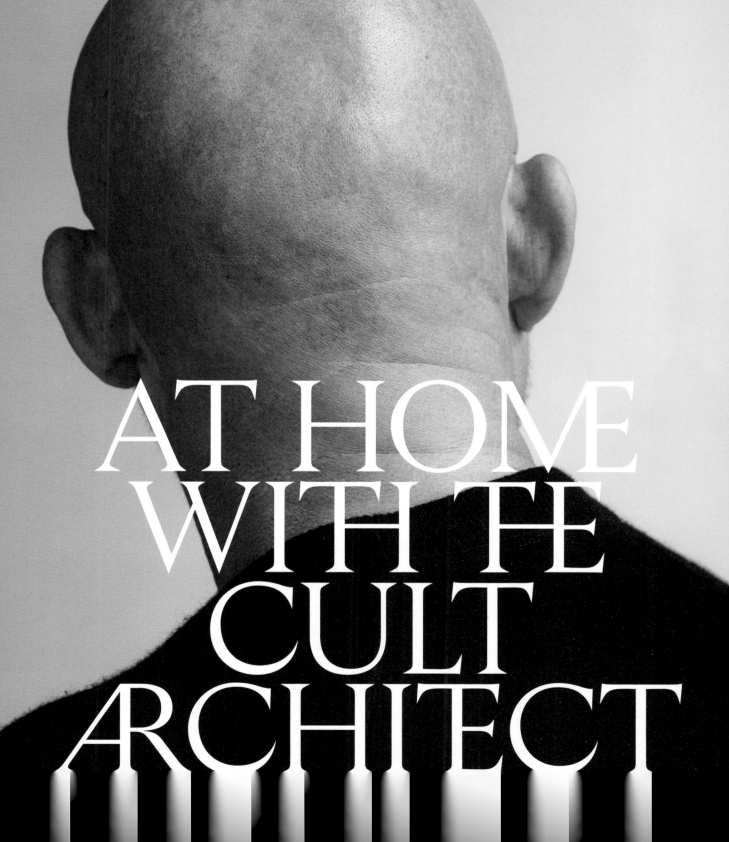

AT HOME
WITH THE
CULT
ARCHITECT

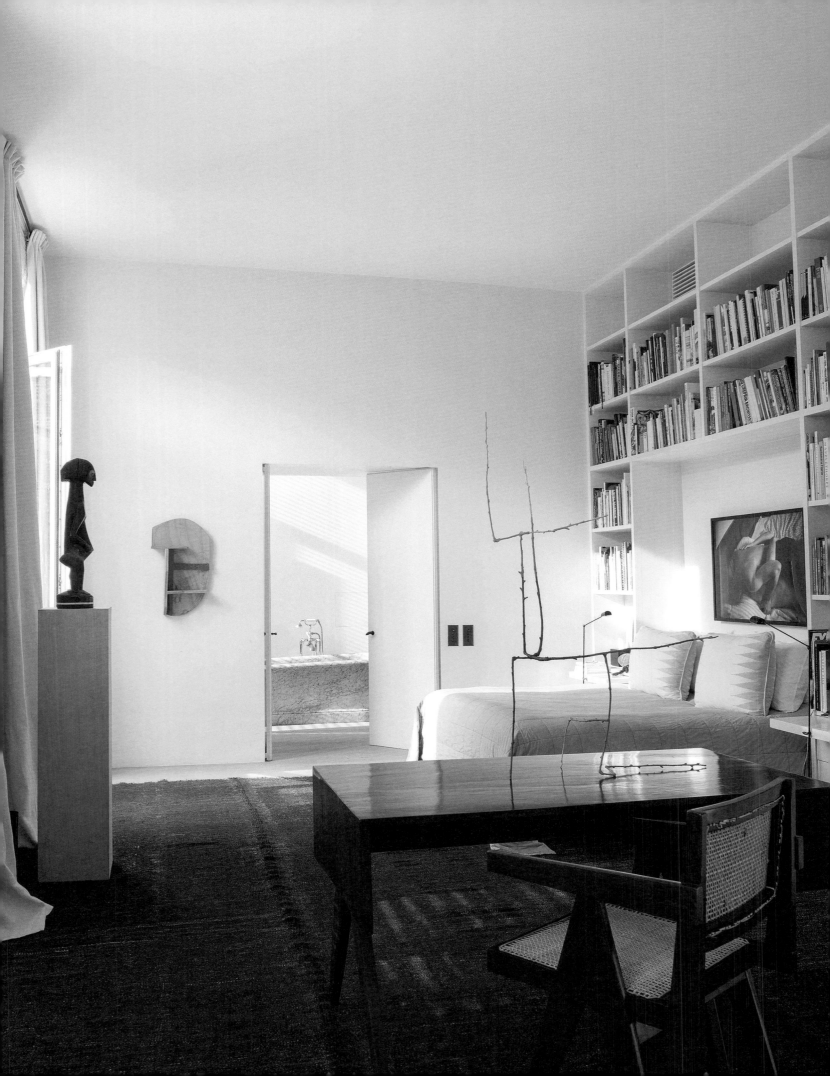

Vincent Van Duysen is not a man who cares for labels. One, in particular, sparks his ire. "It's the way the term is used," he begins. "First of all *minimalism* is something very radical and I'm not a radical at all in heart and soul. I'm here to create warmth and comfort for my clients and myself."

We are meeting for the first time at the Belgian architect and designer's Antwerp home. It's a line of inquiry Van Duysen has been down before. "Of course, I'm a big fan of American minimalist artists," he continues. "But the idea of minimalism that is really going to the bone and stripping away everything, where you cannot have an object or an art piece or books around because it might disturb the minimal environment is not the way I perceive minimalism. When people think that I'm a minimalist, I say *Guys, you don't know me. You don't know me.*"

For those very familiar with his work, this passionate rant should come as no surprise. There is nothing cold and clinical about Van Duysen: A devotion to natural materials and colors means that almost every surface has a texture that invites you to touch it. His color palette might look monochromatic, but it is rich in tone and variation. Fellow designer and former design journalist Ilse Crawford once described his work as "sensual," which seems a much better fit. Van Duysen's approach is also that of a completist: He says that architecture, interiors, furniture and product design are combined to create "my world."

To understand this total approach, you could look to a hospitality project such as the recently completed August Hotel in Antwerp, where everything, down to the cutlery in the restaurant, is designed by Van Duysen and his team. Or consider the design of his home. Much of the functional "mess"—food storage, bathrooms, electronics, the stack of nearly identical designer black baseball caps in his bedroom—is hidden behind cupboard

or wardrobe walls, but there are still clear traces of real life everywhere. Almost every room has at least three piles of books and magazines, many well-thumbed, including Flemish and English novels, philosophy books and copies of *National Geographic*. He describes the books and objects as the "protagonists" of each space.

Van Duysen moved to Antwerp in the late 1980s. Culturally, he was rebelling, having previously spent eight years at a Catholic boarding school. "I was not a bad boy, but I was exploring everything," he says.

(above)
Van Duysen lives and works in Antwerp, where he founded his eponymous design studio in 1989.

He went to Antwerp's fashion academy to take the entrance exam without telling his parents, and was accepted. But at the same time, his parents hired a tutor to get him through his more technical architecture exams—the part of the discipline he struggled with most—and he passed.

When Van Duysen designed his first house in 1985, Antwerp was cementing its reputation as a unique cultural and design center with a profoundly idiosyncratic character. More than 25 years on, the living room of that first home still regularly appears on Pinterest boards, blogs and roundups for home interior inspiration, often mixed in with images of his current home, which sits an easy walk from his studio in the city center. The 19th-century neoclassical building stands out from the more narrow, brick 17th-century houses that are more typical of Belgium's Flemish-speaking northern region.

The similarity between the two houses indicates Van Duysen's striking consistency over the decades: They share the same textured wall finishes in muted shades, the same almost-black details in functional elements like windows and counters, the same hidden fixtures and refined detailing. His architecture retains a sense of sparse, stylized domesticity, even in the showrooms, shops, hotels and offices his team now works on, which include stores in Italy for Loro Piana and La Rinescent and a winery in Belgium.

From the outside, his buildings often appear more severe and regimented, more overtly modernist, in contrast with the tactility of his interiors. He describes his approach to design as intuitive. Math is still not his strong suit: "I have other talents," he says. "My team knows this. And I'm very verbal, very narrative, I talk with imagery." He is personally involved in every single project that passes through the practice on a day-to-day basis.

Although Van Duysen's name is associated with the Belgian scene, he is quick to tell people that he has Mediterranean roots. This comes partly through heritage—there is Mediterranean ancestry on his mother's side of the family—and also through scholarship. As a young designer, Van Duysen was heav-

(left) Van Duysen's bedroom overlooks his garden. Large windows fill the room with natural light.
(overleaf) The living room opens into the hallway, stairway and a glass-fronted courtyard garden.

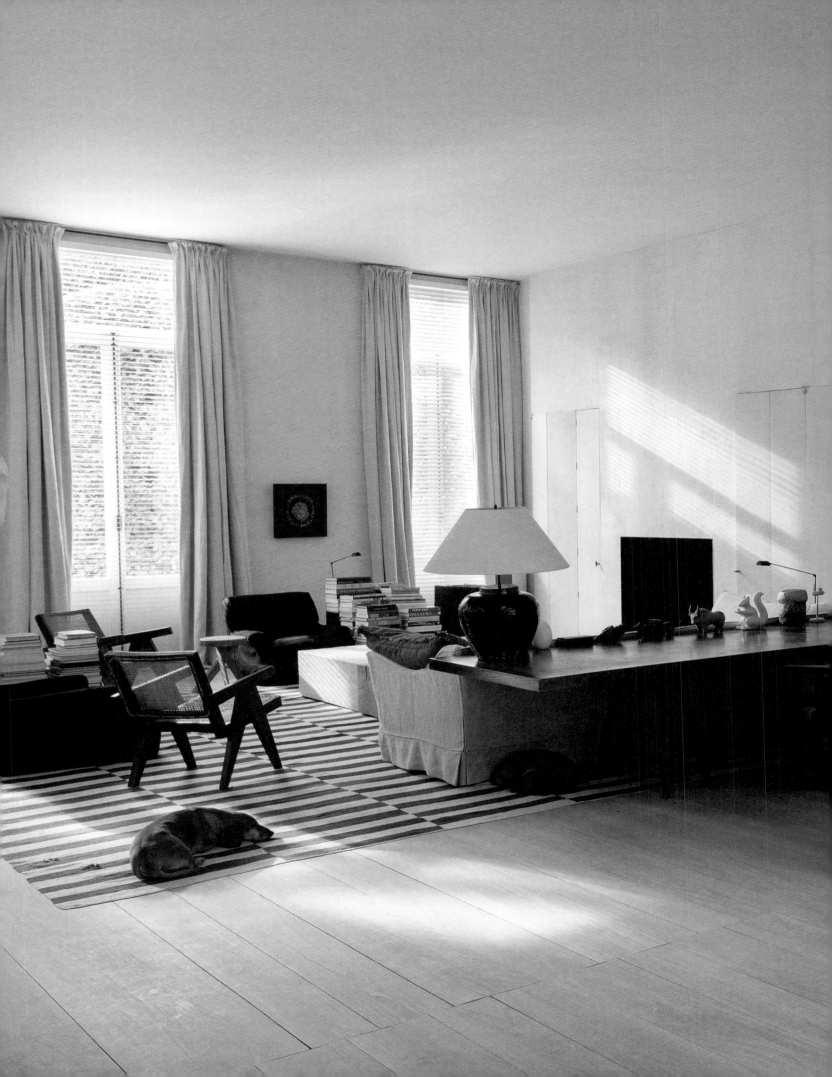

ily influenced by his relationship with Italy and its design industry. In his 20s, he worked with the postmodernist designer and architect Aldo Cibic, who was a partner in the Milan studio of Memphis movement founder Ettore Sottsass.

On the surface, this experience seems strikingly at odds with his reserved, quiet aesthetic, but he says it influenced him on a cerebral level. "I was a young kid, 22 or 23 years old, and I was arriving in that craziness—the end of postmodernism—with all these intellectual people, these crazy, Pasolini-ish people. They were teaching architecture in a completely out-of-the-box way," he recalls. "What appealed to me at that time about Sottsass and Aldo Cibic was the interest in primary forms. One of the first collections I worked on was called Standards, a series of furniture really going to the basics but with a fun twist."

When he returned to Belgium and started his own practice in 1989, it was an Italian who first spotted his potential as a furniture designer. Giulio Cappellini, head of the iconic furniture brand Cappellini, "considered my interiors and my furniture as domestic architecture," says Van Duysen. His commissions for Cappellini were the first of many collaborations with Italian furniture brands. In 2016 he was appointed creative director of Molteni&C—the furniture institution founded by a family involved in creating the Salone del Mobile, the world's most important furniture fair. Van Duysen was the first non-Italian to take the helm and now considers himself part of the family.

"When people think I'm a minimalist, I say 'Guys, you don't know me.'"

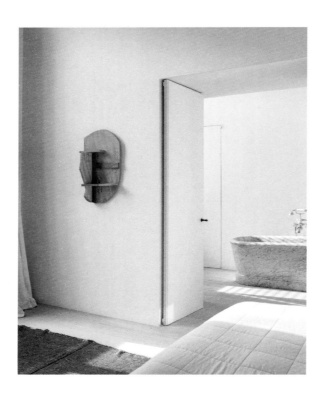

Sitting at the long wooden table that runs along the side of his living room, overlooked by a cardboard work by the artist Sterling Ruby, Van Duysen is not the severe individual that he seems in photographs. He is energetic and warm. Wearing his signature head-to-toe black—a casual version of the standard architect's uniform—he is disarmingly open. He tells me, for example, that his standard-issue baseball cap is the result of a doctor's warning that he should never go bareheaded in cold weather with a shaved head.

But he is blunt, too. He lays bare his irritation at how an anemic version of his style is now wheeled out to sell "luxury apartments" carved out of old buildings across Antwerp and other European cities. These cynical displays of façadism are built by developers keen to cash in on the aesthetics of so-called "Belgian minimalism," the term coined in the early 2010s to describe an aesthetic exemplified by Van Duysen and his fellow Antwerper Axel Vervoordt. They tend to miss the point of Van Duysen's approach and lack the subtlety of his best work. The surfaces are too smooth, the whites too brilliant, the blacks too flat, the storage—which is so abundant in his own home and key to keeping the spaces open—completely absent. "I know my work is very inspirational, and in Belgium, we see a lot of look-a-likes. It's sometimes very irritating," he says. "It's good that I inspire others. But there is huge complexity in my approach and the richness of materials, this tactile world that is omnipresent in my work. It reflects who I am."

Still, he doesn't register the competition as anything other than a minor annoyance. "My work is more profound. My work has more layers," Van Duysen says dismissively. "It's something you cannot copy. Luckily I have this gift, that I'm very blessed with, that within this style, this tactile world, I can still surprise myself, surprise my clients." In Van Duysen's home, there is little true black or white. The colors are muddied with blues, greens and browns. "Most of the color comes from the material, from the use of wood, of blue stone, but also the objects we live with, the plants," he says. "I'm a big admirer of [Mexican modernist architect] Luis Barragán—I visited most of his projects in Mexico—but his use of color reflects Mexican culture and their color reinforces his architecture within that context. Our use of color in Belgium is different."

(above) The bathtub in Van Duysen's en suite bathroom is rendered in white marble.

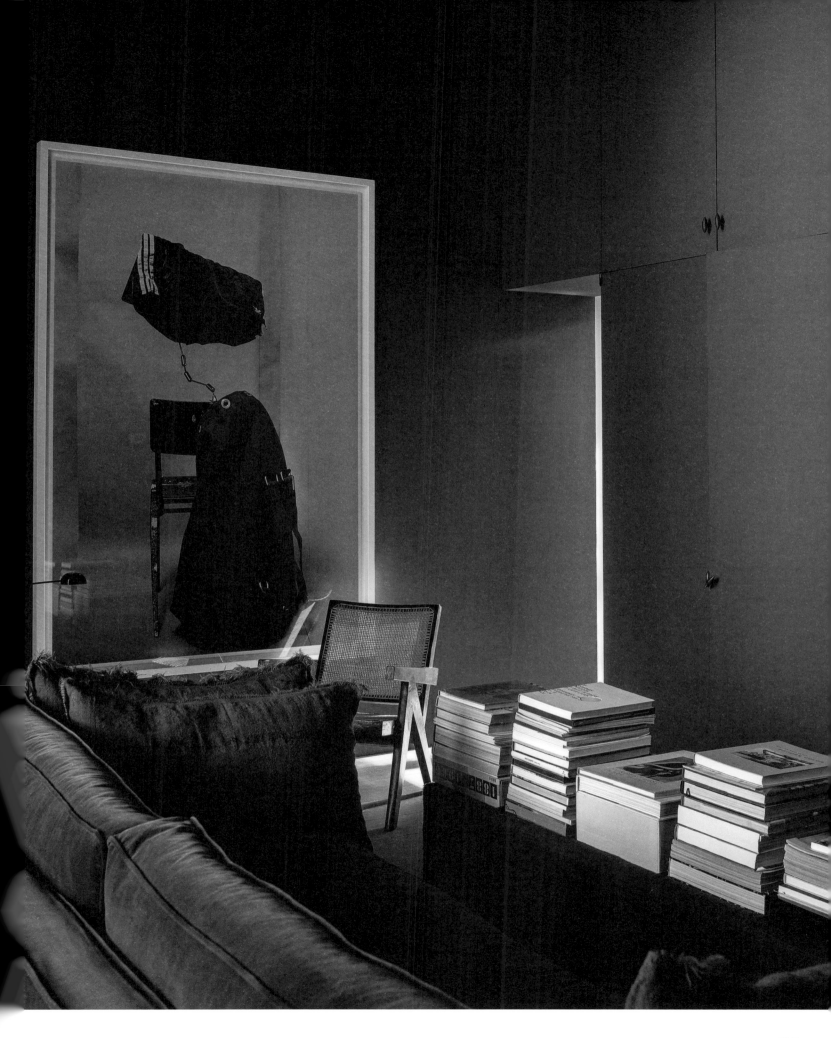

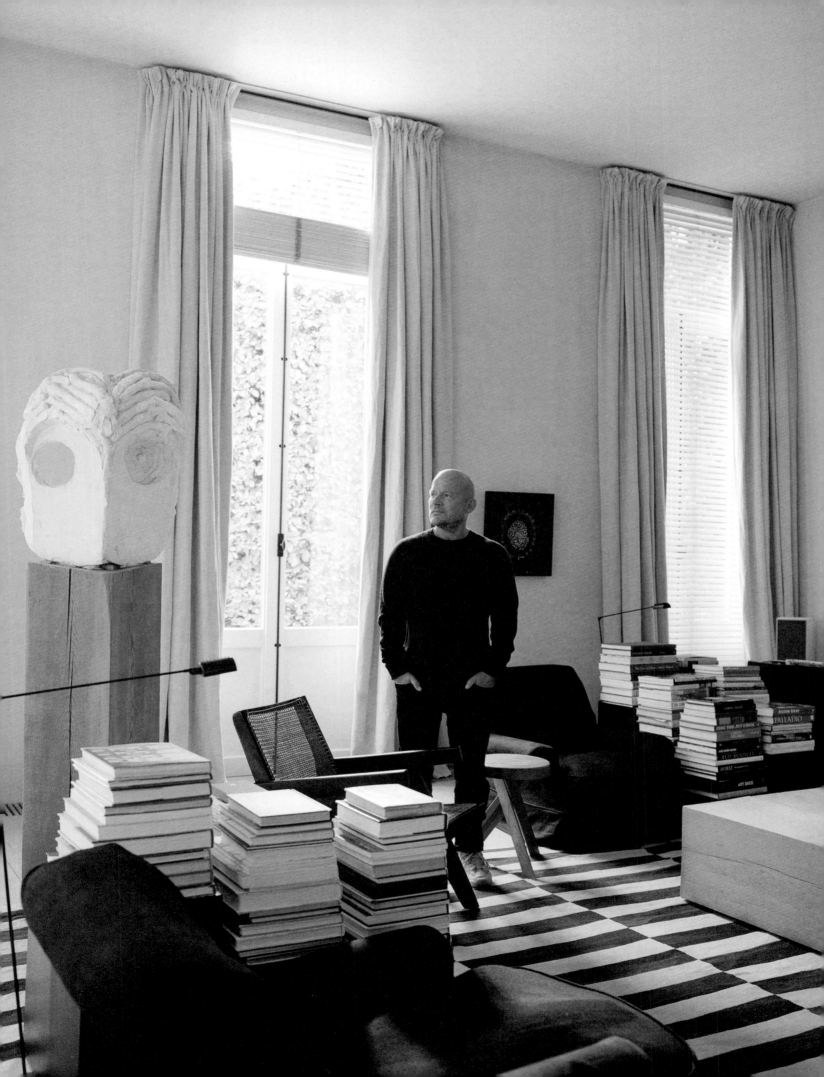

Although his home could easily accommodate large dinner parties and houseguests galore, he claims to rarely entertain, and when he does it's generally no more than a handful of friends. He describes his home as his safe haven, an island of calm, that he has little desire to leave when he isn't at work. Many of his peers—the generation of creatives including Ann Demeulemeester and Dries Van Noten who cemented Antwerp's reputation as a center for fashion and architecture in the 1980s and 1990s—have moved out to bigger houses in what passes for the countryside in heavily developed Flanders. But Van Duysen sees no need to leave the city, especially when his home already feels like a country house.

Next year, Van Duysen will turn 60. An only child, he lost his mother last summer. His father is growing older, although still heavily involved in the business side of his son's work. Van Duysen has no children. Does he want them? Usually, the architect talks a mile a minute about his work, about art, about books, about meditation, about his houses, about his work again. But this question elicits a strikingly long pause. "I think I believe in destiny. It was not meant to be," he says, cradling Pablo—one of three dachshunds that are clearly devoted to him, hovering around protectively and barking when they don't feel his attention for a while. The tone of the conversation flips between light and heavy quickly. "It's not that my dogs are a surrogate for not having children," he laughs, "but they are my little babies, even if they are dogs."

"Also, I am gay, which doesn't matter now. And I am conservative—you can see this twisted kind of conservatism in my work. I think I would have had a lot of problems in terms of being able to educate my kids. If I had kids, I would want to be with them every day, and that's not possible.... But if I am not in a relationship, who is going to take care of me as I did my parents? I will have my friends, and my cousins and my nieces. I will make my own family in a different way."

There is a sense, in the way that he talks about his relationship with some of his clients, that they might also be his family, inhabiting his spaces, owning pieces of his world. Kanye West is perhaps the most famous and the most intriguing.[1] West is enamored with everything Antwerp and is rumored to be buying a house in one of the city's residential neighborhoods, so it's perhaps no surprise that he commissioned Van Duysen to collaborate on the house he shared with his former wife, Kim Kardashian, in California. When he comes to Antwerp now, West often stays in Van Duysen's wood-lined attic space, which he once described as the sexiest room he'd ever seen.

"Kanye is a genius, you know," says Van Duysen. "He's an artist. He's inspiring, a very emotional person. He has these extremes, and we talk about that. But more important is the chemistry. We're friends. We like each other. It's not always easy to follow him, but he gets me out of my comfort zone." Two weeks ago, West was here in Van Duysen's living room and asked for all the furniture to be moved out. "He's really into the essence of space, into sacred architecture, monasteries. He was standing in the pureness of the space with all of the windows open," he recalls.

"I'm grateful. Being surrounded by people I can learn from, great conversations. That's what I like the most. This is what I am."

(1) Axel Vervoordt led the design of Kim and Kanye's Los Angeles home. Van Duysen, who helped furnish the living room as well as the children's bedrooms, was one of a group of designers who contributed to the project, which also included Claudio Silvestrin and Peter Wirtz.

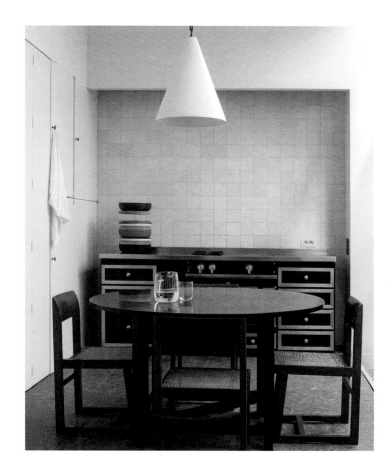

Who are the
influencer-activists
really helping?

ESSAY:
FOLLOW ME!

Words
MOYA LOTHIAN-MCLEAN

There's a meme that regularly makes the rounds on social media, which features a Twitter user replying to themselves. The first tweet is a limp message of some sort, for example, "#endracism." The second tweet, in response, reads, "That's enough activism for today I think."

Unlike many memes, you don't have to be versed in deep internet history to understand its point. The punchline plays on a certain perception —that the power of activism as we traditionally know it has been diluted by a flood of self-professed activists who exist almost exclusively online and see starting, or maybe just signing, a change.org petition as the height of civil disobedience.

In the summer of 2020, this background skepticism about the merits of "clicktivism" became a mainstream news item when CBS announced *The Activist*, a show in which young people would

people did, maybe because there were less people so we had stronger networks."

Taylor Stone, who defines activism as "strategic action that leads to some form of change in society," says that she's noticed a gradual shift toward activism being perceived as an identity category as well as a practice.

Ditto corporate campaigns, such as Nike's work with race equality activist Colin Kaepernick, or Pepsi's much derided 2017 commercial, which featured model Kendall Jenner attending a "protest" during which she hands a can of soda to a police officer.[2]

"You have to *do* something. There's always an action, hence the 'act' part of activism," Taylor Stone says. "And most definitely, no way on this earth would I have seen anybody doing anything with Nike or Adidas."

" Now anyone who runs a meet-up club is an 'activist.' I think that's why people have moved away from using the term 'activism' because they see it being misused."

compete—*X-Factor* style—for the prize of "lobbying world leaders."[1] Activism as an entertainment spectacle turned out to be a leap too far; the show was quickly shelved following public outcry over its concept being the literal embodiment of performative activism.

Against this backdrop, there has been a reckoning of just what "activism" means and if the attention of corporations and the entertainment sphere is impacting work on the ground.

"When I think about the period when I started, the people who considered themselves 'activists' were very much grassroots and a smaller number of people doing stuff," says Chardine Taylor Stone, a UK-based community activist who started organizing during the 2001 Stop the War movement, which campaigned against the UK's involvement in global conflicts post-9/11. "It was very anti-corporation and there was a lot more strategy in what

The commodification of certain strands of activism has led to the emergence of the influencer-activist, a figure defined by their large platform on social media, their vocal support for specific campaigns close to them—and their sponsorship deals. They are admired by some and regarded with suspicion by others for what's seen as the prioritizing of self-promotion over collective liberation. Take the LGBTQ+ influencers and activists engaging in pinkwashing for huge corporations. Former *Bachelor* contestant Colton Underwood, for example, promoted "the Amazon finds that help him show off his Pride," in a June 2021 *E! News* article.

(1) Responding to the backlash over *The Activist*, would-be show judge Julianne Hough tried to save face by praising it as "a powerful demonstration of real-time activism."

(2) The commercial, in which protestors hold up generic signs such as "Peace," "Love" and "Join the Conversation," was an attempt to capitalize on the aspirational face of activism. It backfired, and the company was obliged to pull the ad and apologize for its cynical bandwagoning.

"Activist" has become a selling point for those hoping to raise their profile; lifestyle magazines often add weight to celebrity profiles by tacking the word onto the list of their accolades. It's not enough just to be an entertainment figure or a D-list celeb. You have to (appear to) be pushing for change, too.

If all this seems distinctly new, it is worth noting that a version of the influencer-activist has been around for a long time. "There's always been the problem of what we call 'micro celebrities' in social movements," explains Akwugo Emejulu, professor of sociology at the University of Warwick. "You have one person who [is] very charismatic, articulate, who is able to bring people together, like Martin Luther King. Then the media focuses on them and that causes divisions and problems within these movements."[3]

> " There's always been the problem of what we call 'micro celebrities' in social movements."

But Emejulu concedes that there is "something new in this moment about the commodification of activism." She points to some activists who were involved in early 2015 Black Lives Matter protests (people who, she notes, are not "claimed" by other BLM organizers) who have been accused of profiting from their profiles.[4] "They've garnered sponsorship deals, they have podcasts, they have all these things they've managed to leverage in order to increase their bank account," she says. "An ongoing problem within activism is that in the process of joining together, some voices are amplified and some are silenced. But certainly, in the contemporary moment, we see this problem of activists being plucked from these spaces because they

(3) Martin Luther King was the most charismatic of a group of activists involved in the civil rights movement. The role of other leaders has been less studied: For example, it was only recently acknowledged that Dorothy Height, president of the National Council of Negro Women, was a key organizer of the March on Washington.

(4) Online activism also raises questions about what counts as acceptable activism. In the case of Breonna Taylor, a Black woman killed by police during a botched apartment raid, influencers have been accused of trivializing her death by turning it into a social media punchline, selling merch and, in one case, organizing a conference called BreonnaCon.

fit a particular frame, they're media-friendly. And then they're able to leverage that for their own financial security."

While influencer-activists are a tiny minority, their disproportionate visibility has seen some impact on the wider perception of what activism is. Increasingly, people who do the groundwork are referring to themselves as organizers in order to set themselves apart. "Now anyone who runs a meet-up club is an 'activist,'" says Taylor Stone. "If you want to start a book club, it has to have an activist angle on it. I think that's why people have moved away from using the term 'activism' because that's how they see it being misused."

However, she's quick to point out that activism can still come in a huge array of shapes and forms.[5] "Sometimes it can get a bit like 'If you're not on the streets with a placard, you're not an activist,' which I've never really agreed with," Taylor Stone says. "People can't get there for whatever reason, so they do things in other ways, like cooking food for people when they're [released] from [police detention]."

Emejulu agrees. "What we find is, the folks on the ground who I think are doing the most interesting work are women of color," she says. "More often than not, women of color do not call themselves activists because they are doing the kind of unsexy work that keeps communities going, that oftentimes is derided as 'volunteer work' or 'self-help stuff.'" She points to mutual aid groups which sprang up in global communities during the height of the COVID-19 pandemic. "That's a real sense of community care."

Dr. Lynn Bennie, coordinator of the University of Aberdeen's new Political Activism and Campaigning master's program, wants to challenge the assumption that technology has changed everything about the way activism operates.

"It exists in parallel with traditional methods of protests," she says. Bennie points to the classic obstructionist tactics of high-profile movements like the UK climate group Extinction Rebellion, or blockades by Indigenous activist groups in Canada as evidence. What has changed is the ability to project these campaigns to the world. "I remember looking at the activities of Greenpeace decades ago, and their major aim was to get onto the evening news," she says. "Now we've got social media platforms that spread the word quicker, but it's the same aim—to get attention." One could almost view the influencer-activist as a part of this news ecosystem; where we once would have pamphlets or newsletters, now there are infographics and Instagram stories by specific individuals.

Influencer-activists have had an undeniable impact on communication and "awareness raising" via digital spaces: Take the renewed vigor of the global pro-Palestine protests that occurred in May 2021 after several years of the cause being relegated to the back burner. Word was spread via individuals online. The real problem organizers face now, says Taylor Stone, is a lack of collective strategy through which to channel this energy, harnessed by new channels.

"There's a lot of stuff going on [right now] but what's happening is boots to the floor at the moment—let's try and raise consciousness—but where does it go?" she says. "We've had huge protests [and awareness-raising] but has that filtered down to organizing locally? I don't know [...] We need to think, *What is our strategy?*"

As for the internet, the space where the influencer-activists thrive, it's a "useful tool," Taylor Stone believes. But "too many people are invested in the idea that social media is enough." At the end of the day, she adds, the internet is controlled by a small cohort of large corporations and can be "easily switched off," taking all online activism with it.[6] "Then what the fuck do we do?"

(5) Online activism is also more accessible to people with disabilities. For example, during the 2017 presidential election, the hashtag #cripthevote was used to draw attention to the need to make voting more accessible to disabled people.

(6) It is easy to think of the internet as a neutral platform, but it is not. In November 2021, after Chinese tennis star Peng Shuai accused a senior political leader of sexual assault, censorship saw all potential search terms, including "tennis," banned from the nation's search engines.

Hermès:
IN THE MAKING

Words by
Daphnée Denis

Photography by
Marina Denisova

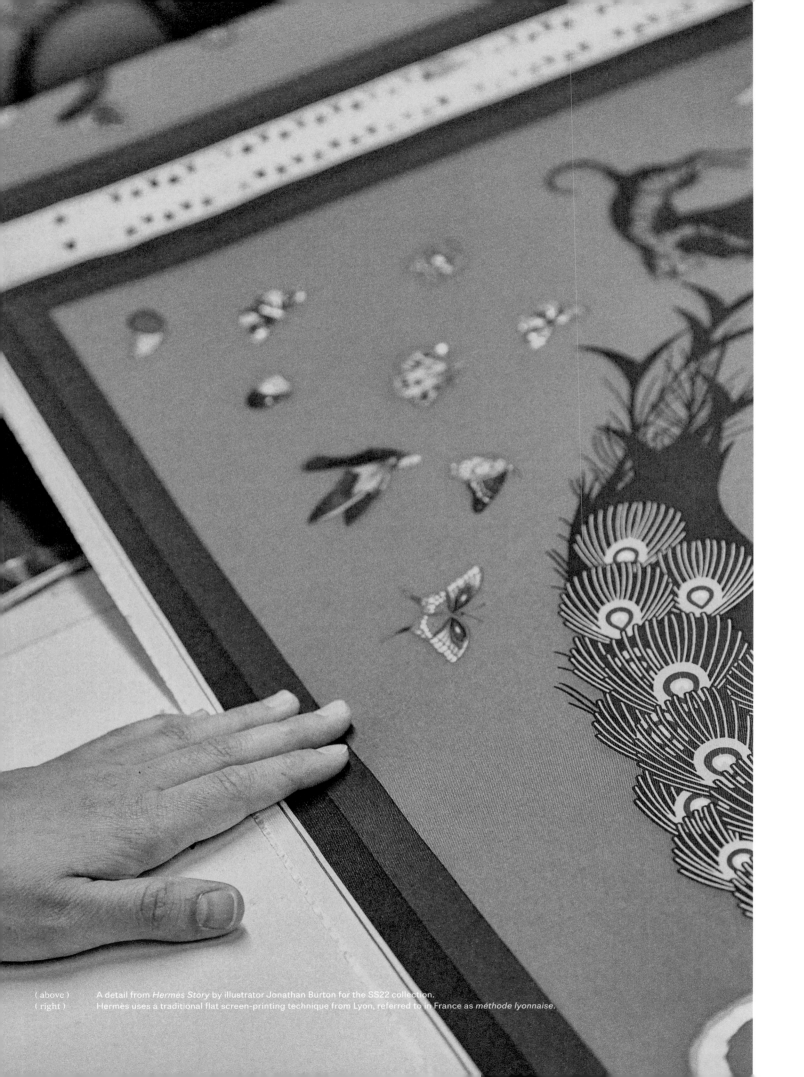

(above) A detail from *Hermès Story* by illustrator Jonathan Burton for the SS22 collection.
(right) Hermès uses a traditional flat screen-printing technique from Lyon, referred to in France as *méthode lyonnaise*.

In the beginning, there were two silkworm moths. Hundreds of cocoons. Miles of thread. And one simple accessory that would become synonymous with effortless elegance: *le carré*.

As told by Hermès, the story surrounding the creation of its legendary silk scarves is not unlike a foundational myth—the start of an epic love story built around a fiber so noble it once caused wars and gave its name to history's most famous trade route. Indeed, although the French luxury house was originally founded as a harness workshop in 1837, its iconic 35.5-inch square silk scarves have been at the heart of its business for nearly a century.

Hermès' own silk route currently starts in Brazil, in the region of Paraná, where a community of third-generation silkworm farmers are based. Once the cocoons arrive in France for the manufacturing process, the city of Lyon takes center stage. Lyon became the epicenter of Europe's silk industry 500 years ago, when King Francis I granted the city's residents a monopoly over the fabric's production and trade. Lyon and its surroundings were naturally where Émile

Hermès, grandson of founder Thierry Hermès, set his sights when he decided to include twill scarves in the house's catalog, using a style of silk weave then mainly found on jockeys' jackets.

Until the 1920s, the harness-maker's main clients had been horse and carriage owners, but as automobiles started taking over the streets of Paris, the family business had to diversify its offerings, venturing into leather goods, clothing and jewelry. At the time, Émile had decided to launch a scarf department, naming his son-in-law, Robert Dumas, as artistic director. Dumas, whose dreams of becoming an architect had been shelved due to World War I, brought a more creative eye to the house. It was his idea to design the drawings for the scarves in-house rather than buying them ready-made from silk printers. That's how, in 1937, on the house's centennial, the first Hermès-designed carré came to be. *Jeu des omnibus et dames blanches* referenced a popular 19th-century board game, with players pictured at the center, horse-drawn carriages appearing on the outer edges, and a cheeky inscription: "A good player never loses their temper."

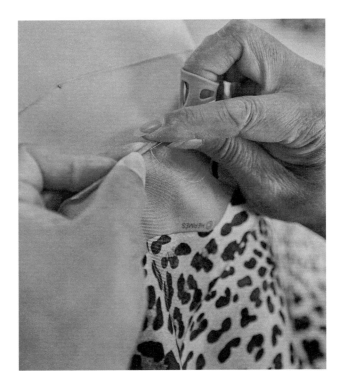

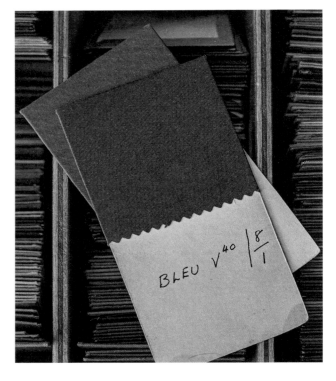

Manufacturing the carré was, and remains, a stringent process. Once the design is approved by Pierre-Alexis Dumas, the group's artistic director and grandson of Robert Dumas, each drawing is turned into engravings and broken down further into printing screens, each matching one color from the scarf's pattern. After the colors are printed one by one onto the silk, the fabric must be dried, the hems rolled by hand and the garment checked for quality. A decade after the first carré was put on sale, Robert Dumas began working with two partners whose unique skill set has stood the test of time: printer Atelier AS, and textile engraver Établissement Marcel Gandit, both based in the commune of Bourgoin-Jallieu on the outskirts of Lyon. Today, the two companies continue to be central to the scarf-printing process for his grandson. They are among the eight companies that make up HTH, the group's textile division, which employs around 850 people in the Rhône-Alpes region.

Greeting artisans by name, Kamel Hamadou, head of communications at HTH, guides me through the different stages of carré-making at the Lyon atelier, highlighting the level of craftsmanship required in each position. On average, a twill square contains between 25 to 30 colors, and often counts up to 48. As we walk past seamstresses working on tigress-illustrated scarves, he points out the four shades of blue in the animal's eye: That's four separate printing screens needed for the pupil alone. On a different floor, we meet the graphic designers scanning illustrations to deconstruct each color pattern into templates—the shapes then reproduced onto the printing screens. Depending on the level of detail of a given drawing, that step alone can take up to 800 hours. "For us, real luxury is time," Hamadou says. "If you add up the time needed for each step, we're looking at two years to give life to a carré."

The concept of luxury is a debatable one at Hermès. The Parisian house labels itself a "house of quality," rather than a "house of luxury." While everyone has their own definition of the latter, the former is objective, Hamadou muses: Quality is either there or not.

" For us, real luxury is time. If you add up the time needed, we're looking at two years to give life to a *carré*."

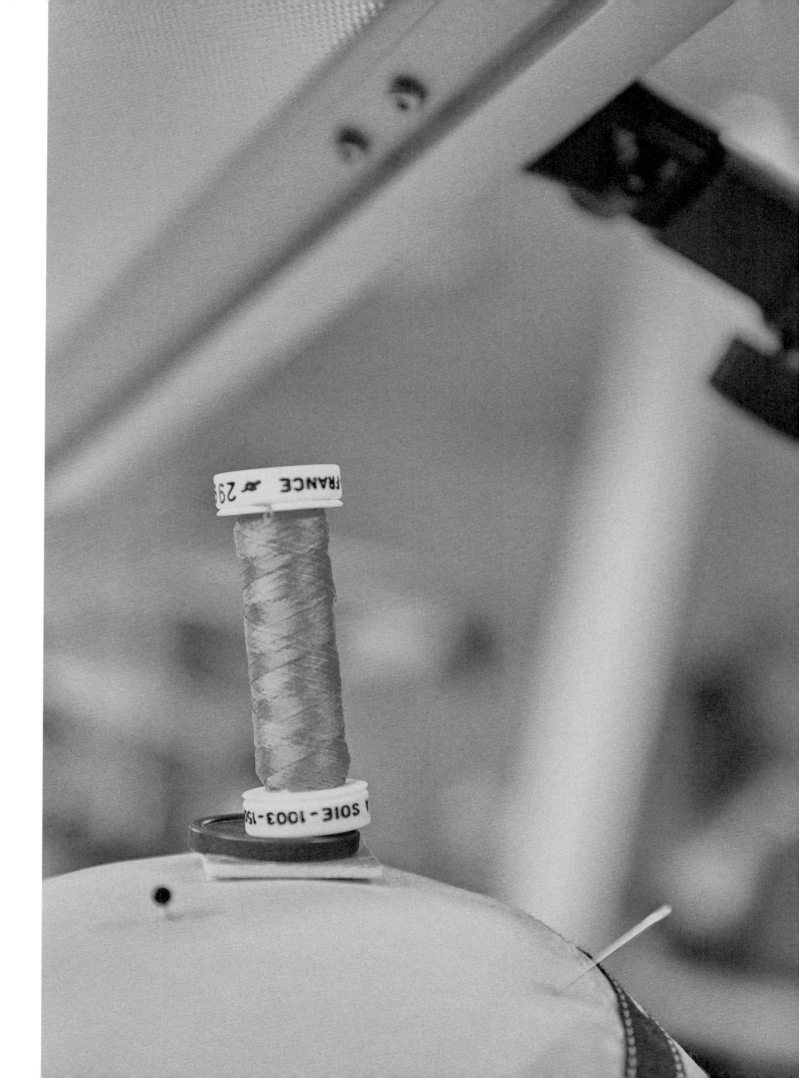

In the 2000s, as other designers had sworn off prints entirely, Pierre-Alexis Dumas and Bali Barret, the former artistic director of the Hermès women's universe, brought modernity to the carré, bringing in colorful streetwear references and breaking the bourgeois mold. Hermès has always adapted to meet the moment, but has never followed industrial revolutions blindly. Historically, as harness makers, their first concern was to make sure clients would never have an accident, and that their products could be repaired. Today, all Hermès creations are still subject to repair.

That human-first philosophy also permeates the culture at the Lyon ateliers. Though much of the printing process has become automated over time, machines are there to help artisans, not the other way around, Hamadou explains. Colorists, whose job is to design new colors (the Hermès chart boasts 75,000 different shades) and dream up new combinations, use technology to virtually mix tints together, but it's thanks to their expertise that the correct recipe lands in the workshop's color "kitchen." Printing is an elaborate dance between machine-operated screens and humans gauging just how

much color needs to be poured at any given time. And at the end of the production line, the squares are always folded by hand.

The story of the carré may have started due to industrialization, but it is a tale of human craft at every stage. "Paris looks after the artistic side, we handle the manufacturing process from the thread to the finished carré, and Hermès also oversees the distribution," explains Hamadou. "It's a singular economic model." This incorporated system fosters a unique relationship between employees and the company, he adds: For him, working with silk is truly a labor of love.

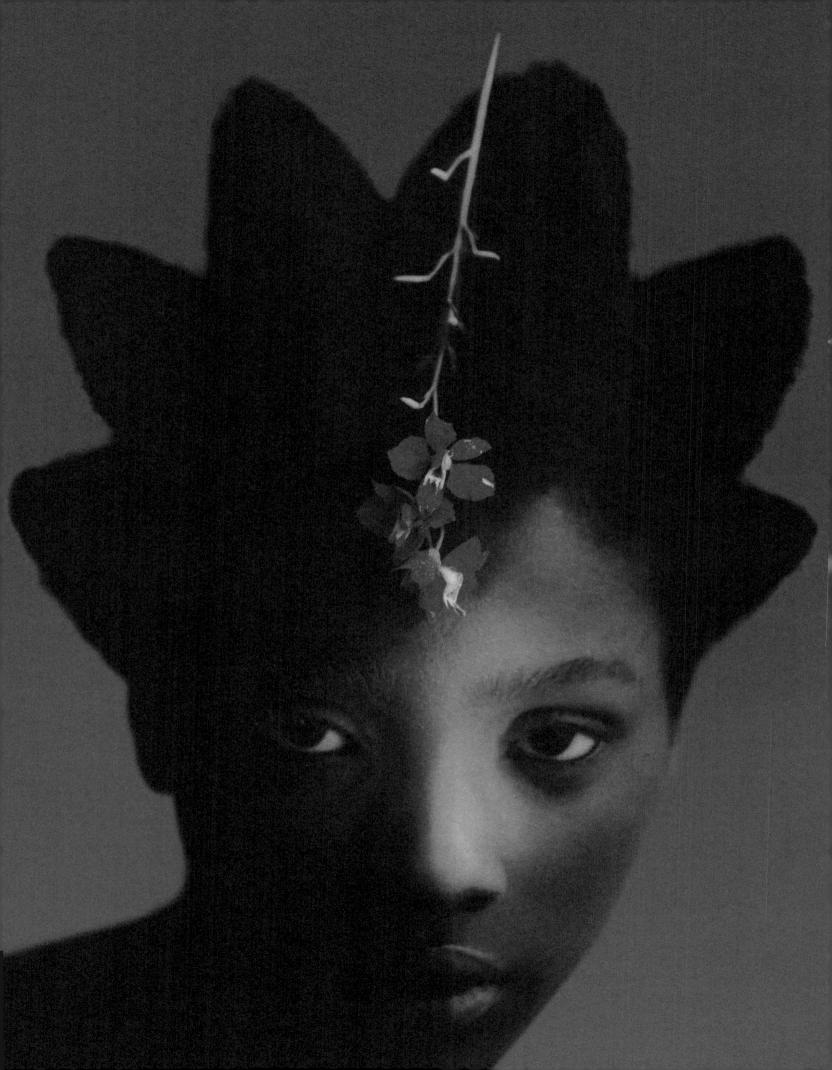

An improbable
explosion of
Brazilian blooms.

71 FRESH STEMS

Photography
MAR+VIN
Styling
MAIKA MANO

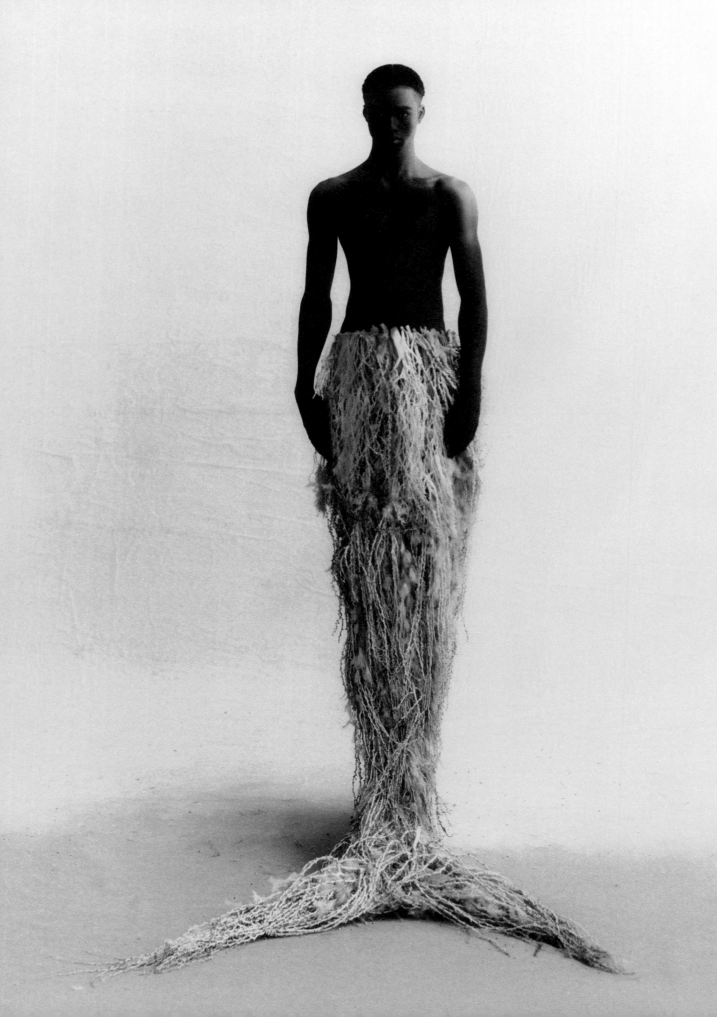

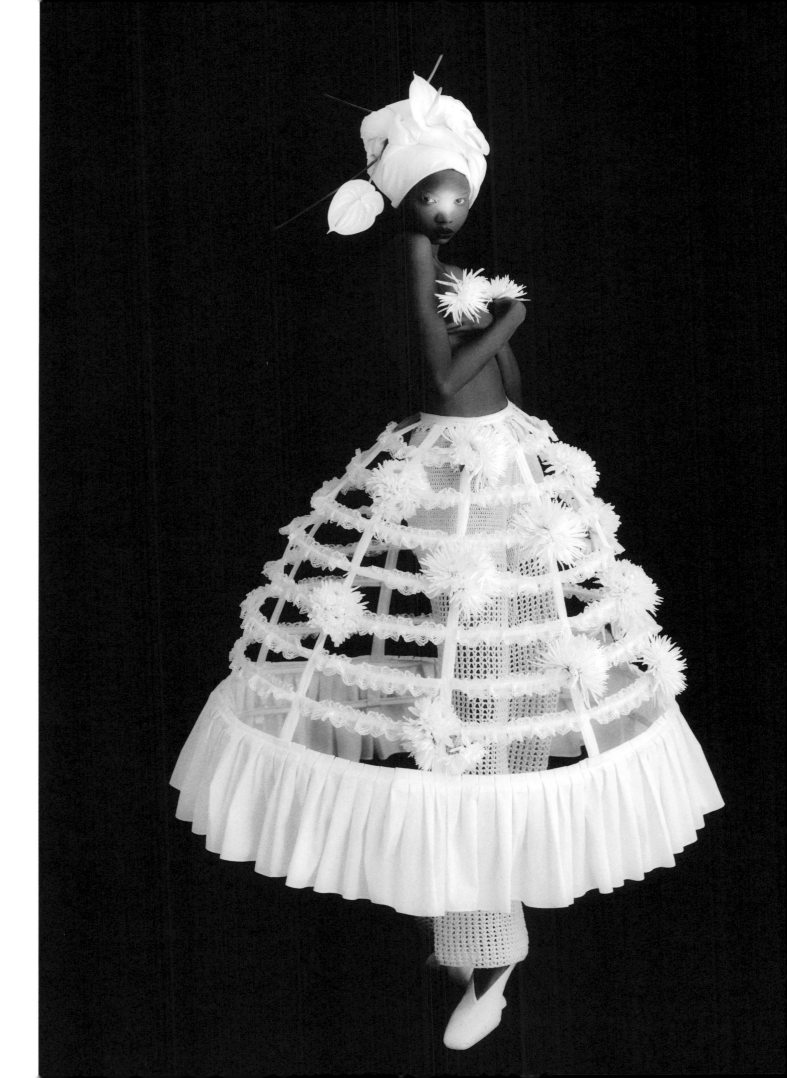

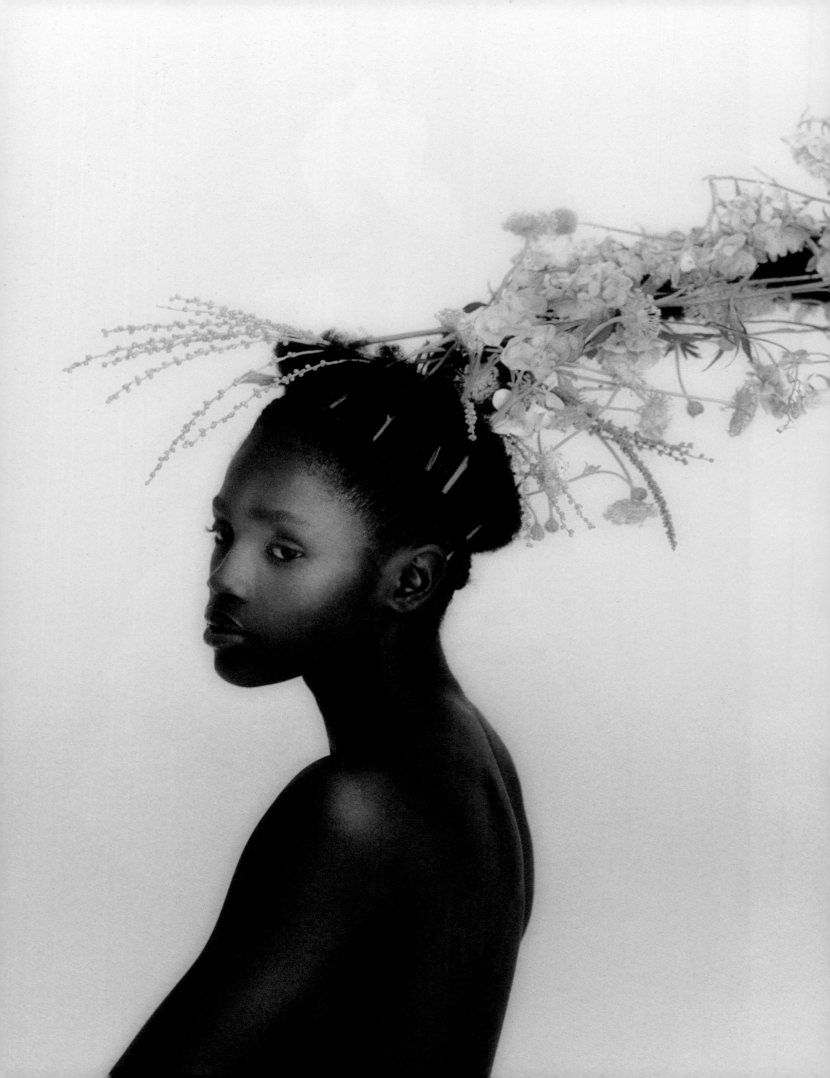

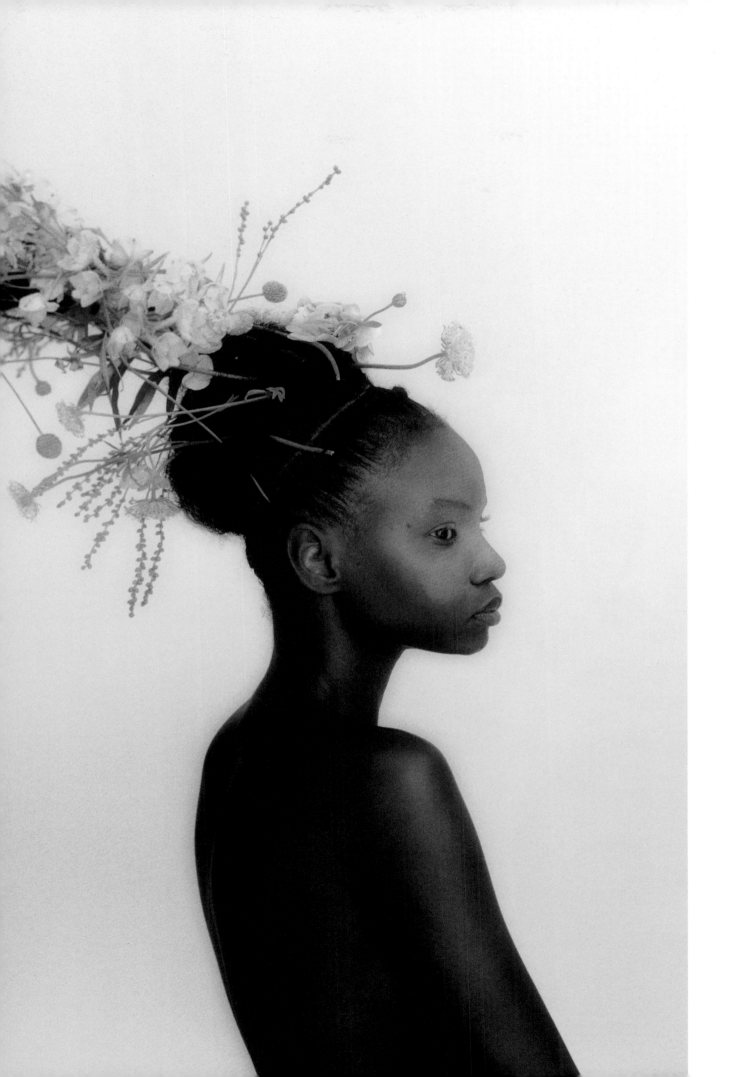

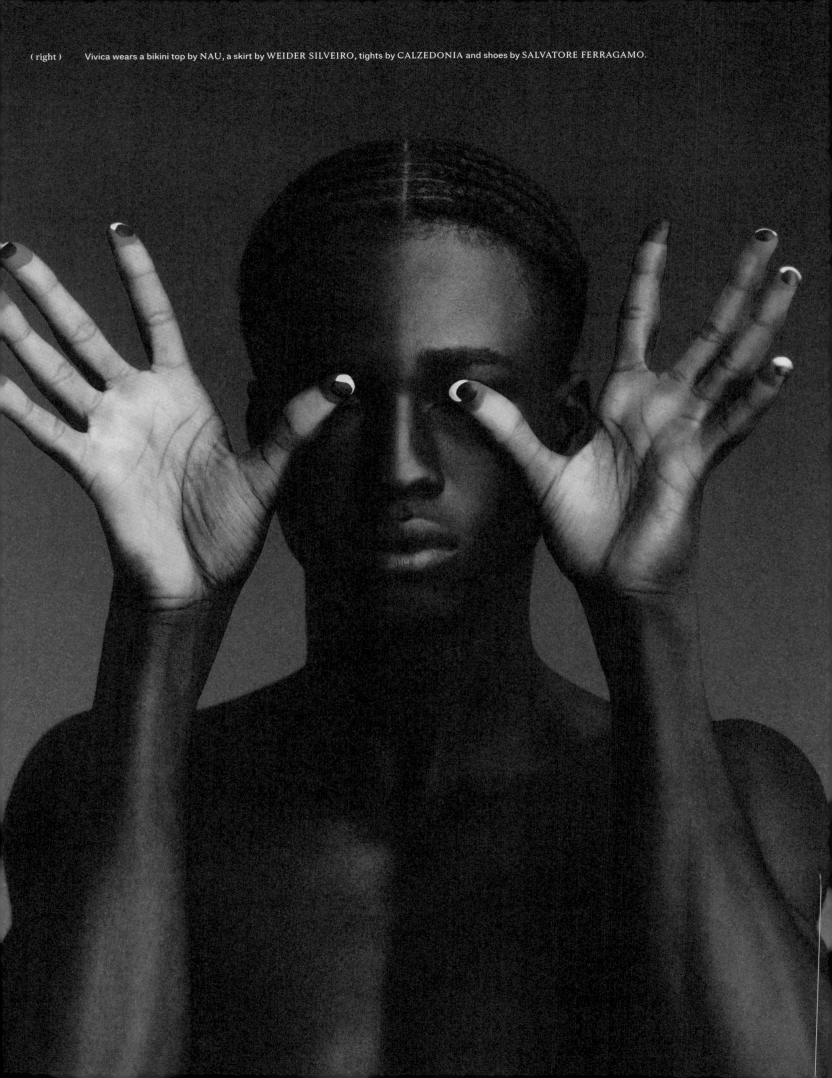

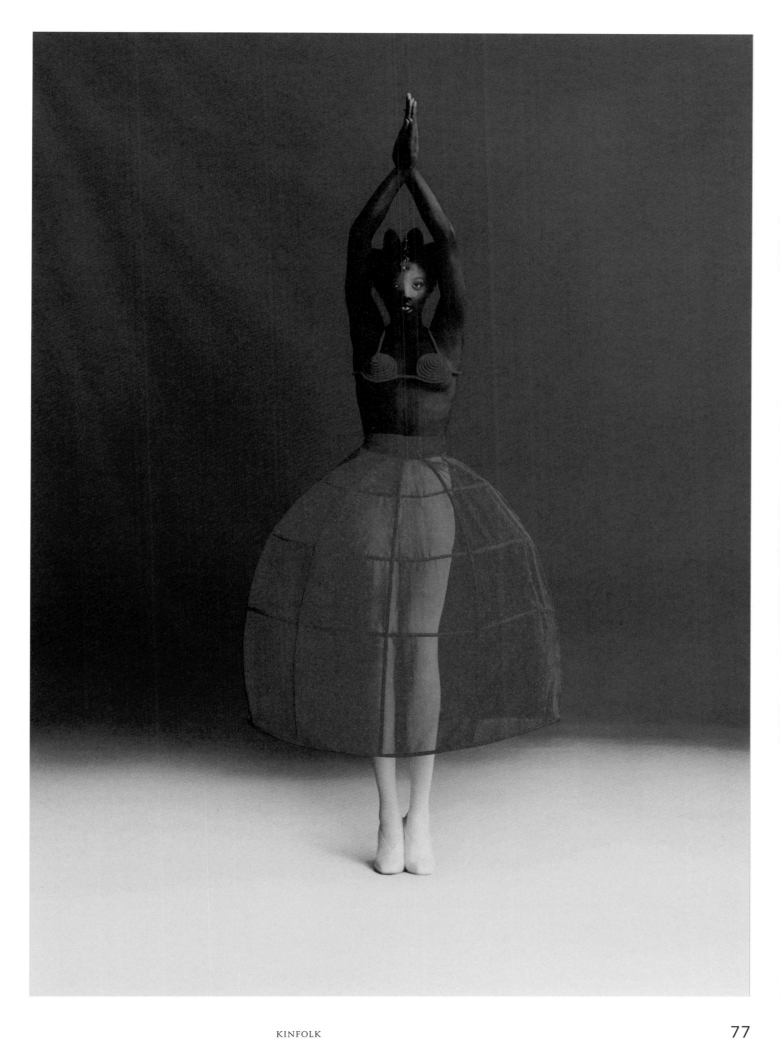

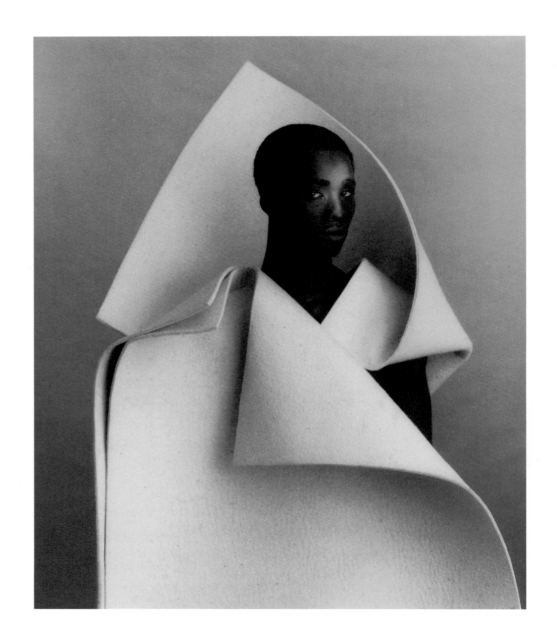

Set Design
JOSEPHINE CHO
Floral Styling
FLOWER BAR
Models
BRUNA DI at Another Agency
VIVICA IFEOMA at Way Model
PETER SILVA at Joy Model

Hair: Stefane Silva. Makeup: Suyane Abreu at H.A Management. Props: David Martins. Executive Producer: Diego Domingos at SDC?

(above) Bruna wears headwear by PAULA RAIA.

Stylist
JAMES SLEAFORD

Words
PRECIOUS ADESINA

Photography
PHIL DUNLOP

Pa apa

THE BRITISH STAGE STAR

STEPS ONTO A NEW PLATFORM.

There was a time when Paapa Essiedu's talent was a secret known only to the British theater establishment. The actor, who was born in East London, joined the Royal Shakespeare Company in 2012 and played a string of roles both there and at the National Theatre. He played Hamlet in 2016 with "a priceless vitality," according to *The Guardian*, and won best performance in a play at the UK Theatre Awards.[1] In 2020, that all changed when Essiedu took up the role of Kwame in Michaela Coel's revelatory HBO–BBC series *I May Destroy You*. He has been nominated for both a Bafta and an Emmy for the performance he gives of a gay man struggling with the justice system, trauma and his own sexuality in the aftermath of sexual assault. He also plays Alex, the son of a gangland boss, in *Gangs of London*, released in 2020. This year, he'll find new audiences in *Extinction* for Sky, a thriller written by Joe Barton, and in season two of *The Capture* for the BBC, in which he plays a young politician with ambitions for the very top. You wouldn't know what a roller coaster it's been from his demeanor. Over breakfast at a small café in East London, the 31-year-old says that he couldn't imagine being famous; the thought of people clinging to his every word terrifies him—even as I prepare to do just that.

PA: Do you prefer being on stage or working on TV?

PE: I'm really lucky to get the opportunity to do both. The experience of doing them and what you get out of it is different. I feel like when I'm doing a play, I want to do something on-screen, and when I'm doing something on-screen, I want to do a play. It's a "grass is always greener" type thing. You can reach more people with screen work, which I think is important as an artist. As long as someone can get a phone, laptop or television and an internet connection they can get access to the work that we do. Consequently, art on screen can be shared with a wide spectrum of people as opposed to a person who can afford to splash out on going to the theater in a particular city at a particular time and on a certain day.

PA: Do you feel as if the stage can be limiting in terms of international recognition?

PE: International recognition isn't something that I wake up in the morning with a deep desire for. It's nice to be acknowledged for your craft but it's a motivation that's never going to be fully satiated if that's at the top of your agenda. The stage is very important to me. There's something about a live audience being in front of you that is both terrifying and rewarding. With film and television, there's so many talented people editing and making it into the final product. To an extent, it's the same on stage with directors and designers, but there's also an authentic connection between you and the people watching it. It's pure and can't be faked—if it goes well then it goes well and if it goes badly it *definitely* goes badly. It's sort of like being a musician or a stand-up comedian.

(1) Essiedu was a relatively unusual choice to play Hamlet in a theater scene that increasingly prizes big names to boost ticket sales. Benedict Cumberbatch was playing the role in another production at the same time, and Michael Sheen and David Tennant had both performed it recently.

PA: You were originally going to study medicine at university and then changed your mind. What encouraged you to make that big decision to pursue acting instead?

PE: If I'm honest, I don't really know. I was supposed to go to University College London to study medicine. I think I would have also been really happy if I had done that. As a doctor, your whole modus operandi is to help, which fits well with my temperament. I like being around people and interacting with them. But, at that age, who knows anything about what you want to be? At the time I thought acting was fun: You do a play and people clap for you at the end. I feel really lucky that I was given the support to pursue it and, thankfully, it hasn't gone wrong yet.

PA: What was is it like auditioning for *I May Destroy You* in front of a friend?

PE: Michaela is an important person to me.[2] We were in the same class at drama school and come from similar backgrounds. We'd never really spoken about working together and our relationship has always been very separate from our careers. The first time we had a conversation about it was when I was in the room auditioning for the role of Kwame. She was directing so she behaved like a director would. I didn't know how to respond.

PA: There's a lot of talk about representation and who plays what character. How did you feel playing a gay character at a time when people would be expecting a queer actor to play him?

> " No one is the villain in their own
> story or leaves their home thinking
> they're going to be the bad guy."

PE: I thought a lot about that before auditioning and before accepting the part. I spoke to Michaela about it quite a lot too. She mentioned that she had auditioned a lot of people of different orientations for the role. She was like, "Look, I trust you to be able to do justice to this character where there's big question marks about his relationship to his sexuality." I wanted to respect what this man was asking himself and not belittle or trivialize or sensationalize his experience. It was about creating a three-dimensional person.

PA: Is there one character you've played where you've thought "I really love this person"?

PE: I love all my characters and I think you have to. Or at least, you shouldn't be judging them. No one is the villain in their own story or

(2) Essiedu and Coel bonded in part at their overwhelmingly white drama school. According to *Vulture*, Coel wrote at the time that she was the "only black girl in the village"—the first Black woman Guildhall had accepted in five years. For their graduation showcase, the two performed an original piece set on an East London basketball court.

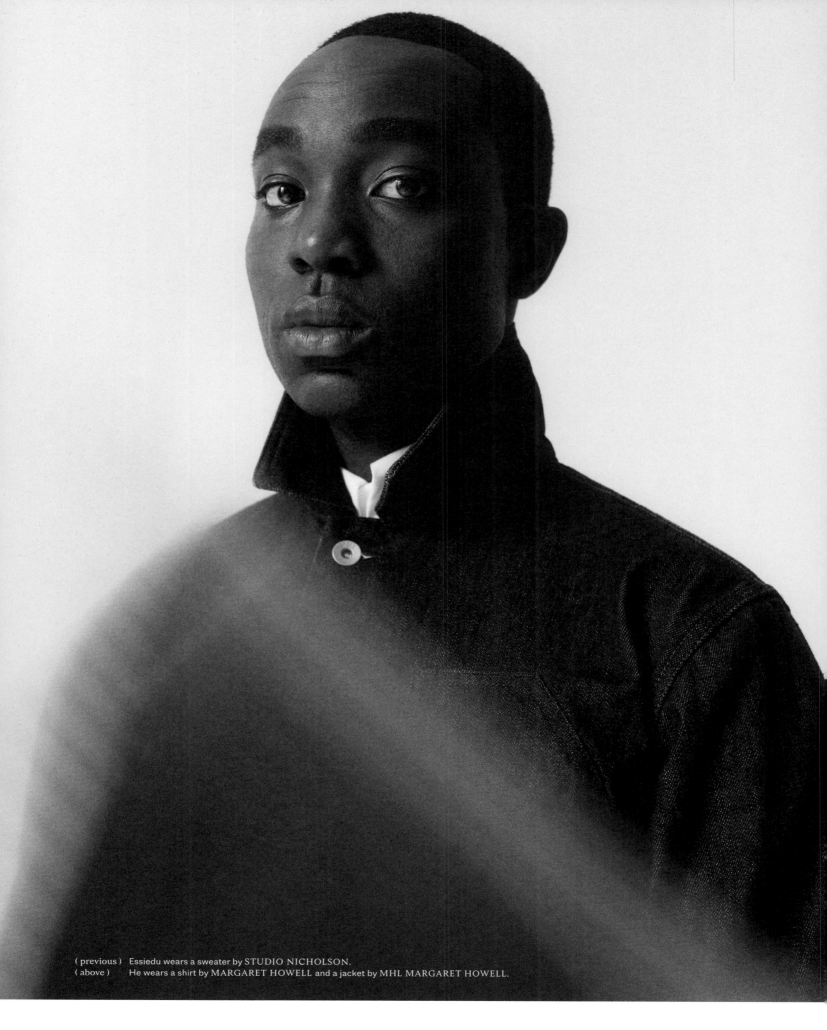

(previous)　Essiedu wears a sweater by STUDIO NICHOLSON.
(above)　　He wears a shirt by MARGARET HOWELL and a jacket by MHL MARGARET HOWELL.

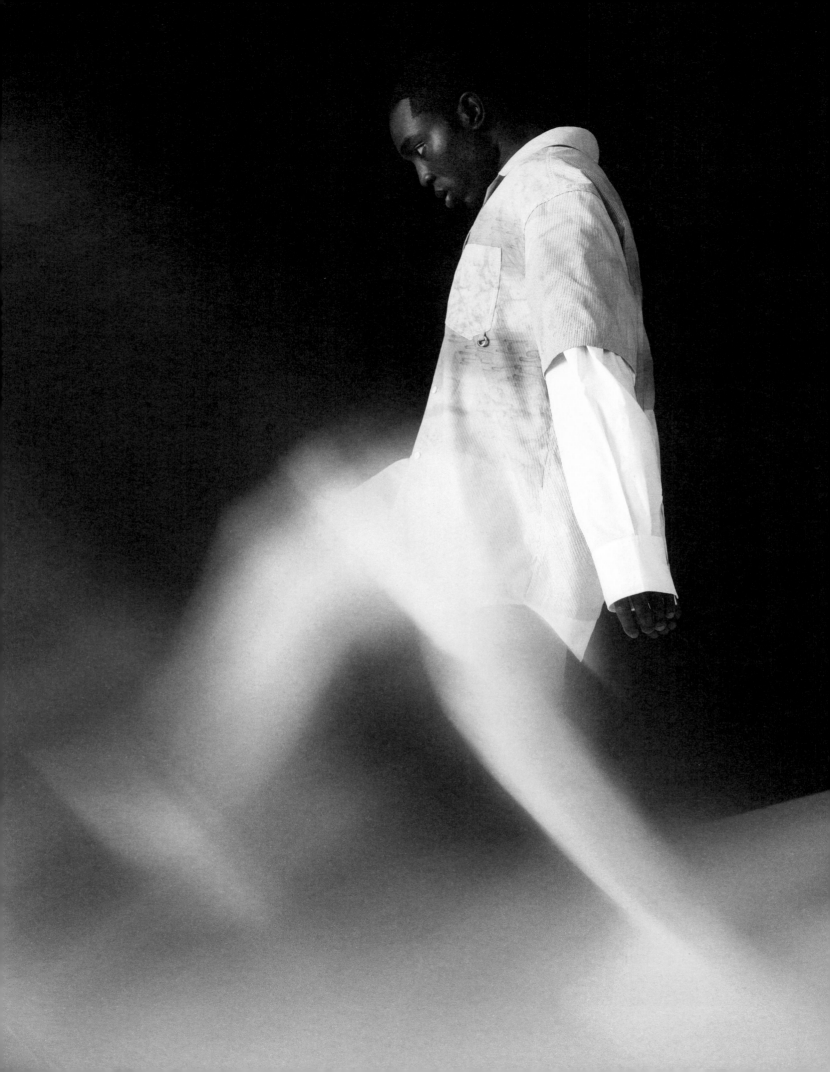

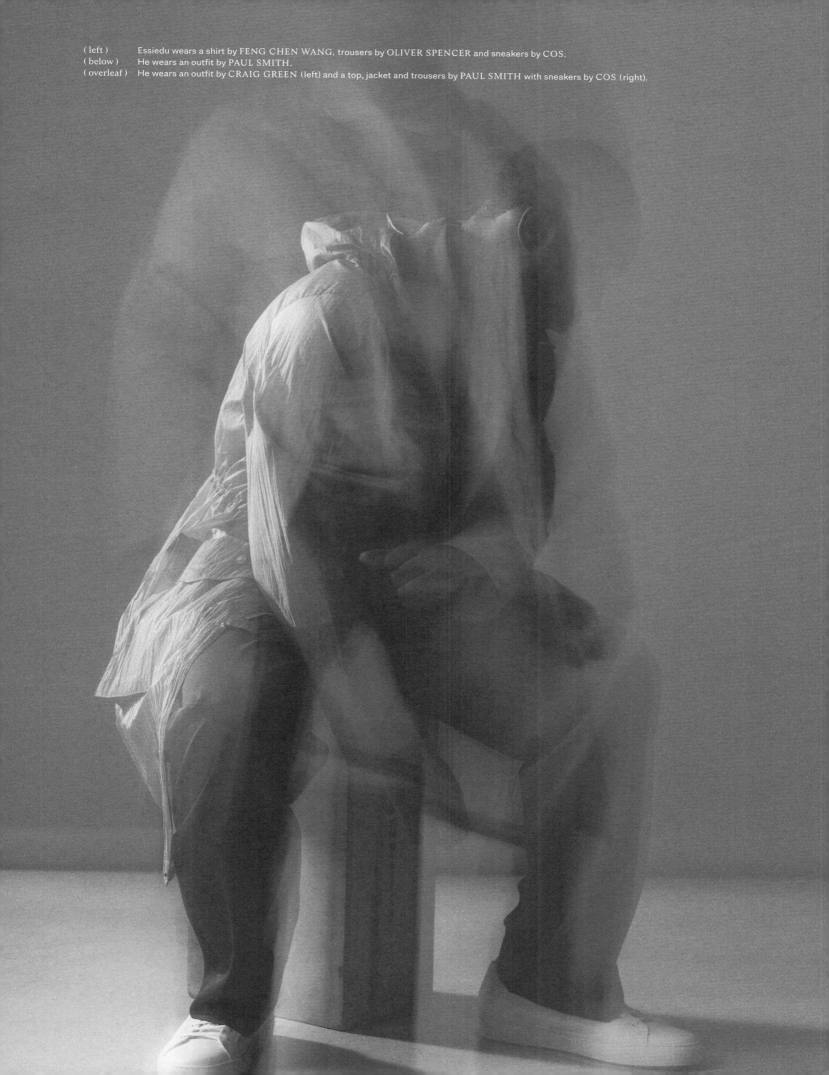

(left) Essiedu wears a shirt by FENG CHEN WANG, trousers by OLIVER SPENCER and sneakers by COS.
(below) He wears an outfit by PAUL SMITH.
(overleaf) He wears an outfit by CRAIG GREEN (left) and a top, jacket and trousers by PAUL SMITH with sneakers by COS (right).

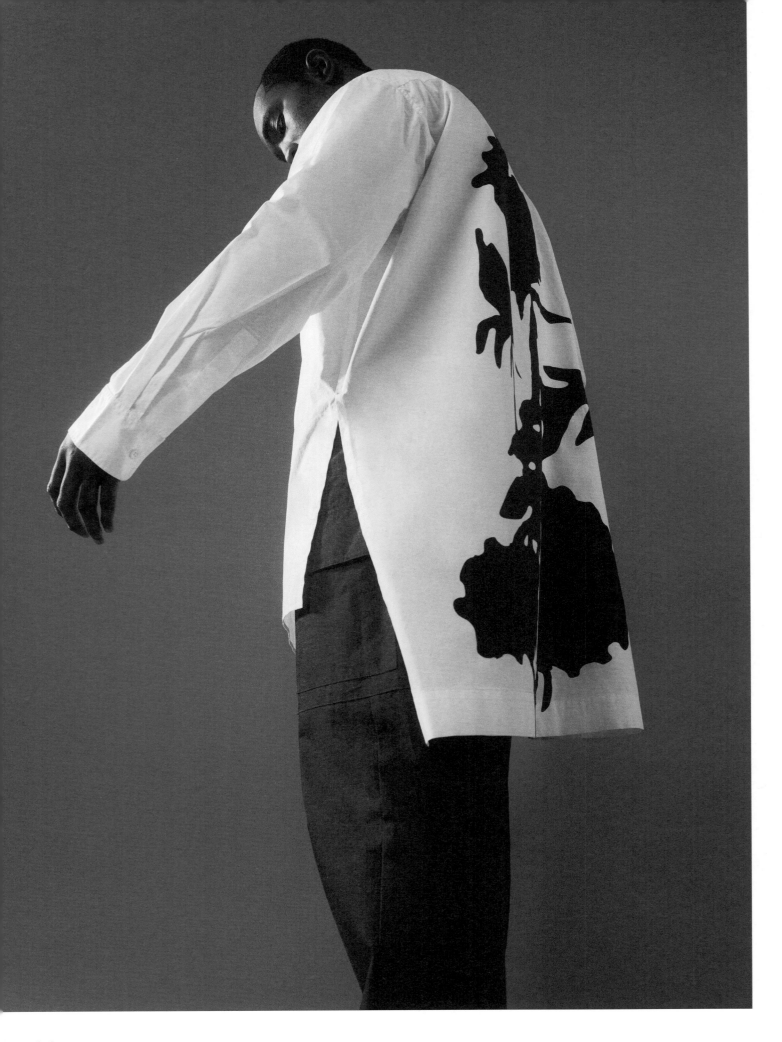

leaves their home thinking they're going to be the bad guy. They're more like, "I'm going to support my family" or "I'm going to get what I deserve."

PA: Both of your parents passed away at a young age. Do you feel as if it can be difficult making decisions without a parental figure?[3]

PE: Grief is a wild and ongoing thing, but I feel like it metamorphizes over time. The idea of your parents being there or not starts to take on a different meaning. They might not be there in the physical form, but they're there in you through the person that you've become and through the lessons they've taught you. I think the big decisions in my life are difficult to make because big decisions are just difficult to make. Everyone struggles, parents or not, it's just a different type of struggle.

(3) Essiedu was brought up by his mother in Walthamstow, London. His father died in Ghana when he was 14, and his mother when he was 20. Essiedu now goes back to Ghana and credits the country as inspiration for his interpretation of Hamlet. Speaking on the *Theatre Voice* podcast he said: "I went to Ghana and asked loads of questions about the culture, death, ghosts, conjuring and music."

(left) Essiedu wears a jacket by CRAIG GREEN.

Room dividers from
a Roman studio.

SPACE INVADERS

Artwork
ROBERTO RUSPOLI
Photography
CHRISTIAN
MØLLER ANDERSEN

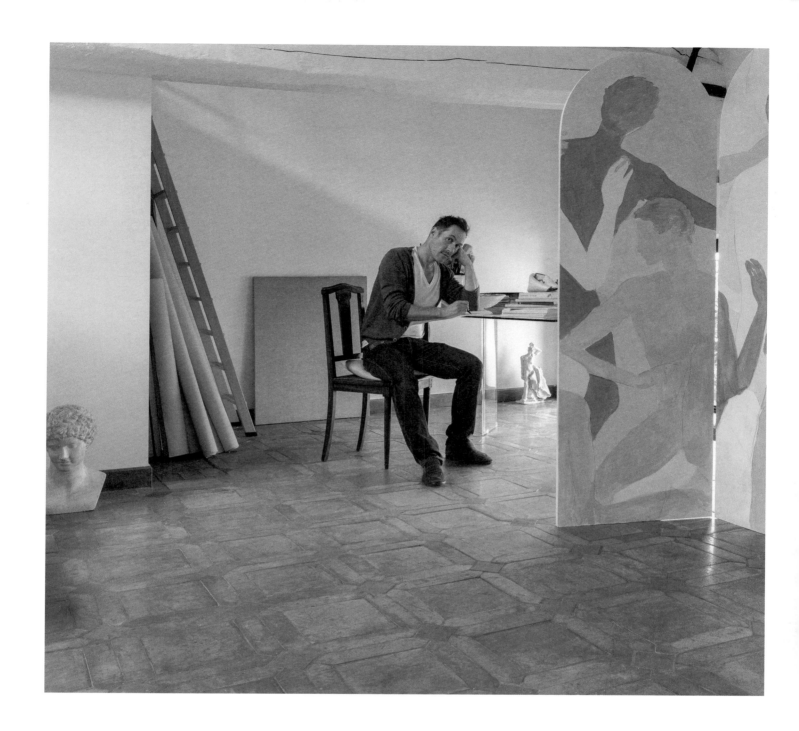

Set Designer: Victoria Salomoni

Q&A:
ROBERTO RUSPOLI
Words by Harriet Fitch Little

HFL: What inspired the design of these room dividers?
RR: The dividers are inspired by the classical motifs so often present in my work. In this case, they are the result of a collaboration with *Kinfolk* to present a selection of possibilities based on painted screens. In part, they are inspired by a much larger series of paintings I've been working on lately.

HFL: What appeals to you about classical imagery?
RR: I feel at home in the classical. I'm overwhelmed by their shapes, forms and archetypes, in the sense that they transcend time.

HFL: Could you work anywhere, or is this studio in Rome important to you?
RR: Working on-site often has given me a great sense of adaptation in terms of spaces in which to work. Perfection would be a silent, spacious, luminous place but it happens rarely when you are on-site! I particularly love this atelier because it is where I grew up, so it's home. But also the light is perfect and has beautiful energy. I feel and see the sky from here. At the same time, I get a sense of intimacy that I do not get anywhere else.

Home Tour:
ROSE UNIACKE

Words by
George Upton

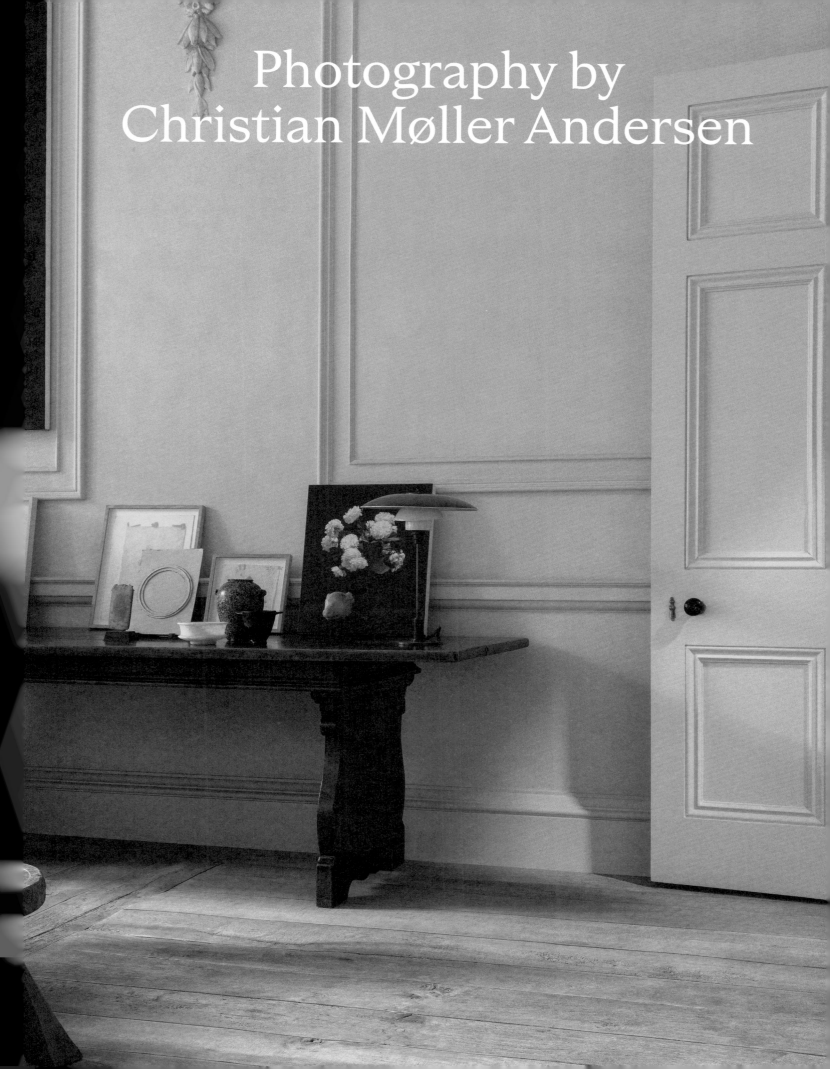

Photography by
Christian Møller Andersen

Rose Uniacke lives in a quiet pocket of West London known for its neat rows of white stuccoed houses and private garden squares. This typical London scene, immortalized in 1990s rom-coms, is suddenly interrupted by Uniacke's home: a sprawling striped brick house with vast windows.

The house has dominated its corner of the square since it was built in 1860 for James Rannie Swinton, an artist who had become the most fashionable portrait painter of his time. "There's a story that he was able to ignore the local planning regulations because he was so well connected," says Uniacke, who moved into the house with her family 15 years ago and runs her eponymous business—which spans interior and furniture design—from a shop nearby. "It's a mad folly to have been built here when they were creating these very ordered squares."

It was this sense of the house as an eccentric artistic endeavor that appealed to Uniacke. Designed by the architect George Morgan around vast north-facing windows that offered the best light for Swinton to paint, the house once featured an elaborate glass-domed picture gallery where the artist would exhibit his work to new clients. After Swinton's death, it became the home of another artist, engraver Iain Macnab, who founded the progressive Grosvenor School of Modern Art in the building. When that closed in 1940, it was used intermittently as artists' studios and an exhibition space.

"It felt very institutional," Uniacke says, recalling the first time she saw the house nearly 20 years ago. The delicate plasterwork had been buried beneath layers of thick white paint and the glass dome of the picture gallery, damaged during the bombing of London in the Second World War, had

been replaced with an ugly '70s skylight. "But there was a magic about it," she continues. "So much had been spoiled but there was an energy that was different."

With four children and a baby on the way, the house offered Uniacke the room and floor space that she had been struggling

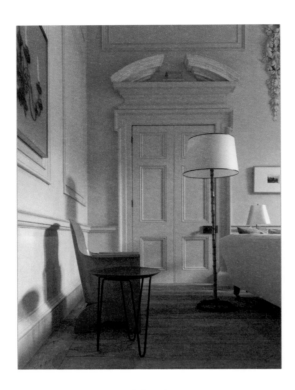

(above)
The Venetian palazzo style that inspired Uniacke is reflected in details such as the architrave above the door.

to find in London. Yet restoring the building as a home would be a long and complex process, requiring the original period features to be carefully reinstated and the internal spaces reorganized. It would be four years before the family moved in.

Today the house is a perfect expression of Uniacke's erudite and instinctive

approach to design. As one of her most well-known projects, and the subject of a monograph published by Rizzoli in 2021, the house has established Uniacke as one of the leading interior designers with an exclusive, and undisclosed, client list (discretion is key for Uniacke). Her practice stems from her practical experience in furniture restoration. "I happened upon a restoration workshop at the end of the road where I was living," explains Uniacke. It was the late 1980s and she had just finished studying philosophy at University College London. "Luckily it turned out to be a very high-quality operation."

Having trained as a specialist in paint and lacquer, Uniacke set up her own business and moved to France in 1992, staying for three years. "I was always trawling through markets, looking at antiques and old textiles," she says. "I started sending furniture back to my mum, who had an antique shop in London." When Uniacke returned to London a few years later, she began working with her mother, helping to style the shop. One day, a client came in and asked if she would do their house. "So I said, 'Okay, if you like,' and started my design practice."

Uniacke's enthusiasm to find new directions in her work drives a multifaceted approach. You get a sense that, whether she is working on a "maximalist full-color, full-pattern project," or on the understated London headquarters of fragrance and lifestyle brand Jo Malone (or, indeed, on the homes of Dua Lipa and Alicia Vikander), she is always experimenting and asking new questions.

"I'm very interested in what makes a room somewhere you want to stay in. Why do we respond to space in the way we do? What do you need to do to make a space feel right?" she says.

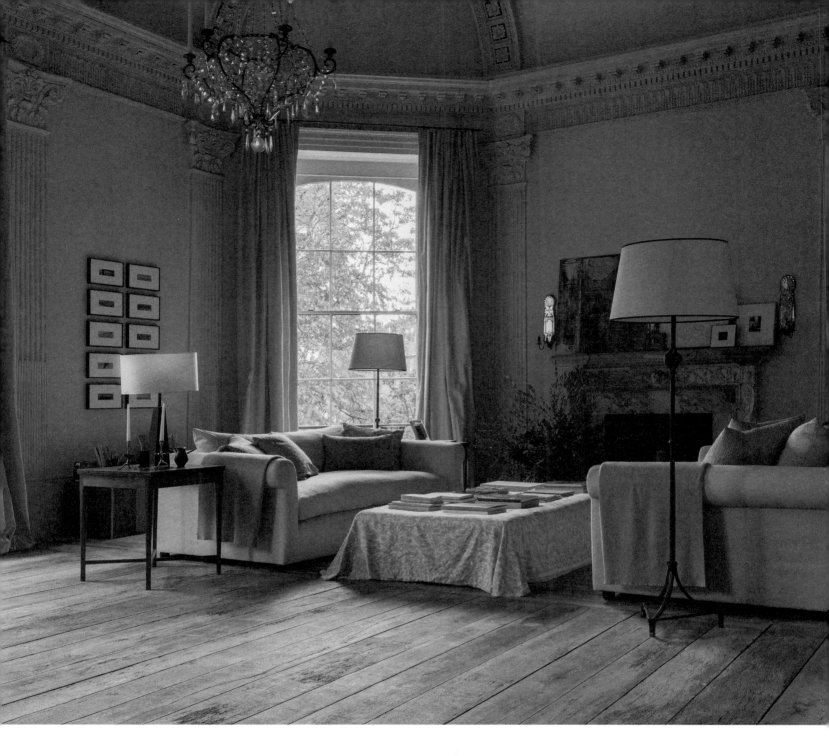

(above) Uniacke's home contains a mixture of antiques and pieces from her own interior design collections.

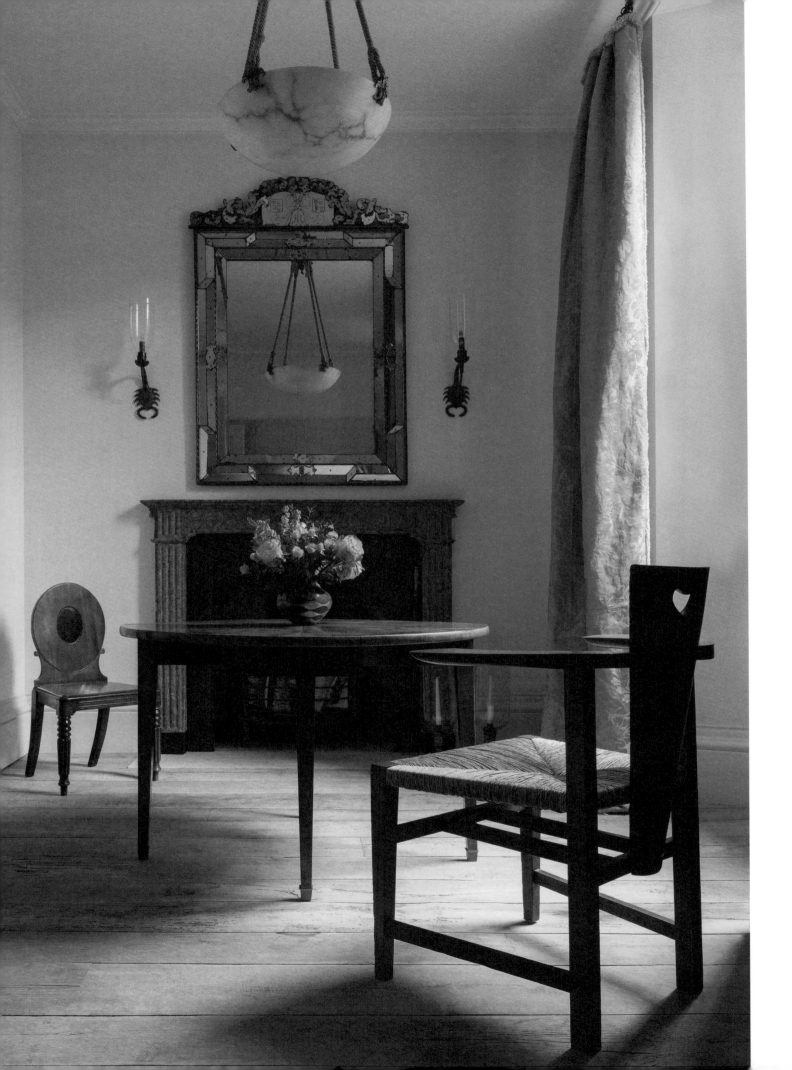

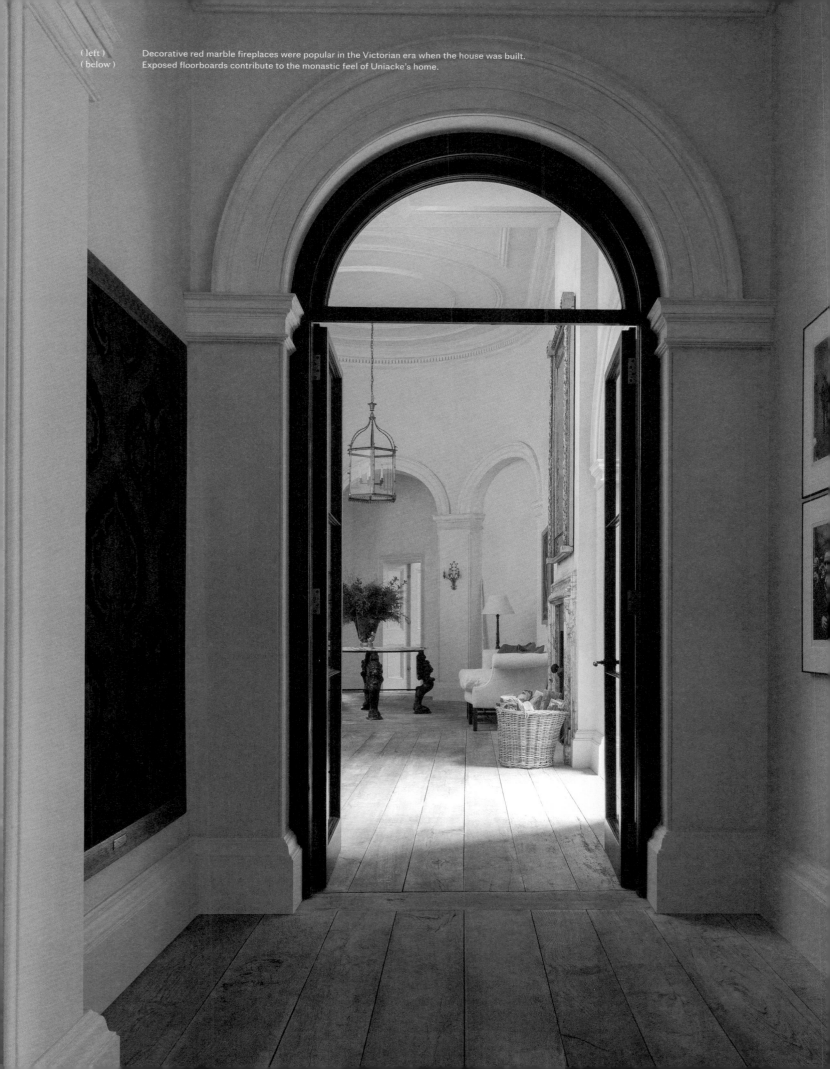

(left) Decorative red marble fireplaces were popular in the Victorian era when the house was built.
(below) Exposed floorboards contribute to the monastic feel of Uniacke's home.

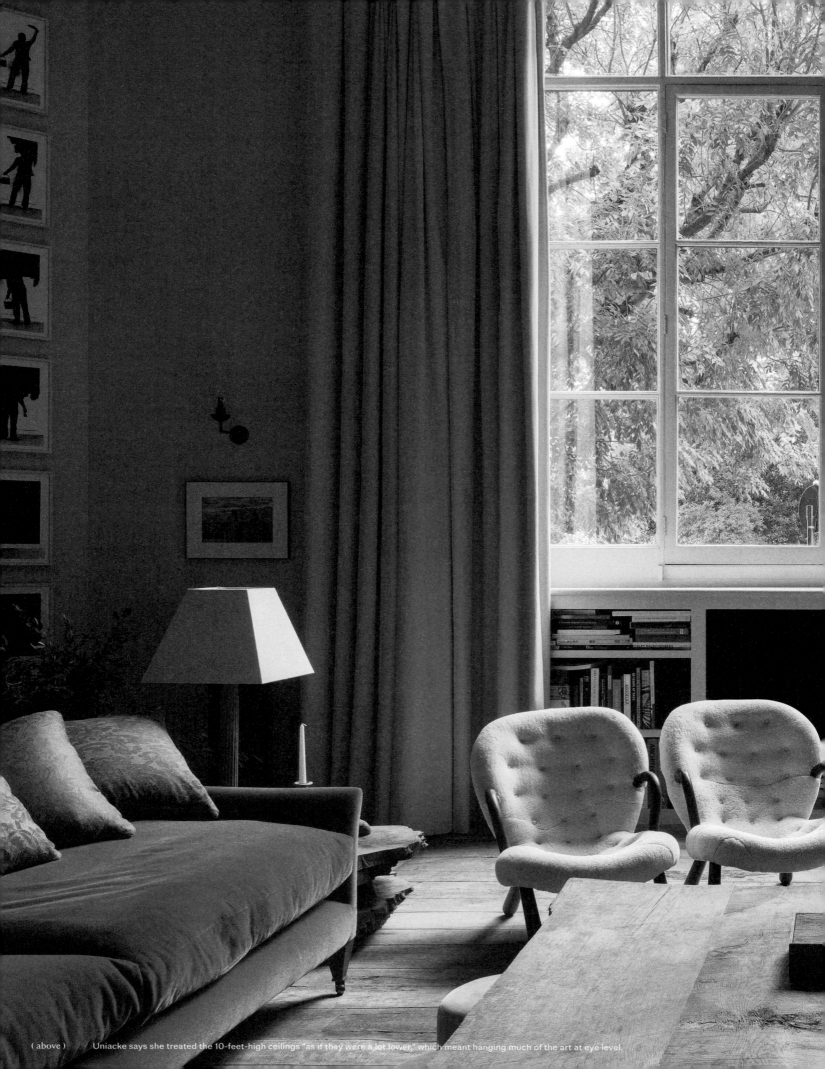

(above) Uniacke says she treated the 10-feet-high ceilings "as if they were a lot lower," which meant hanging much of the art at eye level.

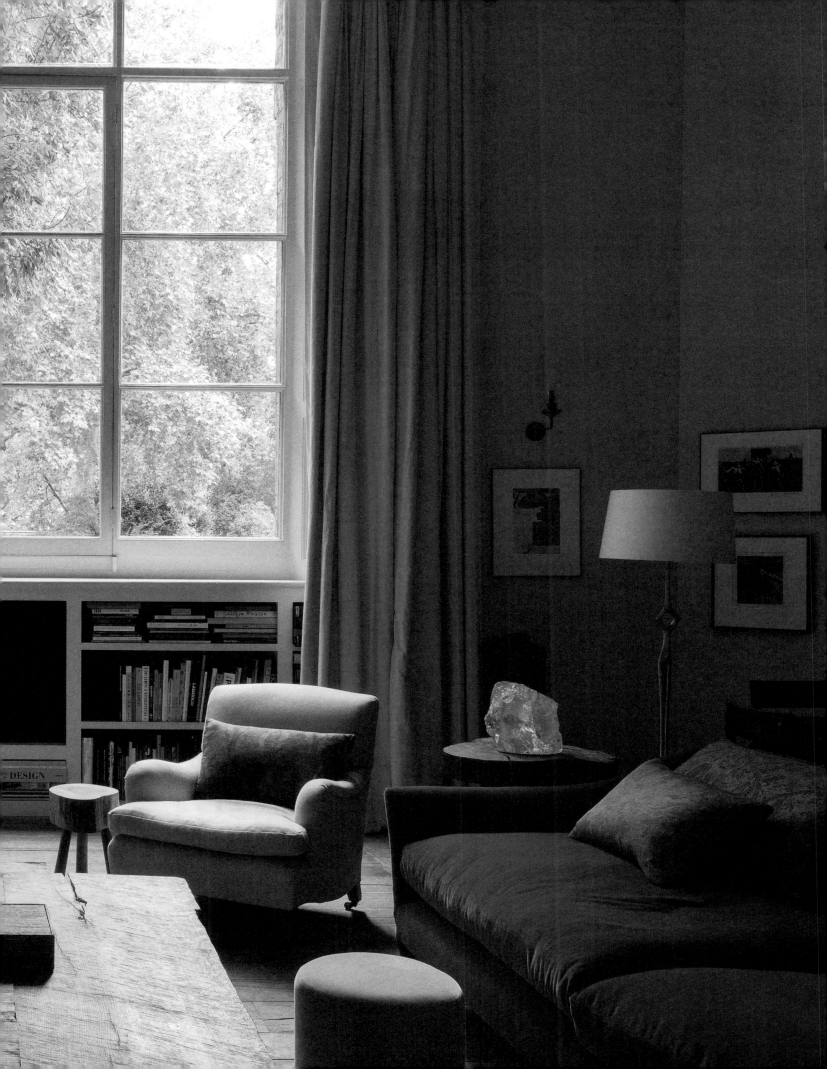

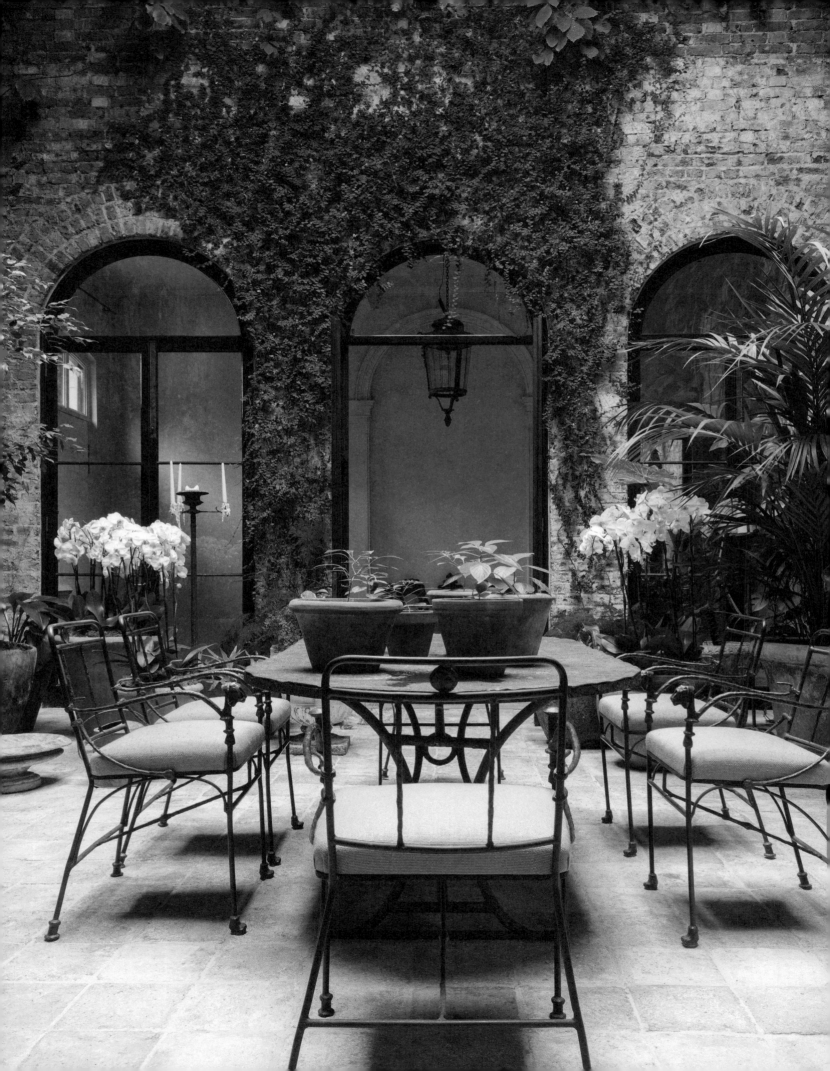

At Uniacke's home, this curiosity is borne out in an emphasis on quality materials and respect for history, along with a sense of integrity in the building and the objects she has introduced there. It was important, for example, to first strip back the layers of paint and remove unsympathetic interventions before thinking about the function of each room or how she would approach them aesthetically. "It took a long time but with the house completely stripped back it felt like a Venetian palazzo," she explains. "I decided then that I wanted to combine this playfulness with a monastic simplicity and function. I thought it would make an interesting mix."

Working in this way, Uniacke discovered a fragment of the original stone staircase buried in the wall, which allowed her to reinstate a striking, period-appropriate cantilevered staircase. Likewise, in what became the winter garden, the original rafters were found intact and carefully restored with wire brushes.

When it came to reorganizing the sequence of rooms, Uniacke enlisted the help of celebrated Belgian architect Vincent Van Duysen (interviewed on page 46). As a result of their collaboration, the floor plan was simplified, restoring the original vast rooms that had been divided up, reopening doorways between rooms, and introducing antrerooms to mark the transition between the dramatic open spaces.

The architect's influence is also suggested in a tactile, comfortable minimalism that defines Van Duysen's work, evident in the reclaimed 18th- and 19th-century oak floorboards and the unvarnished banisters. The plasterwork, too, has been painted with distemper, a type of whitewash that has been gradually built up in thin layers, leaving the texture of the plaster visible.

"It was important to restore the house responsibly," says Uniacke. "All the details

(above)
The detailed chair back is typical of Uniacke's
sharp eye for antiques.

—the window furniture, the doors—are correct. If the bones feel right, then that gives you the freedom to do what you need to bring the house into the 21st century. I only used one color for each room, for example; I didn't want to highlight the cornicing or the other plasterwork as it would have originally been."

This was one of the many steps that Uniacke took to create spaces that are relaxing while still acknowledging the scale and grandeur of the building (even on the first floor, the ceilings are 10 feet high).[1]

"I treated the ceilings as if they were a lot lower," says Uniacke, explaining how she approached hanging the considerable collection of contemporary art she has built with her husband—movie producer David Heyman.

The furniture, too—as you might expect given Uniacke's background—has been carefully curated. As well as comfortable and accommodating 18th- and 19th-century English pieces, there are French lights from the 20th century and modern Scandinavian furniture by Kaare Klint and Poul Henningsen. "I like to furnish in a way that suggests it has been collected over time," she says. "Your mum might give you a table that has been in your family for years, or you might pick something up on your travels. So here there is a real mix of periods, dates and styles." (It helps, in this pursuit, if your mother is an established antiques dealer.)

The most important piece, however, is perhaps also one of the easiest to overlook: A humble wooden bench designed for Fonthill Abbey in Wiltshire. It encapsulates the careful and considered approach that Uniacke has taken toward decorating her home. Even if you might miss it when you first arrive, distracted by the dramatic exposed brick and towering plants in the winter garden, the elaborately carved back or the arms—polished over a century and a half of use—might catch your eye. Like the house, the bench dates from 1860. "It's practical and simple and monastic," she says, "but it is also playful and fun. In a small way, it embodies everything I wanted to achieve in this house."

(1) Uniacke has James Rannie Swinton to thank for her home's high ceilings. The Scottish society painter, who commissioned the house to be built, wanted to ensure it would show off his art to maximum advantage. His home was among the first spaces in London to combine an artist's studio, gallery and residence into one.

(left) The conservatory was used by the original owner to exhibit paintings. Uniacke has installed a misting system in the roof to support the growth of orchids.

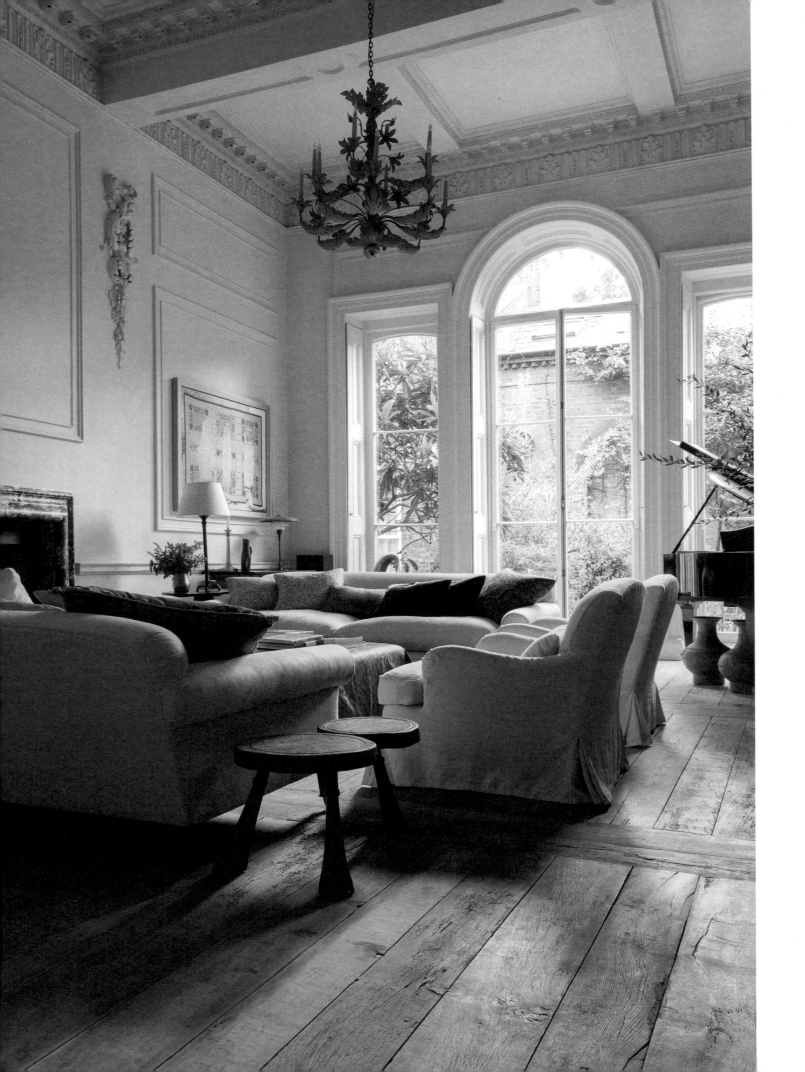

114 David Erritzoe
122 Spring Trance
134 Amia Srinivasan
144 The Alt-Right Wellness Loop
148 Open Relationships
158 Mind Games
168 Tricks of the Mind

Part 3.
THE MIND
Acid trips, TV therapy and pop philosophy.
114 — 176

Words
TOM FABER

David
ERRITZOE:

Photography
ANNIE LAI

ON TE
MIND
BENDING
POENTIA
OF PSYCHE
DELICS.

David Erritzoe arrives at our meeting on a fold-up bike, perfectly coiffed and turned out in navy, ready to talk about drugs. As the clinical director of the Centre for Psychedelic Research at Imperial College London, he is at the forefront of a new wave of scientists researching the therapeutic potential of psychedelics. Their early results have indicated that psychedelic compounds, such as psilocybin [the active ingredient in magic mushrooms] could work as powerful treatments for a range of mental illnesses including depression and addiction.

Sitting by a canal in the bright winter sunshine of Hackney Wick, near his East London home, he navigates deftly between two languages to speak about psychedelics: the meticulous doctor with a deep knowledge of brain imagery and psychopharmacology, and the believer who speaks of the near-religious experience his trial participants undergo, using terms like "oceanic boundlessness."

It has been a long road to be able to study the effects of psychedelics legally. After promising initial research in the '50s and '60s, these compounds were demonized and criminalized in the '70s, putting a stop to all research for 30 years, before finally beginning to open up over the past decade.

Erritzoe had his curiosity about psychedelics piqued when he was doing a study to understand the longterm effects of MDMA [the active compound in ecstasy] on the brain and found that the participants in his trial who also took psychedelics spoke thoughtfully and powerfully about their experiences. He soon moved from his home in Denmark to London and met Professor David Nutt and Dr. Robin Carhart-Harris, the group that went on to found the Centre for Psychedelic Research at Imperial College London.

TOM FABER: Humans have been using psychedelic substances for thousands of years. How did they first come to the attention of the medical world?

DAVID ERRITZOE: During the Second World War, a Swiss chemist called Albert Hofmann developed a new compound in the lab and accidentally ingested it, triggering a powerful psychedelic experience. He had created LSD, which lasts for several hours—it was probably an overwhelming experience for him. He shared his experience with psychiatrists who realized it might actually have positive mental health outcomes and therapeutic applications.

TF: What were the first medical trials with psychedelics?

DE: It was tested in trial settings throughout the '50s and '60s. During that same period, Hofmann also synthesized psilocybin in the lab, which is the compound that naturally occurs in magic mushrooms and truffles. In that period, there were around 40,000 patients worldwide who were given these compounds in a therapy setting and a thousand scientific publications, so it attracted a lot of interest in the science and mental health communities. The results showed psychedelics might be effective in treating depression and alcoholism, and some prominent politicians like Robert Kennedy spoke warmly about these treatments.

TF: If it looked so promising, then why did it stop?

DE: Partly because the nature of psychedelics clashed with the way medical research was was advancing at the same time. If you want to test the effect of a drug, then in theory you would prefer to simplify trial conditions, which could be by taking the whole context away, and trial it in a very clinical and controlled design and setting. This is great for testing an antibiotic or a painkiller, but psychedelics are so context-dependent that this doesn't result in brilliant results. It can even traumatize patients. Then there were trials that were not conducted according to existing psychedelic therapy guidelines, with people being pushed into taking really high doses on their own without support. That combined with political developments like the Vietnam War and counterculture movements in the '60s when psychedelics became popular for self-exploration. The Nixon government became increasingly critical and psychedelics were demonized. So around 1970, new UN conventions led to scheduling of

Hair: Katsuya Kachi. Makeup: Jinny Kim using SUQQU

THE MIND

these compounds across the world. This meant the compounds were classified in a way that you couldn't conduct research on them, so nothing happened for decades.

TF: Was there a particular experiment that sparked the current wave of research?

DE: Johns Hopkins did a trial in the early 2000s that showed healthy people using psychedelics could have profoundly meaningful experiences, as significant as giving birth to their first-born child.

TF: That's what a participant actually said?

DE: Not just one. Two-thirds of the participants rated it among the most significant experiences in their lives.

TF: What has the Centre for Psychedelic Research been studying?

DE: We've been trying to understand the brain biology behind these experiences and what they can tell us about consciousness, which is a deeply abstract phenomenon that nobody completely understands. We're also looking into whether these drug-induced experiences, together with psychological support, have a therapeutic value for a range of conditions, which at this point it looks like they do.

TF: What have been your principal findings?

DE: We've found that the brain under the effect of a psychedelic enters a chaotic, flexible state that allows for free-thinking and a loosening up of thought patterns. This could help with depression, where people have narrowed their thinking into negative thoughts about themselves and interpret everything in a way that confirms their negative self-image.

We conducted the first trial of a psychedelic intervention for depression in 50 years and saw very promising therapeutic results with psilocybin. In our next study, we compared it to conventional SSRI [selective serotonin reuptake inhibitors] antidepressants and the results overall favored psilocybin.

TF: Would it be right to say that, unlike conventional antidepressants, psychedelics treat the causes of depression rather than the symptoms?

DE: Yes, I think so. Psychedelics seem to dive deeply into the psyche, loosening it up, changing perspectives and allowing deep material to be dealt with in a fascinating way. In our trials, we have seen traumatic things brought to the surface and reassessed in a new light. The feeling of being trapped in the rigid, negative thought spirals of depression turns into a sense of connectedness with the universe, nature, the people around you and your own emotional life.

TF: And the changes last long after the drugs have left your system.

DE: Absolutely, which is very interesting, but we don't yet know exactly for how long. A big question for us is how often you need to redose or have a top-up experience. A colleague at Johns Hopkins framed it as a kind of "inverse PTSD"—we know that profoundly traumatic experiences can change the wiring of your brain and cause long-lasting negative impacts on mental health such as anxiety, depressive symptoms and flashback nightmares. So shouldn't it be possible that a deeply meaningful spiritual experience that offers a

profound sense of belonging could have a long-lasting positive impact on your psyche and your life?

TF: How does this work on a scientific level?

DE: Everything that changes us leaves some signature in our biological brain tissue. A psychedelic experience might make changes in the actual brain wiring and how brain cells connect. This might create a window where we can reframe and reshape the way we think and live.

TF: It's interesting that psychedelic users often talk about their experiences using religious and spiritual language. Is that a challenge for the scientific approach?

DE: Our questionnaires were originally based on the language people used to talk about their experiences, with terms like "mystical experiences" and "oceanic boundlessness." These are very poetic and, and perhaps scientifically somewhat fluffy terms, but that's because the the nature of these experiences are difficult to articulate. Some of these terms are provocative for scientists who come from hard-core pharmacology and want to measure everything on a scale of depressive symptoms. But these experiences are so rich that the language needs to be broader. It's a new vocabulary for medicine.

TF: Can participants in psychedelic trials have negative experiences?

DE: If you have a vulnerable person with mental problems, perhaps severe depression or trauma, then a psychedelic experience can bring up a lot of subconscious or repressed material. This can also happen in a person without any mental illness. If that's done in

"The brain under the effect of a psychedelic enters a chaotic, flexible state."

a safe therapeutic setting then it can be interesting and potentially very fruitful, which is what we see in the trials. But these people are prepared, supported and guided, to help them discuss and integrate the experience. It's important to have someone who can ground you: You're flying this airplane but we're the cabin crew and we'll help to make it all safe. But ultimately, as in therapy, it's mainly for the person themselves to make sense of things.

TF: Is taking psychedelics in a clinical setting safer than doing it recreationally?

DE: In recreational settings it can also go incredibly well. If you're out in nature you can experience a profound sense of unity which is difficult to re-create in a clinic. But if it's challenging and people lose touch with reality during the experience, they might do something dangerous or have a traumatizing experience. This is why they need support, but that doesn't have to be a therapist. These drugs have been used for thousands of years in different cultures, mostly very wisely. If it's in a shamanistic setting or with wonderful friends and people who know what they're doing, they can make a lot of progress, even with severe mental illness.

TF: Does the research suggest that certain psychedelics can treat specific illnesses?

DE: Right now MDMA, which is not strictly a psychedelic, is being used to treat PTSD, and psilocybin mainly for depression, but they might work inversely or be combined. Then there's a powerful psychedelic compound called 5-MeO-DMT, which comes from a poison found in toads, which has been tested underground in retreats and seems very powerful for treating addiction—but that's mainly anecdotal at this point and we need to do more testing. Personally, I don't see them as incredibly different. I rather regard them as different doors into the same, big dark house to be explored.

TF: How does the fact these substances are illegal affect your research?

DE: It makes research much more complex and expensive to undertake, but right now regulations are loosening and the number of trials is exponentially increasing.

TF: Your center received a lot of attention around a recent study that showed that microdosing psychedelics—where people regularly take a very small psychedelic dose and report improvements to mood and creativity—is actually no more effective than taking a placebo.[1]

DE: We are deeply unpopular because of those results, but nevertheless those are the results. In our trial we saw that the positive impact came from thinking you were microdosing, rather than actually taking the chemicals. Perhaps a key factor for the placebo effect being so strong is that microdosing is so hyped in many Western communities, such as Silicon Valley, at the moment, and featured in all the books and magazines. This hype together with the alternative and even anti-big pharma vibe around microdosing gives you the potential for a massive placebo effect.

TF: Do psychedelics have something to teach us about the workings of the mind more broadly?

DE: Absolutely. They already have, because a lot of our understanding of the role of serotonin in the brain came from early work with LSD and psilocybin. Anything that can change waking consciousness into a dreamlike state is interesting because it allows us to get closer to understanding complex, abstract mind phenomena which are difficult to study.

TF: What ramifications might your research have for people who don't suffer mental illness and don't want to take psychedelics?

DE: I think the idea of paying close attention to the context of how medicine is taken, as we do in our studies, could benefit everyone in mental health. Psychedelics could also help reevaluate the sometimes arbitrary classifications of mental illnesses we treat, as they allow a flexible reshaping of brain models and a breaking down of internalized, habitual negative states.

TF: Are there limits to what brain imaging can tell us about the human mind?

DE: There's close to nothing but limits; we're only scratching the surface. Though the field is getting better, we can now look at the brain with radioactive imaging, magnetic images and measure electrical activity, and by combining such techniques in the same experiments we try to achieve additive value when investigating the brain. AI might begin to help by letting computer systems understand brain patterns. But there's still generations of development to get closer to understanding the mind. We'll probably never completely understand this thing that we all run around with inside our skull.

(1) Microdosing—the practice of taking a low dose of a psychedelic drug in an attempt to improve creativity and productivity—has become wildly popular in Silicon Valley. Founders and entrepreneurs can avail themselves of the services of a "trip coach" to help them experiment safely.

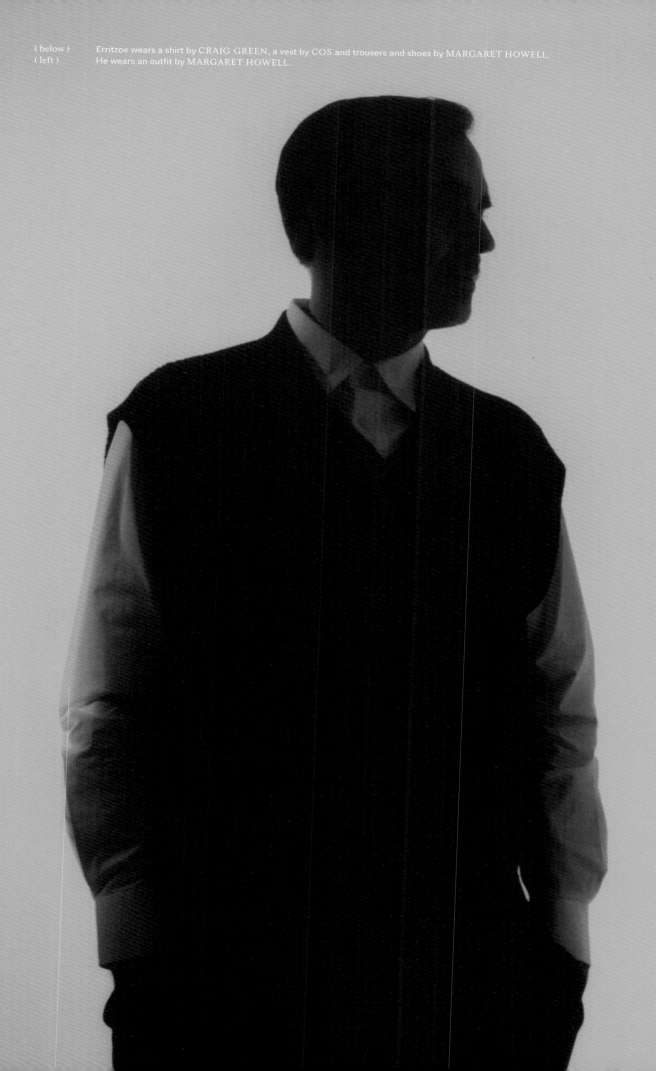

(below) Erritzoe wears a shirt by CRAIG GREEN, a vest by COS and trousers and shoes by MARGARET HOWELL.
(left) He wears an outfit by MARGARET HOWELL.

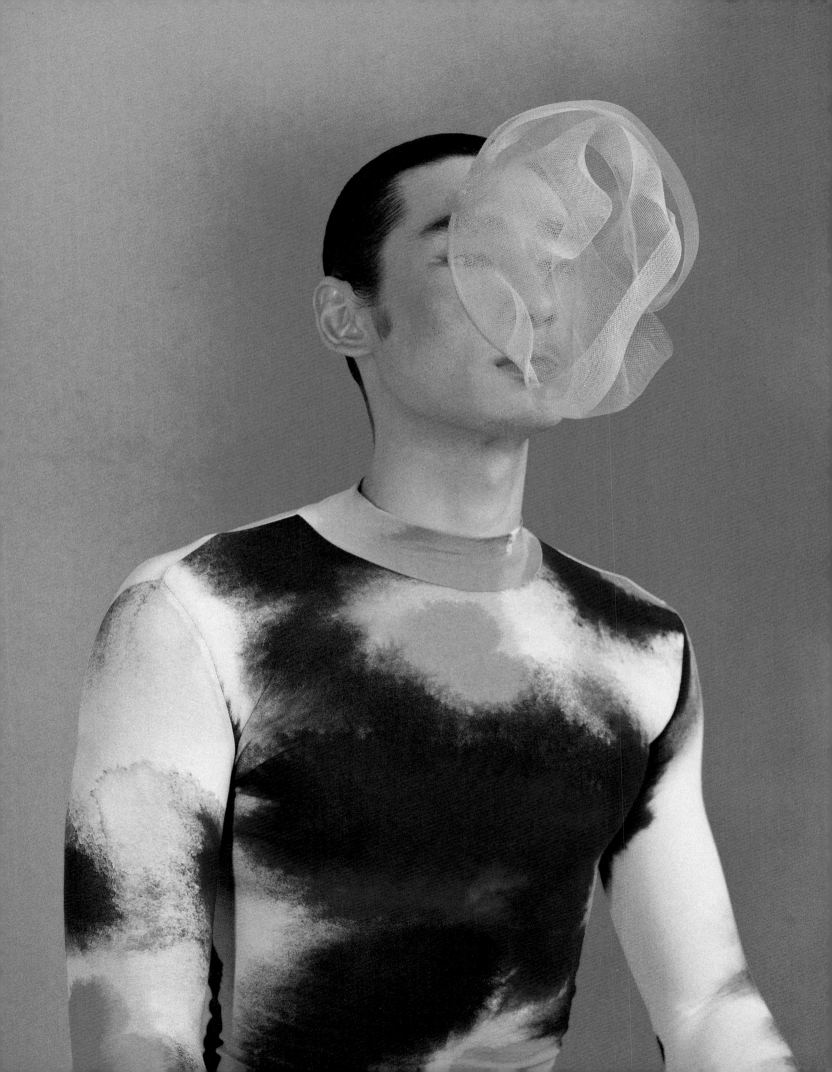

Hypnotic looks for
a new state of mind.

123 SPRING TRANCE

Photography
ZHONG LIN
Styling
MARK JEN HSU

(below) Nash wears a sweater by TERRENCE ZHOU.

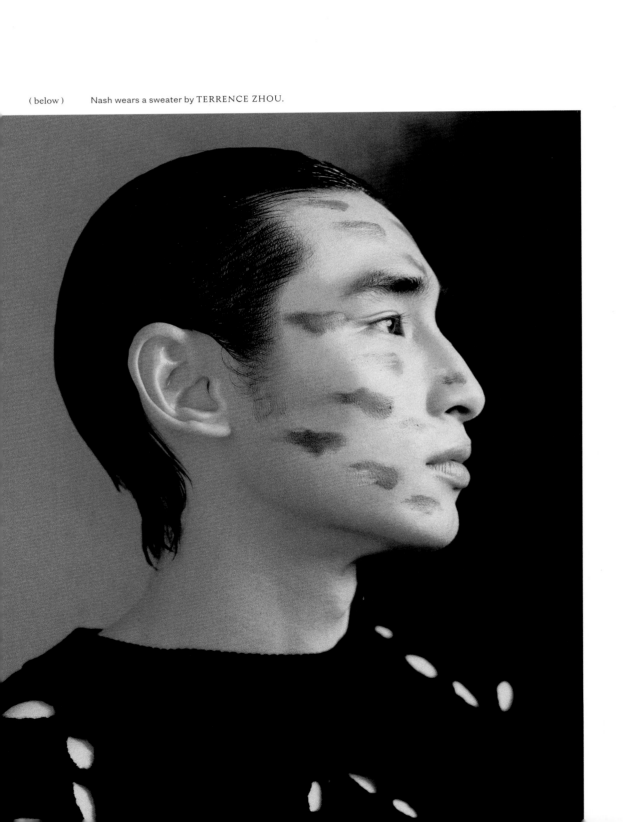

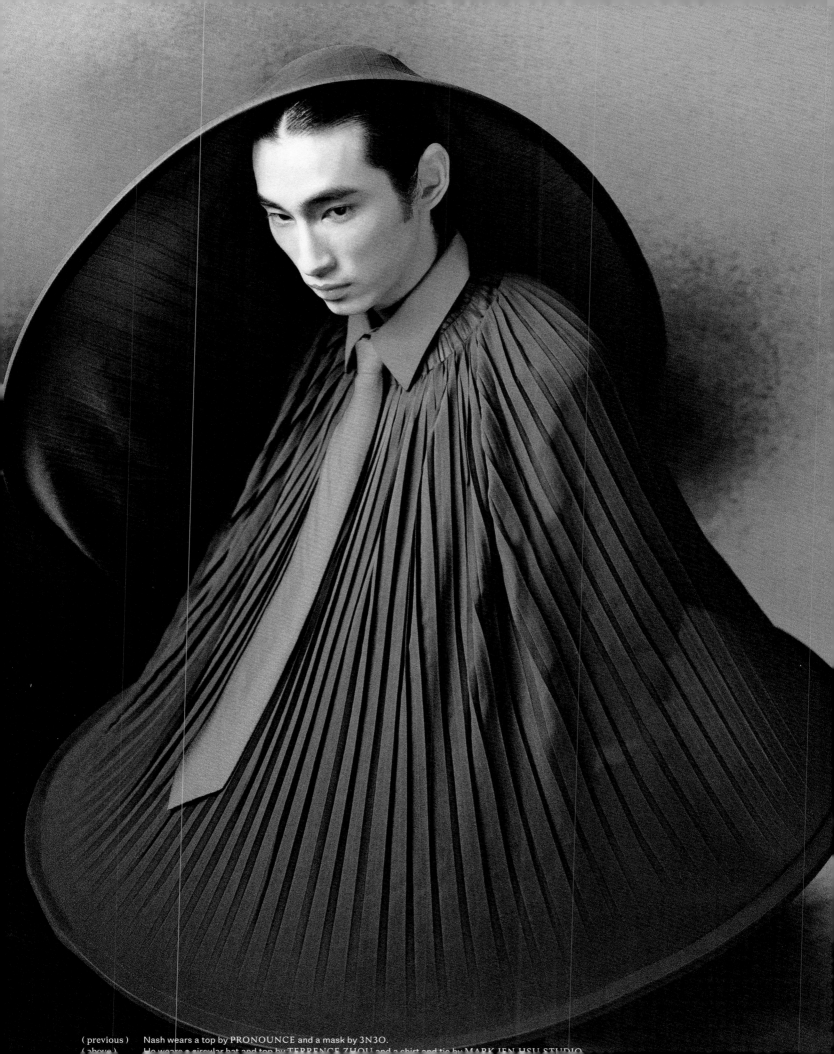

(previous) Nash wears a top by PRONOUNCE and a mask by 3N3O.
(above) He wears a circular hat and top by TERRENCE ZHOU and a shirt and tie by MARK JEN HSU STUDIO.

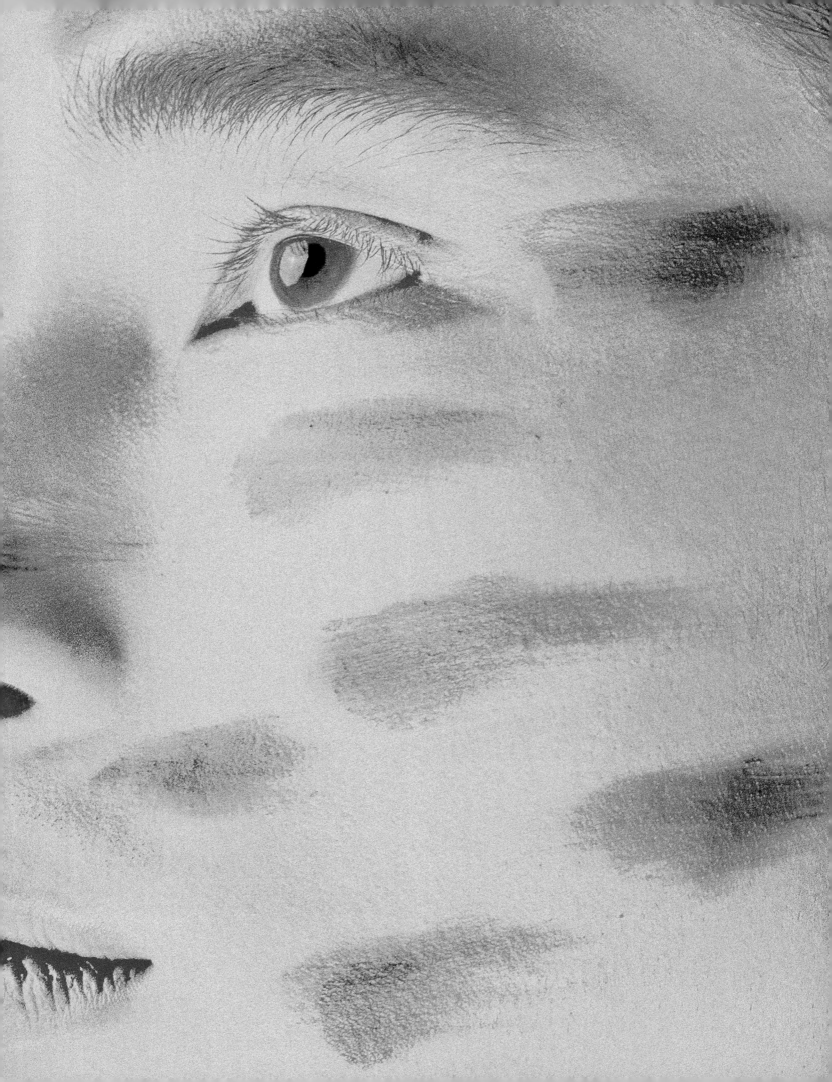

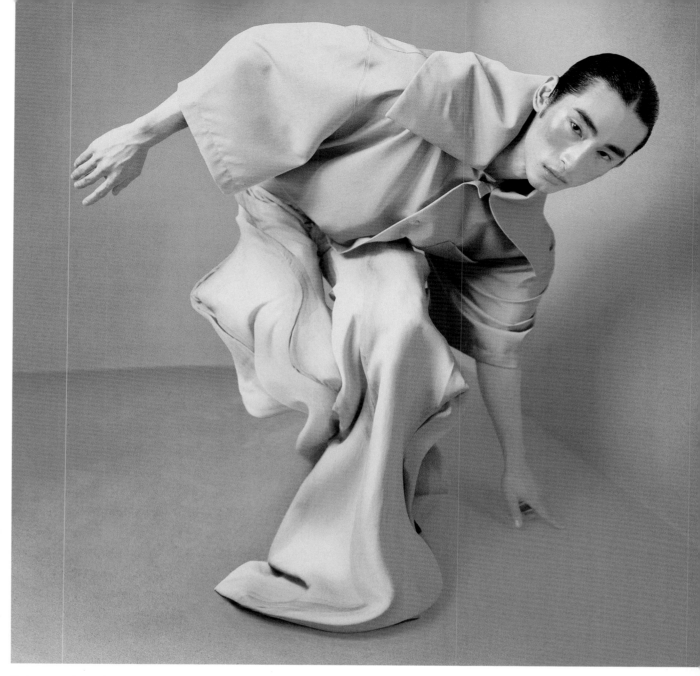

(above) Nash wears a shirt with an oversized collar by WILLY CHAVARRIA and trousers by VINCENT WONG.

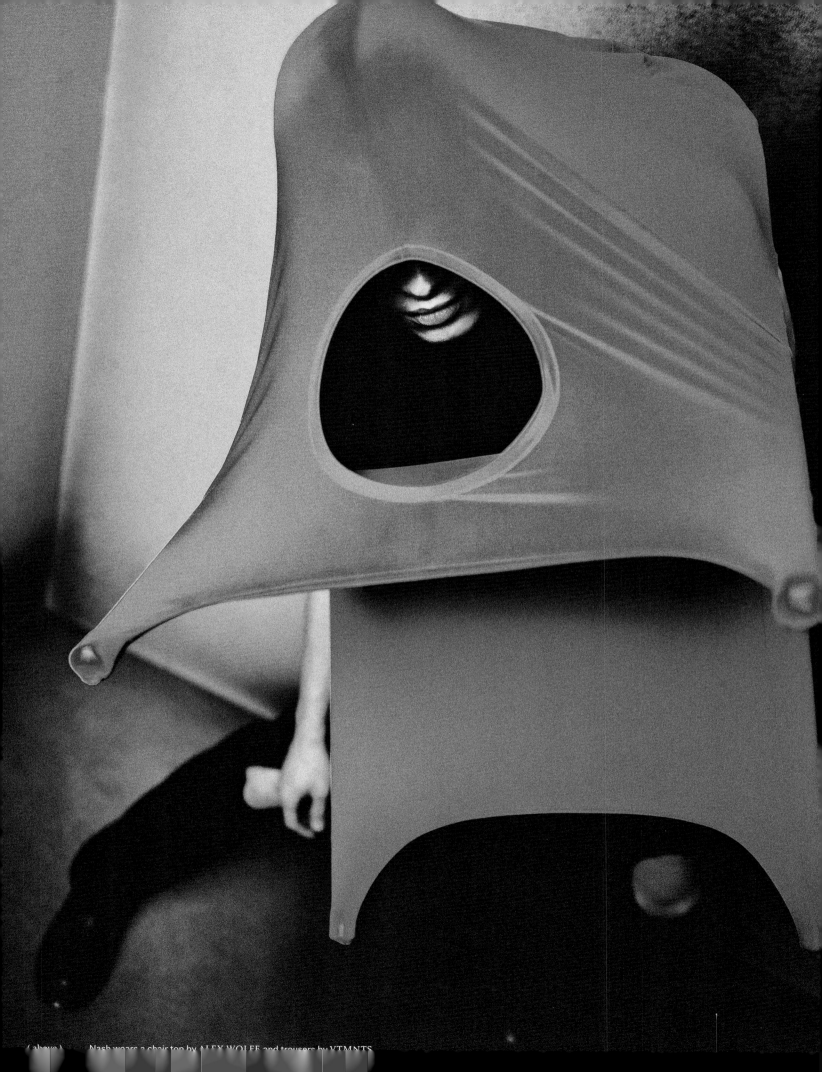

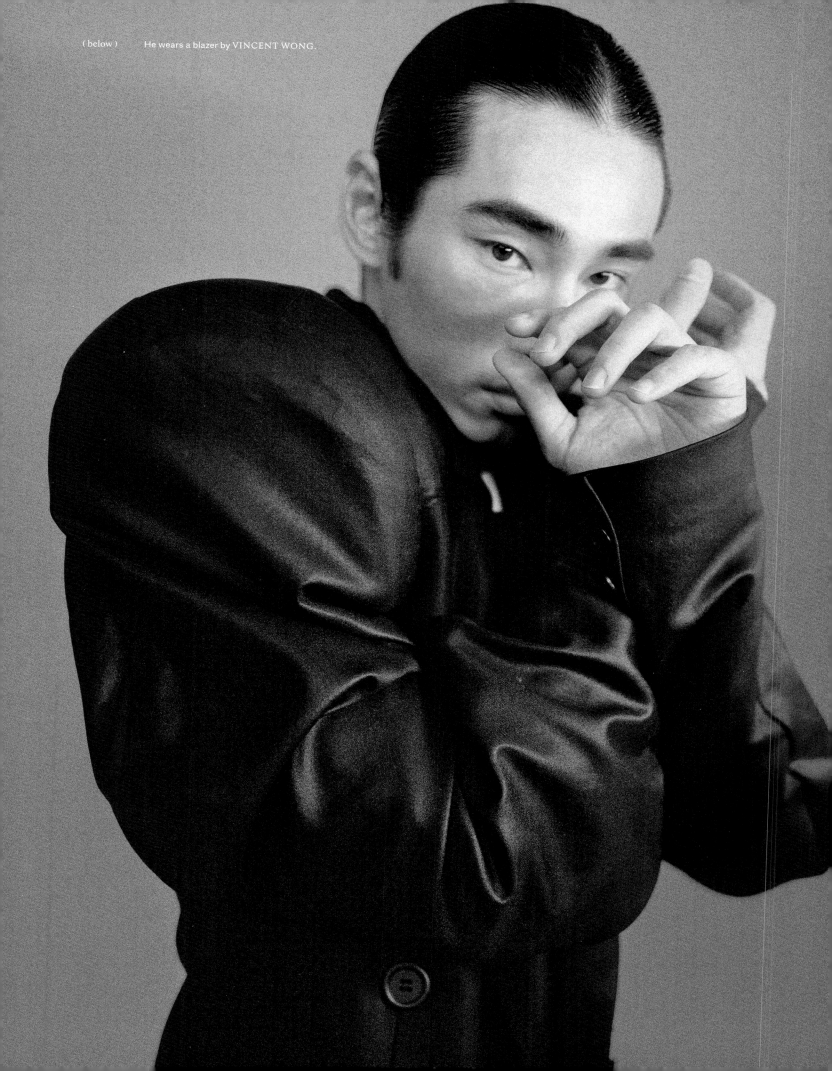

(below) Nash wears a shirt with an oversized collar by WILLY CHAVARRIA and trousers by VINCENT WONG.
(right) He wears a sweater and oversized trousers by VINCENT WONG and boots by VTMNTS.

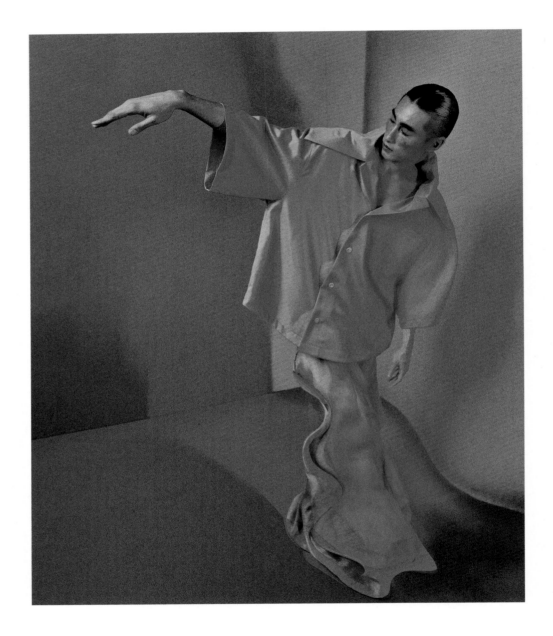

Styling Assistant: Li Kuan Zhen. Hair & Makeup Assistant: Ke Rong Chen

THE MIND

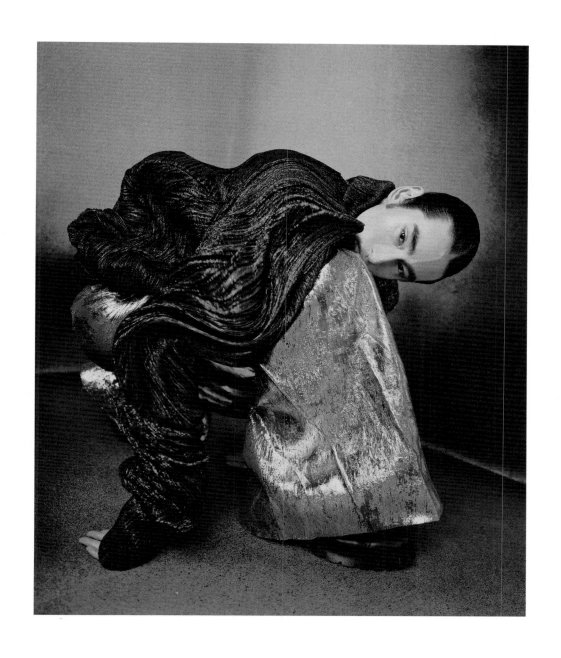

Model
NASH ZHANG
Hair & Makeup
SUNNY HSU

(left) Nash wears a top by PRONOUNCE and a mask by 3N3O.

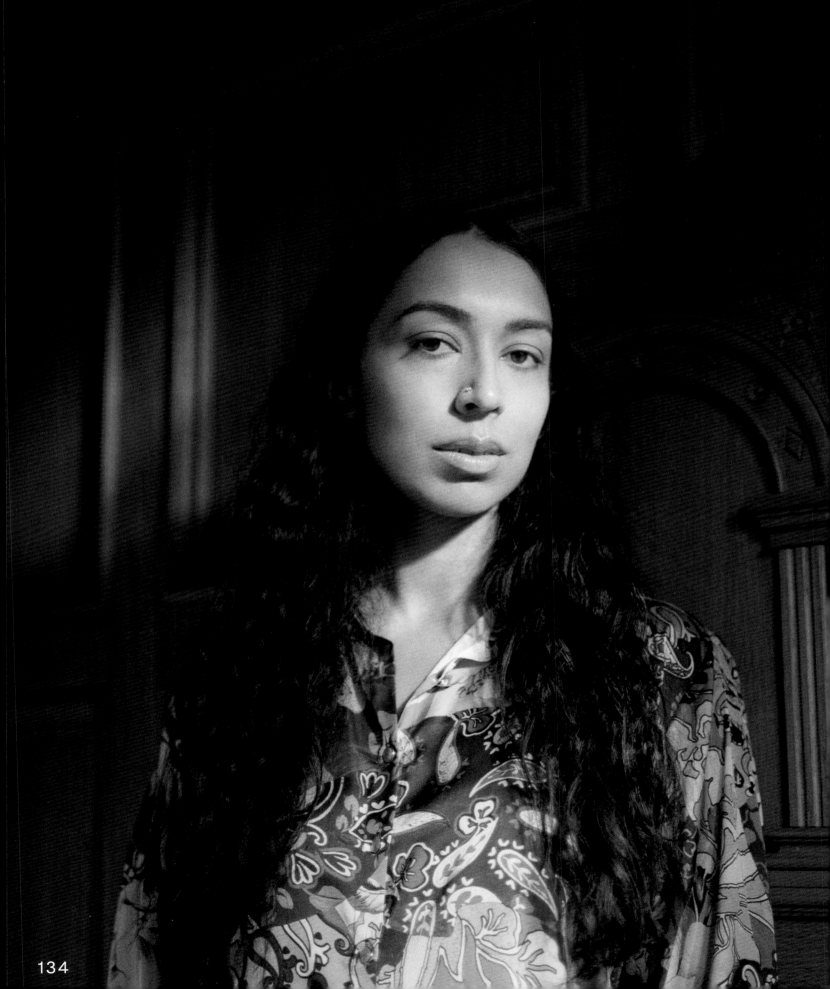

Amia Srinivasan on the philosophy of sex.

A mia

Words
HETTIE O'BRIEN

Photography
MARSÝ HILD ÞÓRSDÓTTIR

ON SEX, POLITICS AND THE

ROLE OF THE PUBLIC ACADEMIC.

THE MIND

Our sexual desires dwell privately within us, waiting to emerge when elicited by context. We have no power over what we want, and rarely desire what we would be wise to. Or so it's long been thought. This idea—that desire is private, natural, fixed—is both a timeless precept and a defining feature of our contemporary sexual culture. But what might happen if, instead of treating desire as innate, we thought of it as something contingent and politically determined? This idea preoccupies Amia Srinivasan, a philosophy professor at the University of Oxford. "As a matter of good politics, we treat the preferences of others as sacred," she writes. "But the fact is that our sexual preferences can and do alter, sometimes under the operation of our own wills."

This approach is typical of Srinivasan's sensibility: her commitment to feelings as worthy of serious attention; her interest in the experiences of everyday life; her intention to use the tools of analytic inquiry to think seriously about politics in the world. It is an unusual position to hold within academic philosophy, which is better known for paying attention to narrow abstractions. As a graduate student at Oxford University, Srinivasan often felt her mind was being "pruned." She feared that being a philosopher would be incompatible with being a public thinker. "When you undergo that training, part of what you have to do is set aside your ambition to speak broadly about the things that feel most important to you," she says when we meet at her college in Oxford on a drizzly day in early November.

But Srinivasan, who is now 37, stuck with the subject and has since found a way back to the issues that concern her most. Today, she is regarded as one of the most exciting living public intellectuals. It's a status that she has acquired quickly, through a flow of essays, a prestigious appointment at Oxford and, most recently, a book about the politics of sexual desire. Srinivasan is also the rarest of things: an analytic philosopher whose work is a joy to read.

The Right to Sex, a series of essays on desire, consent, pornography and the ethics of sleeping with students, probes the limits of contemporary feminism and is characterized by Srinivasan's bracing questions and delicate rigor. When faced with the reality of sex within an unequal power dynamic, for example, many people—feminists included—have suggested "consent laws" as a remedy.[1] But there is no blanket agreement that can replace the nuances of true consent. So what is to be done? Srinivasan is wary of apparently simple solutions: "Could the reason that this question is so hard to answer be that the law is simply the wrong tool for the job?"

Srinivasan is spirited and warm in person. She has shiny dark hair that reaches to her waist, and is dressed casually in navy jeans and white sneakers. Her imposing, wood-paneled office at All Souls College is humanized by a trail of objects: framed posters,

(1) In 2018, a Dutch company called LegalFling drew headlines for promoting an app that allowed partners to sign contracts before engaging in sex. Critics described it as fundamentally misconstruing the nature of sexual consent, which can be withdrawn at any time.

a magazine on a green velvet sofa, a Mughal miniature and tingsha bells from Ladakh on the mantelpiece. Srinivasan was born in Bahrain to Indian parents. Her mother, to whom the book is dedicated, is a dancer and choreographer; her father a retired banker. She was raised in a Hindu household, where she first encountered Indian philosophy, and had an itinerant childhood, living in New York, Singapore, Taiwan and London.

In some of the interviews she has given since being appointed the Chichele Professor of Social and Political Theory (I struggled to pronounce the position correctly—she told me the poet Philip Larkin used to rhyme it with "bitchily"), Srinivasan has cut a stern figure.[2] "I've often made a deliberate choice to present myself as more serious than I am. Entirely because I am a young woman," she tells me. One also imagines that it is because of how some regard her field of inquiry; in the introduction to *The Right to Sex*, for example, Srinivasan recounts a famous male philosopher who told her that he objected to feminist critiques of sex because "it was only during sex that he felt truly outside politics."

> " I've often made a deliberate choice to present myself as more serious than I am. Entirely because I am a young woman."

A thread that runs through Srinivasan's writing is her concern with the way that our beliefs and worldviews are shaped by the contingencies of where and with whom we find ourselves, and whether we could be capable of wanting different things under different circumstances. In *Does Anyone Have the Right to Sex?*—a magisterial essay that went viral after it was published in the *London Review of Books* during the height of the #MeToo movement in 2018—Srinivasan begins with the case of Elliot Rodger, a 22-year-old "incel" (involuntary celibate) who killed six people and injured 14 in Isla Vista, California, in 2014.

What Rodgers did was twisted, propelled by a nauseating misogynistic and racial hierarchy. But Srinivasan traces in his lengthy manifesto a sense of sexual entitlement to particular bodies (the "stuck-up blonde slut") that is indicative of the exclusions that shape contemporary sexual politics. That some bodies (including, Rodgers felt, his own) are considered "unfuckable" is a symptom of the way desire is politically constituted and closely tracks our social prejudices. Once, feminism would have offered a way of thinking this through, but female desire is now regarded as an expression of agency rather than a field for political criticism.

(2) Since its creation in 1944, the Chichele Chair in Social and Political Theory has previously been held by a string of influential thinkers including Isaiah Berlin. Srinivasan is the first woman and first person of color to be appointed, and the youngest person to hold the role.

Srinivasan's embracing of discomfort and complexity is both unfashionable and deeply refreshing. In a review of *The Right to Sex*, the Irish novelist Naoise Dolan wrote that Srinivasan is "dauntless about the potential scrutiny of people who read books primarily to tweet screenshots. You will not find each paragraph pegged with qualifiers intended to debar you from making her look bad." Indeed, in person she seems more bothered by the prospect of being willfully misrepresented than by being disagreed with. She is concerned by the anti-intellectual stance that some critics have taken toward her work (one less flattering review of *The Right to Sex* summarized it as an "Orwellian tract" of "Soviet-style sex re-education").[3] "I'm happy to be the object of people's ire and anger, but the unwillingness to correctly describe arguments to begin with… I find [that] very troubling," she says.

(3) Writing in *The Telegraph*, Jane O'Grady accused Srinivasan of arguing that sexual preferences must not be exclusionary. In *The Right to Sex*, Srinivasan says she is "not imagining a desire regulated by the demands of justice, but a desire set free from the binds of injustice."

Srinivasan's work has attracted more public interest than most philosophers ever will. Earlier this year, she appeared in *Vogue*.[4] I ask her whether philosophers in general have a responsibility to make themselves available and their ideas publicly accessible. Srinivasan admires philosophers such as Bernard Williams and Derek Parfit who made no sharp distinctions between their public and academic writing. "There was a relentless insistence on complexity and difficulty, and the expectation that a non-philosophically trained audience could keep up, which I think it often can." The problem of communicating complex ideas to a public audience can be a symptom of poor writing, she thinks. But the notion that all knowledge has to be publicly useful also frightens her, insofar as it folds easily into a conservative attack on the arts and humanities. "I think there should be a lot of room for so-called 'useless' inquiry," she says.

At times, the fine brushwork of Srinivasan's work can seem far removed from the messiness of life outside the classroom. Many of the anecdotes in her book are drawn from her students and academic colleagues. But much has changed over the last decade within universities, too; when Srinivasan was an undergraduate at Yale, which was less than two decades ago, feminism was "completely off the radar." By contrast, the undergraduate module on feminist theory she now teaches at Oxford was so well-attended before the pandemic that lectures had to be moved to the university's largest exam room.

> " I'm happy to be the object of ire and anger, but the unwillingness to correctly describe arguments to begin with... I find that troubling."

The fact that Srinivasan has spent most of her adult life teaching or being taught at elite universities does not always mean she has dwelled comfortably within them. In one 2015 interview in *The Rhodes Project*, she spoke of feeling like "a stranger in a strange land" while studying for her PhD at Oxford, surrounded by people that she felt little connection to, with no sense of fitting in. When she was asked in that interview what she imagined the next decade of her life would look like, she answered: "I fervently hope not to be bored and not to bore others." With her resistance to easy answers and reductive thinking, it's an aspiration she has made into a reality.

(4) Srinivasan was interviewed by *Vogue* in the aftermath of the death of Sarah Everard, who was abducted and murdered by a serving police officer in London in March 2021. Srinivasan reflected on the fact that many women supported the Conservative government's solution of putting plainclothes police in nightclubs to protect women. "State power has to be handled with care and delicacy. That's not something that feminists have totally—this is to understate the point—grappled with yet," she said.

Where alt-health
meets the alt-right.

ESSAY:
THE ALT-RIGHT
WELLNESS LOOP

Words
ROBERT ITO

At the dawn of the pandemic, Los Angeles–based yoga and fitness instructor Derek Beres began noticing an uptick of tweets and Facebook posts pushing a variety of conspiracy theories related to QAnon and COVID-19. The messages weren't coming from the radical right and its malcontents, however, the sorts of folks one might expect to believe that a cabal of blood-drinking, Satan-worshipping pedophiles is trying to take over the world, or that COVID-19 was caused by 5G.[1] No, these tweets were coming from leaders and influencers within the yoga and wellness community, people not unlike himself, some of whom Beres personally knew.

In 2011, sociologists Charlotte Ward and David Voas coined the term "conspirituality" to describe this weird blend of New Age spirituality and the shadowy world of the conspiracists. The

This sort of thing wasn't entirely new to Beres. For years, he and Julian Walker, a yoga teacher and fellow Angeleno, had written about grifters and scoundrels in the wellness community.[2] There were yoga teachers blaming the 2011 tsunami in Japan on bad karma, cashing in on bogus 2012 Mayan prophecy courses or running lethal sweat lodges. But COVID-19 ramped up the conspiracy talk in unprecedented ways. David Icke, a longtime presence in the New Age self-publishing world, began claiming on Twitter and his YouTube channel that 5G mobile phone networks, alongside Bill Gates and unnamed "Jewish cults," were somehow behind the pandemic. In May 2020, Mikki Willis, an Ojai-based filmmaker, released *Plandemic*, a 26-minute video alerting people that vaccines were making them sick and that face masks could actually "activate" the virus. Within a week

> " These were people who were susceptible to a kind of quasi-religious tonality that the QAnon material had: this sense of a great awakening."

burgeoning web movement, wrote Ward and Voas, was based on two core convictions. The first was that a secret organization, whose members may or may not include Tom Hanks, Oprah Winfrey and Barack Obama, is trying to control the world's major political and social institutions (or already does). The second belief was that humanity is undergoing a paradigm shift in consciousness—an essential step toward combating the evils wrought by the aforementioned cabal.

of its release, Willis' video was viewed more than eight million times. "Here's this guy who we trust, who's been a liberal activist, who made a film traveling with Bernie Sanders," says Walker. "He's not some crazy right-winger. And that thing took off like wildfire in the yoga and wellness space."

Beres and Walker teamed up with Matthew Remski, a Toronto-based yoga therapist and author, to launch the podcast *Conspirituality*. As longtime observers and critics of the worlds of yoga and wellness, the trio could understand why the sorts of things they had been observing for years were accelerating at such a pitch during the pandemic. Many in these communities were already distrustful of the government and wary of traditional medicine and doctors. When it came to mysterious pandemics, a number of them were more inclined to believe in homeopathic remedies and "natural" cures than in some vaccine cooked

(1) 5G technology does not cause or spread COVID-19. According to UNICEF, the conspiracy theory that it does is more often believed by people who do not use the internet.

(2) Rhonda Byrne, author of the bestselling self-help book *The Secret,* once claimed that the victims of 9/11 were in the wrong place at the wrong time due to their own negative thoughts and outlook.

up by Big Pharma. "There was an audience who had been primed over many years to be receptive to these online conspiracy theories," says Walker. "These were people who maybe didn't know how to think critically about these sorts of claims, and were susceptible to a kind of quasi-religious tonality that the QAnon material had: this sense of a prophecy and a great awakening."

For the influencers themselves, the pandemic created a strong financial incentive to chase the latest and weirdest conspiracy theories. Yoga instructors had long supplemented their incomes by selling a variety of products with questionable efficacy, from the relatively benign (essential oils to combat stress) to the downright charlatan (cancer-curing crystals). "When the pandemic

" Influencers found that the more inflammatory they could make their content, the more visibility they would have."

happened, suddenly there were no more public classes," Beres says. "So these instructors had to figure out how to make a living." Some tried to support themselves in questionable yoga-adjacent multilevel marketing projects, or by selling online courses or life coaching to get folks through these uncertain times. Some would draw in the curious with posts about the latest and weirdest conspiracy theories, then solicit money from them through memberships or PayPal donations. Others chased views and potential followers by posting QAnon and anti-vax messages.[3] Still others claimed that spirits or aliens were talking to them about the pandemic, and for a price, they could talk to you,

(3) A March 2021 report by the Center for Countering Digital Hate, a UK/US nonprofit and NGO, found that the majority of COVID-19 anti-vaccine misinformation and conspiracy theories originated from just 12 people. Around 65% of the 812,000 Facebook posts and tweets they analyzed originated from this "disinformation dozen."

(4) Northrup is also the author of *Dodging Energy Vampires: An Empath's Guide to Evading Relationships That Drain You and Restoring Your Health and Power*. In April 2021, Instagram disabled her account, severing her from her followers for spreading misinformation about COVID-19 and vaccines.

too. "Influencers found that the more inflammatory they could make their content, the more visibility they would have," says Remski.

The ranks of the conspiritualists include some of the most recognized names in the yoga and wellness community. There's Kelly Brogan, a self-described "holistic psychiatrist" and former Goop contributor, who believes that it's not a virus that's causing all those COVID-19 deaths, but the *fear* of the virus. There's Christiane Northrup, an OB/GYN and author of the bestseller *Women's Bodies, Women's Wisdom*, who claimed that getting injected with the COVID-19 vaccine would make us the property of the patent holders (untrue) and that she was a former resident of the lost world of Atlantis (unverified). "Northrup is a revered and trusted expert, who seemed to be doing a reasonable kind of integration of holistic medicine and more, shall we say, science-based medicine," says Walker. "Then she gradually became someone who had gone completely into QAnon."[4]

For many, says Remski, the conspiracy theories fill in for medical and political systems they feel have failed them. It's no wonder, he says, that QAnon exploded in the US, with its enormous income inequality and lack of universal health care. "The QAnon people are fantasizing about government officials being publicly executed on television," he says. "Where could that bloodlust come from, other than some deep-seated feelings of neglect?" Combine profound feelings of disenfranchisement with the economic uncertainties brought on by a global pandemic and it's not hard to understand why people would be desperate for a bit of clarity.[5]

Many didn't fully trust the politicians, who were all disagreeing anyway, or the doctors, whose stories kept changing as more was learned about the virus. The conspiracy theorists, however, had simple-to-understand explanations for all that was going on, and stories that never changed. It's the government! It's a cabal! And a lot of the people most susceptible to these ideas were getting all of their information from limited news and social media sources that were just echoing back what they wanted to hear. Given this environment, one can see why otherwise-rational people might begin having some really irrational thoughts.

And it's not like the conspiritualists are creating this stuff out of whole cloth. "First of all, conspiritualists are right about a lot of things," says Remski. "They're right that Jeffrey Epstein ran a well-hidden, well-financed sex trafficking ring that implicated many powerful people. They're correct that medical institutions have been responsible for terrible, terrible tragedies like Tuskegee.[6] So the bias towards cynicism is absolutely valid."

What is to become of the victims of these conspiracy theories? "There's a couple hundred thousand people on the QAnon casualties subreddit, talking about how they've lost family members or friends to QAnon," says Remski. Every day, he says, people write dozens of notes to him or to the podcast describing, say, a significant other who's fallen down the rabbit hole, and asking what can be done for them. Or, *I'm slowly starting to recover, can I give you a call and chat?* He lets them know that, no, none of us are therapists at the podcast, but here's a list of therapists you could call. All of them, he says, are overbooked. "I think there's going to be a huge therapeutic challenge coming for the people who are the hardest core of QAnon and conspirituality indoctrination," he says.

(5) Fascism and New Age theories have made strange bedfellows before. Many prominent figures in the Nazi party indulged in New Age thinking during the 1920s and 1930s. Joseph Goebbels was fascinated by Nostradamus' prophecies, which he thought predicted Nazi success; Heinrich Himmler supported alternative medicine—such as using plant extracts to heal cancer.

(6) Between 1932 and 1972, the United States Public Health Service conducted the Tuskegee Syphilis Study—an ethically abusive study in which more than 400 Black men with syphilis were deliberately denied effective treatment to determine the natural course of the disease. The men were not informed of the nature of the experiment, and more than 100 died as a result.

Essay:
OPEN RELATIONSHIPS

What happens when private therapy becomes public entertainment?

Words by Allyssia Alleyne

Photography by Aaron Tilley

A contender for series villain emerges less than 10 minutes into the first episode of Showtime's *Couples Therapy*. "I don't have complicated needs. I am utterly transparent and completely communicative about what it is I want. I'm also totally consistent. I am the easiest person to deal with," explains one handsome and confrontational husband, sitting next to his wife of 23 years. ("Says you," she counters, weakly.)

"What I want is to have zero responsibility, to have all the sex I want, without any work on my part of any kind. Like, zero work, zero thinking about it—and it has to be both spectacular and enthusiastic and genuine."

In moments like this, it's clear why *Couples Therapy* has gripped viewers across America and beyond since 2019 and is set to expand into Australia this year. For nine 30-minute episodes, we're invited to watch real people assert their desires, refight old battles and try to save their relationships with the help of the patient and perceptive clinical psychologist Orna Guralnik. Regardless of whose lives are being dissected, the therapist's office is a natural set for discussions of personal dramas, secret shames and latent grudges—all of which make for great television.

The show is part of a recent wave of TV shows, YouTube series and podcasts that have turned therapy sessions into entertainment. Those enticed by interpersonal drama can download Belgian author and psychotherapist Esther Perel's podcasts *Where Should We Begin?* and *How's Work?*, which focus on couples and colleagues

respectively. The celebrity-obsessed can revisit *Viceland*'s 2017 series *The Therapist*, which sat musicians including Katy Perry and Freddie Gibbs down with resident shrink Siri Sat Nam. On the podcast *Other People's Problems*, produced by the Canadian Broadcasting Corporation (CBC), therapist Hillary McBride broadcasts her sessions with an anonymized cast of longtime clients. And on iHeartRadio, *Dear Therapists* hosts Guy Winch and Lori Gottlieb (whose 2019 memoir, *Maybe You Should Talk to Someone*, is being turned into a TV series starring Eva Longoria) offer guidance to letter writers in one-off sessions. Subverting the traditions of confidentiality and privacy that therapists have traditionally been bound by (with participant consent, of course), these shows are part of an ongoing collapse of the boundaries between private and public life. But they also speak to the contradictory and evolving nature of our relationship with therapy. Therapy, it seems, is sensational enough to carry an entire series, but normal enough that everyday people aren't ashamed to broadcast their experiences. (It's worth noting that these programs tend to focus on relationships, trauma, and standard life stresses, rather than on mental illness.) And at a time when therapy and other mental health services are simultaneously stigmatized, sought after and inaccessible, is it any wonder that these depictions have gone mainstream?

The use of therapy as entertainment isn't new. Radio advice shows go as far back as the 1920s, when a proto-self-help guru

named Marion Sayle Taylor began offering "human relations" advice to America on his syndicated *The Voice of Experience* show, and they have been gracing the airways ever since. When it comes to reality TV, therapy features heavily on contemporary docudramas as a narrative device, offering insight into a star's interiority (Bethenny Frankel opening up to her therapist on *The Real Housewives of New York*) or providing a convenient backdrop for conflict (NeNe Leakes staging and sabotaging a group therapy session on *The Real Housewives of Atlanta*).

"Television has always had a relationship to the therapeutic," says Brandy Monk-Payton, an associate professor of media studies and Black cultural studies at Fordham University in New York. She traces today's talk therapy reality programming back to early talk shows such as *The Oprah Winfrey Show*, where private problems were discussed in front of studio audiences. Later, the now-ubiquitous confessional cam, employed everywhere from *The Real World* to *The Bachelor*, set the groundwork for the current level of transparency; while programs like *Celebrity Rehab with Dr. Drew* and *Intervention* established clinical therapy as fertile ground for harrowing, high-ratings drama.

"Viewers really enjoy watching conflict transpire on screen, and particularly as it connects to interpersonal relationships," Monk-Payton explains. "So, it makes sense that we would move into this space where viewers are interested in more intimate relationships [between real people] … It's about

Set Designer: Sandy Suffield

(1) Therapists have also found followings on TikTok, where of-the-moment meme formats and dances are deployed to share advice in 60 seconds or under. The informal nature of the platform blurs the normally strict boundary that therapists maintain between the professional and the personal.
(2) Smart set design on *Couples Therapy* means that participating couples feel that they're speaking in a completely camera-free space.

looking at these couples as sensational and looking at them as a spectacle, but also taking on that role as armchair psychologist, in terms of trying to assess their relationship."

Jodie Martinson, the creator and producer for the CBC podcast *Other People's Problems*, believes the "behind-closed-doors" quality is a big part of the allure. "It may sound horrible and crass, but ⌊when I started the show⌋ I thought there might be an aspect of voyeurism; that it's enticing to imagine what's happening in private spaces.[1] So much good podcasting, or good storytelling is about the spaces that are private," she says. "But the most interesting thing ended up being the relationship between Hillary ⌊McBride, the therapist⌋ and the client."

On a basic level, what sets shows like *Couples Therapy* apart from its predecessors is the veneer of professionalism, the production values and the genuine care.[2] "The other therapeutic shows have been on basic cable—VH1, Bravo, MTV. But a show like *Couples Therapy* is trying to engage with reality television, but through this sort of quality, prestige programming," she says. "But it's still fundamentally about trying to capture the money shot—that lucrative moment of an episode that captures audience attention.

There may be less of them because the show speaks to an everyday documentary style, but everyone wants to see someone shouting or yelling."

These shows are often more than just entertainment, however. On the individual level, watching or listening to sessions can also help provide expert knowledge to the masses. This is part of what motivated Martinson, who has participated in therapy herself, to launch *Other People's Problems*. "I know so many people who can't go to therapy or don't go to therapy because it's expensive," she says. "I thought that if we could put a microphone in the actual room of people getting therapy, I could benefit by hearing what they were learning because I'm not that different from those people."

There are limitations, of course. At the start of each episode of the *Dear Therapists* podcast, the hosts warn that the show is for informational purposes only, and "is not a substitute for professional advice, diagnosis, or treatment."

To Lesley Fisher, a therapist with the Family Institute at Northwestern University, this is a crucial caveat. "⌊A show⌋ can inspire you to reconsider your own life—it can make you curious, it can help you

understand why your partner gets so upset when you do this or that. But it's just the beginning," she says. "You might relate to some of those people that you see. But they're not you. They have different early experiences, different backgrounds, different resources, and so just watching that isn't going to give you everything you need."

Fisher suggests that these shows' real influence goes beyond the individual: When executed correctly, they can help shift broader cultural attitudes about therapy.

"These resources can decrease stigma, they can be very normalizing, and they can inspire people to think about their problems, their relationship conflicts, from a different perspective," she says. "I have seen more people start therapy during this pandemic than I have in my career so far, but it takes generations to unravel messages like 'You should be strong enough to solve your problems on your own.'"

"I made this joke tagline: 'Other people's problems are a lot like your own.' And that's true. But other people's reactions and pain and healing are also a lot like my own—our own," Martinson says. "There's some unifying power in hearing people speak when they're really honest about their struggles."

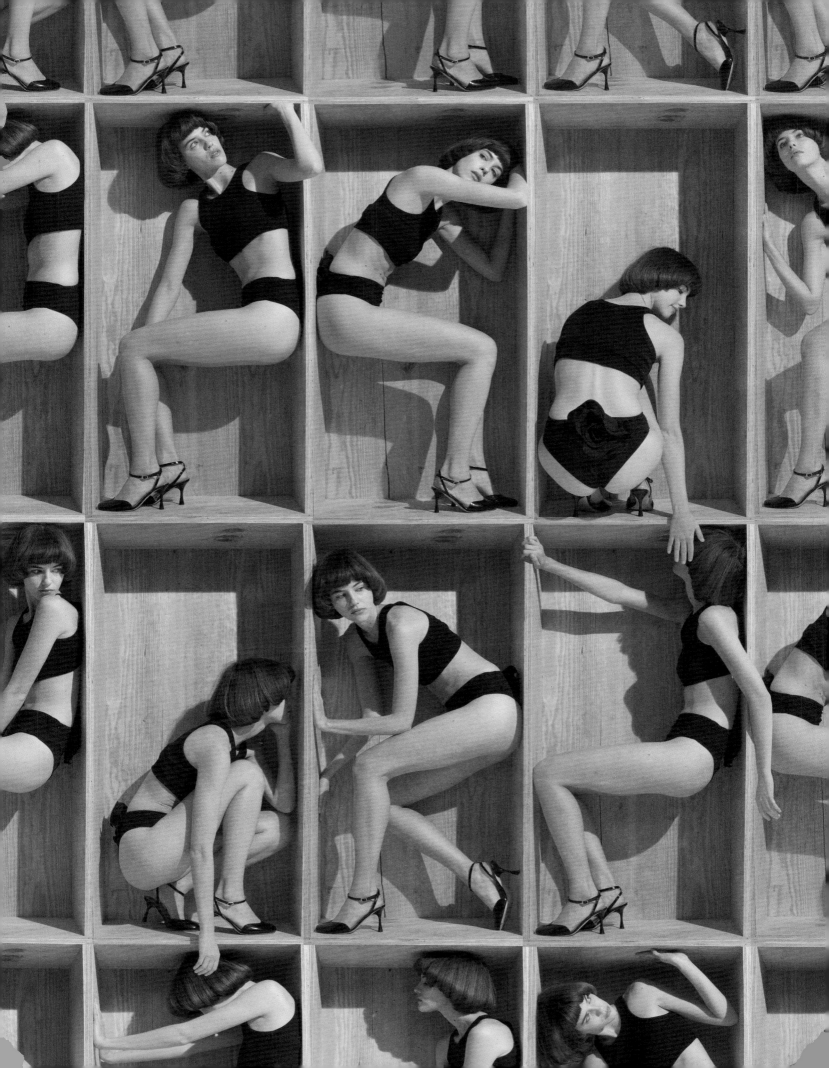

Cerebral fashion,
from the deepest folds
of the cortex.

159 MIND GAMES

Photography
HENRIK BÜLOW
Styling
CAMILLA LARSSON

160

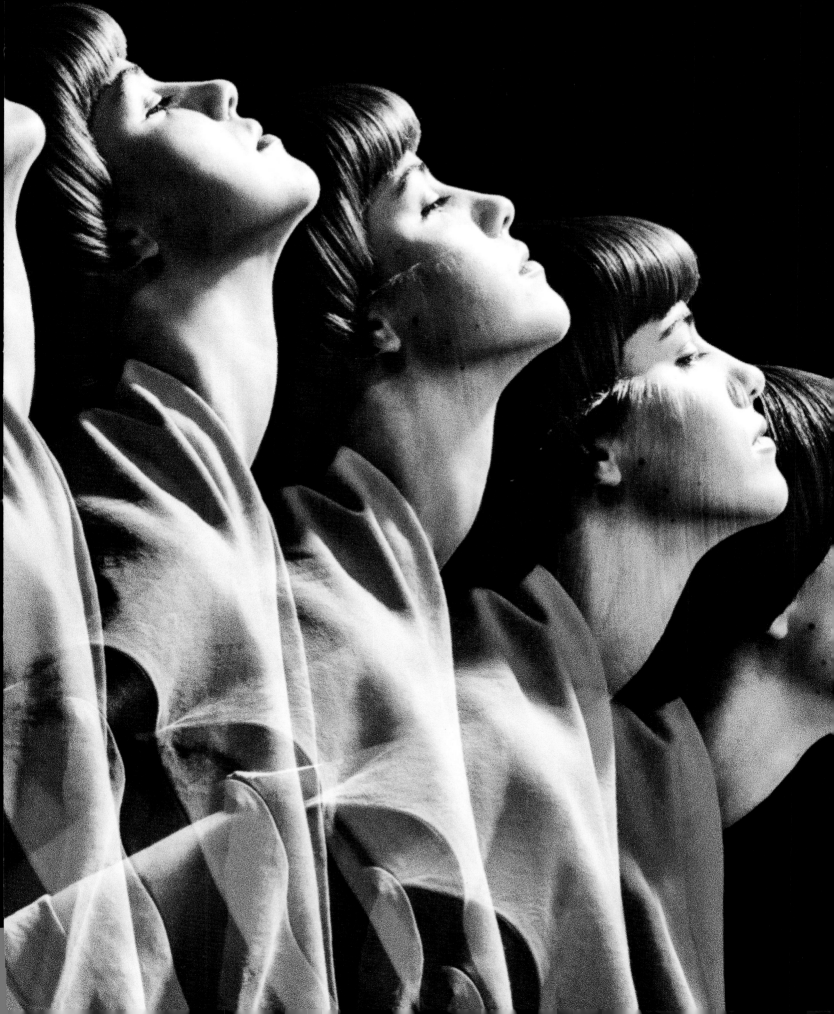

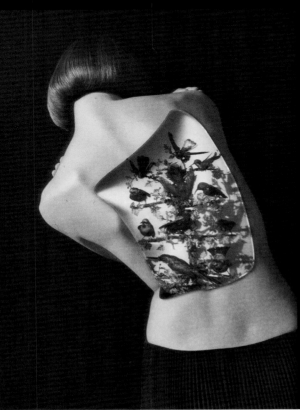

THE MIND

(left) Olivia wears a dress by HERMÈS.

Hair
HENRIK HAUE
Makeup
TRINE SKJØTH
Model
OLIVIA MARTIN
at Oui Management

THE MIND

(left) Olivia wears a suit by MARK KENLY DOMINO TAN.
(below) She wears a dress by LOUIS FÉRAUD from JEROME VINTAGE and shoes by LOEWE. Sculpture by URSULA NISTRUP & LOTTE HENRIKSEN from STUDIO OLIVER GUSTAV.

Study:
TRICKS OF THE MIND

Words by
George Upton

Photography by Aaron Tilley

I: ANCHORING

The saying "it's never too late to make a first impression" is not strictly true, at least when we come to making decisions. Psychologists have found that we place a greater emphasis on the first piece of information we receive than on what we come to learn later. These "anchors" have such a significant influence on our ability to make judgments that even experienced and knowledgeable people can be swayed by this effect.

In a 2006 German study, a group of judges were asked to try a hypothetical case, but only after the prosecutor had asked for a particular length of sentence. Even though they knew the prosecutor's demands were arbitrary, the judges that had been given a higher anchor handed out longer sentences on average than those with lower anchors. No one is quite sure why anchoring is so pervasive but the theories put forward all relate to

the way we interpret and understand the world around us, and it is predictable enough to be leveraged to your advantage. Setting an ambitious goal—a performance target at work, for example, or a low figure when bartering for something—has been found to increase the likelihood of reaching that goal. Something to bear in mind when you're next negotiating a raise.
—

Set Design by
Sandy Suffield

II: FUNDAMENTAL ATTRIBUTION ERROR

Few things are as anxiety-inducing as an unanswered message. If a text or email doesn't get a reply, we often think the worst: that a friend is deliberately ignoring us, when in fact they have lost their phone or stepped into a day of back-to-back meetings.

This tendency to seek an explanation for someone's actions in their (or our) character, rather than in external factors that are beyond control, is called a fundamental attribution error. It is rarely something we apply to ourselves: When we don't write back, there's always a good reason. Fundamental attribution errors are deeply rooted in society. Gossip magazines pore over the minutiae of apparently innocuous celebrity behavior to attempt to determine who they really are: So-and-so is looking sad and flustered in paparazzi pictures because they're going through a hard time, not because they've just locked themselves out of their car. More seriously, the effect can lead to a lack of empathy—for refugees or for those caught up in crime, say—and influence government policy. We believe that the difficult situations other people find themselves in are their fault, whereas our own misfortunes are the result of external factors such as a lack of opportunities, illness or unfair policies.

We can't change these tendencies, but we can be more aware of how we come to form an opinion about someone and, at the very least, give them the benefit of the doubt.

III: MARIKO AOKI

Have you ever walked into a bookstore and suddenly felt the urge to empty your bowels? If you have, surprisingly, you're not alone. It's a phenomenon that came to prominence in Japan in 1985 when 29-year-old Mariko Aoki wrote to bibliophile periodical *Book Magazine*. In her letter, she explained she had been suffering from the condition for the past few years, leading to the magazine being inundated with responses from other readers with "book bowel tendency." By the next issue, two months later, the magazine had commissioned a special extended article on the phenomenon, forever associating Aoki's name with it.

Despite the enthusiasm of *Book Magazine*, and many other publications since, there has yet to be any real epidemiological research into the Mariko Aoki phenomenon. Studies suggest that it affects between 5% and 10% of people in Japan but the cause remains a mystery. Theories range from the ink used in books having a laxative effect to the association of reading on the toilet at home.

It could, however, simply be a case of suggestion; that the more it is mentioned, the more people anticipate and notice the phenomenon. This is perhaps the most plausible explanation, given Aoki was not the first to describe the phenomenon—there are mentions recorded as far back as 1957—and that it took the relatively shocking instance of a young woman speaking candidly about her bowel movements to popularize it. In which case, dear reader, we just hope we haven't passed it on to you.

IV: THE SPOTLIGHT EFFECT

It's a weekday morning and you've slept through your alarm. You jump out of bed, throw some clothes on and run out the door only to realize, much too late, that you're wearing a shirt with a stain down the front, or your socks don't match. When you finally get to the office, everyone is staring at you.

Only they're not, or at least not as much as you think. In fact, most people will be too wrapped up in

their own problems to notice at all. This is called the spotlight effect: the tendency to overestimate the extent to which other people see and think about us. Psychologists explain the phenomenon as a consequence of egocentric bias. We're so used to seeing the world from our own perspective that it can be hard to imagine how differently other people see things. Together with the illusion of transparency—another consequence of

this egocentric bias, where we believe our thoughts and emotions are more apparent than they actually are— the spotlight effect can be debilitating for those with social anxiety.

It's important to remember, then, that people will tend to notice as much about you as you will about them—and generally speaking, that's not very much.
—

V: SWIMMER'S BODY ILLUSION

Nassim Nicholas Taleb is an essayist and ex-trader who correctly predicted the 2008 financial crisis. He is one of the leading thinkers on probability and uncertainty, but admits that when it comes to himself, his insight can be slightly less acute. Writing in *The Black Swan*, he recounts how he compared the physiques associated with different sports when he was deciding exactly how he would get fit. Runners were too scrawny and cyclists were bottom-heavy; swimming seemed to offer the muscular yet lithe body he desired. Later he realized it was only those with a genetic predisposition to develop a swimmer's body who became exceptional swimmers. Just as it's not the new skin cream that makes the model in an advertisement beautiful, or a good university that makes a student intelligent, the swimmer's broad shoulders and six-pack are not only a consequence of spending a long time in the pool: Their bodies were already predisposed to developing in a certain direction. This confusion of selection factors and results has come to be known as the swimmer's body illusion. It's a reminder to be cautious whenever we feel the pressure—whether from ourselves or anyone else—to aspire to something we might not realistically be able to achieve. By all means, go swimming, but don't be disappointed when you don't end up looking like Michael Phelps.

—

VI: FREUDIAN SLIPS

In December 2010, British radio presenter James Naughtie made a now-infamous gaffe when introducing politician Jeremy Hunt, substituting a "C" for the "H" in his last name. It was a mistake that was perhaps not only amusing for the way Naughtie struggled to regain composure but because it reflected a fear that many of us share: how we might inadvertently address our teacher as "Mom," for example, or call our partner by the name of an ex.

Sigmund Freud, the neurologist who founded the practice of psychoanalysis, thought that such slips of the tongue reveal something hidden deep within us; that in these errors of speech, or parapraxias, there is some repressed, unconscious conflict that suddenly bubbles to the surface.

Yet though Freud gives his name to the phenomenon, this—like many of Freud's theories—has been dismissed by psychotherapists today. Instead, Freudian slips are thought to be caused by the much more prosaic phenomenon of becoming tangled up in language. In Naughtie's case, the association between Hunt and his role as C-for-culture secretary made such a slipup almost inevitable, as is proven by many other veteran broadcasters making the same mistake. Rather than revealing an unconscious and institution-wide loathing of the politician, as Freud would have said, it is really only a very funny, and very unfortunate, innocent mistake.

178 Peer Review
179 Object Matters
180 Cult Rooms
182 Chan Marshall
184 Crossword
185 Correction
187 Last Night
188 Bad Idea
189 Good Idea
190 Credits
191 Stockists
192 My Favorite Thing

Part 4.
DIRECTORY
Cat Power, crime scenes and a crossword.
178 — 192

PEER REVIEW:
EDWARD KRASIŃSKI

Words:
Kasia Redzisz

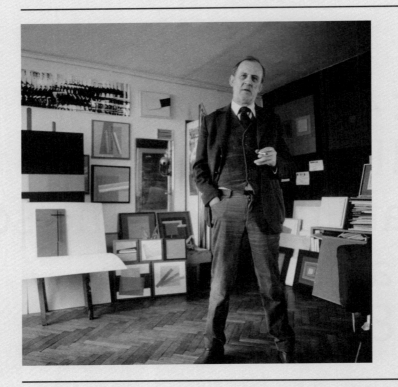

Photograph: Eustachy Kossakowski © Anka Ptaszkowska and archive of Museum of Modern Art in Warsaw. Courtesy Paulina Krasinska and Foksal Gallery Foundation.

Curator KASIA REDZISZ on the surreal wit of the avant-garde artist.

Edward Krasiński (1925–2004) was one of the most important artists of the European post-war avant-garde. He sought to reduce sculpture to a mere line, epitomized by his use of blue adhesive tape, which he placed at a height of 130 centimeters across his installation works. "I encompass everything with it and go everywhere," he once explained. "This is art, or is it?"

The blue tape extends across walls and objects in his Warsaw studio, which has been preserved as he left it. When I first visited the studio—in an apartment on the top floor of an ordinary block of flats from the communist era—I found myself surprised and confused.

Years later, curating Krasiński's retrospective at Tate Modern and then the Stedelijk, I wanted visitors to feel the same while discovering his complex, yet delightfully playful practice. The interior is full of little traps and visual pranks. A coatrack in the hallway has been replaced by a pitchfork sticking out of the wall, hanging too high for anyone to reach it. The envelope lying on the floor is glued there, so no one can pick it up. There is a dry branch sprouting out of the parquet floor and fake mice are hidden in the corners of rooms (the mouse traps are real, though). A metal fin cuts through the table and a water tap is installed purposelessly in the living room.

On closer inspection, the bookshelf reveals itself to be a large photograph of the original item of furniture, which stands behind its photographic reproduction. In this studio-cum-apartment, the border between reality and its crooked mirror image is blurred.

The tension between the real and the imagined is crucial in understanding Krasiński's treatment of exhibition spaces as well as domestic ones. From the mid-1960s, his shows often took the form of total environments: stage sets, where beautifully conceptual artworks resembled props ready to be deployed. Spaces masterfully transformed by the artist contained the suggestion that something was about to happen. Stepping into his exhibitions meant to suspend disbelief and become a participant in an unscripted performance. By detaching the artist and

the viewer from the world outside, Krasiński's practice assumed the role of an alibi, offering the possibility of being "somewhere else" at any given moment.

(1) Edward Krasiński describes his performance of *Spear*, staged in the fields in Zalesie, near Warsaw in 1964: "Spears hung from the wires stretched between the trees created an illusion of movement. They were swishing [in the air]. It was all about preparing the spear to perform its function. Once prepared it could act on its own." When displayed indoors, the linear sculptures hang in the gallery in perfect equilibrium between motion and stillness. They evoke movement and play with our senses. The illusion is achieved with the simplest of means: through the use of color and fragmentation. Reduced to a single line, they exemplify Krasiński's desire to deny sculpture its classical monumentality. They are perfect props in the artist's mis-en-scènes.

OBJECT MATTERS

Words:
Stephanie d'Arc Taylor

A fuzzy history of the carpet.

Human feet have a natural predilection for coziness. The richest among us have been snuggling our toes into pile for at least 25 centuries, according to a 1940s discovery by Russian archaeologist Sergei Rudenko. While excavating the Siberian tomb of a Scythian prince, he discovered the world's oldest carpet, miraculously preserved through the centuries in a block of ice.

By the 1950s, though, it wasn't just princely toes that could afford to be warm and toasty. As the United States emerged from the Second World War, people's minds turned from sacrifice to convenience and consumption. Gone were sugar rations and margarine—and with their new disposable incomes, Americans demanded comfort from head to literal toe. Advances in fabric

technology meant that homemakers had access to more durable, inexpensive carpets than ever before. And they wanted as many of them as they could get.

By the more-is-more 1970s, tufted carpets grew into long shag carpets in modish colors like harvest gold and burnt orange. The trend seemed indefatigable, colonizing not only bathroom floors but even toilet seats, like the vine of an invasive species. But in fashion, as in life, change is ever constant. By the 1990s, carpeted floors were relegated to the realm of kitsch (or at least the suburban).

Any home furnishing trend on which there is an official fact sheet distributed by a nonprofit called the National Center for Healthy Housing is worthy of a second look.

Carpeting was a mid-century trend that went against the prevailing ethos of wipe-down minimalism. Carpets are bacteria havens, but steam cleaning a carpet is significantly more annoying than grabbing the dustpan and broom, so people do it a lot less. This leads to nasties like mildew, pet dander and dust mites—whose main source of food is accumulated flakes of human skin. Wall-to-wall carpeting is officially not recommended for people with asthma or allergies.

Armed with this knowledge, even those with comfort in mind will likely be able to resist the allure of wall-to-wall tufts, so irresistible to our ancestors. But in fashion, of course, we can never say never. If avocado green can make a comeback, maybe carpeting isn't far behind.

CULT ROOMS

Words:
Stephanie d'Arc Taylor

The Nutshell Studies of Unexplained Deaths rendered gruesome crimes in divine miniatures.

Our fascination with murder is enduring. True crime is one of the most popular podcast categories, and police procedurals are bigger business than ever: The *CSI* franchise alone has an estimated audience of two billion people. But it's not everywhere you find depictions of ghastly murders that could also be described as twee. In 1940s America, however, Frances Glessner Lee achieved this feat by rendering crime scenes in adorable dollhouse miniatures.

Glessner Lee, born wealthy in Chicago in 1878, was a strange girl. At age four, she allegedly told her mother that she "had no company but my doll baby and my God." In addition to typically feminine pursuits like dolls and sewing, she was fascinated by medical texts and Sherlock Holmes. Forbidden to go to school by her father, she was adrift for decades until the rest of her family died, leaving her with the family fortune.

Finally free to spend her time and money as she liked, she turned her eccentric attentions to murder. Disturbed by what an investigator friend told her about crime scene contamination by bumbling, untrained detectives who would move bodies, disturb blood spatters and put their fingers through bullet holes in clothing—Glessner Lee took it upon herself to develop a teaching curriculum

for would-be crime scene investigators. And if she couldn't bring them to crime scenes, she would just have to bring the crime scene to them.

The resulting oeuvre is *The Nutshell Studies of Unexplained Death*, a series of 20 meticulous dioramas of grisly murder scenes. "The inspector may best examine them," she advised, "by imagining himself a trifle less than six inches tall." The crime scenes she selected were not only real, they were the most puzzling ones she could find, to test potential detectives' powers of observation, logic and inference. Some clearly depict crimes (like her lurid re-creation of a teenage Dorothy Dennison's decomposing corpse covered in bite marks, white dress ripped open, knife in the gut). Others are more puzzling: Ruby Davis' body at the bottom of the stairs, for example, may or may not have been pushed there by her husband. (Despite the discrimination she faced, Glessner Lee was not immune to society's fascination with the gruesome deaths of women in particular.)

As any sleuth knows, cases rest on the tiniest detail. Glessner Lee's attention to detail is immaculate, frequently drawing the viewer's eye to lurid, almost cinematic noir minutia. Years of grime appear to accumulate on light switches of seedy motel rooms. Half-peeled potatoes languish by dirty sinks. Ashtrays overflow and liquor bottles seep brown liquid into moldering carpets. Tiny family photographs grace vanities draped in lace, and newspapers feature minuscule representations of the relevant front page. "When I saw these miniature crime scenes," filmmaker John Waters told *The New York Times*, "I felt breathless over the devotion that went into their creation."

It's the juxtapositions of the *Nutshell* dioramas that make them impossible to turn away from—the control and exactitude Glessner Lee devotes to these scenes belie the murderous rage at their core, perhaps the most out-of-control moment of the participants' lives.

It makes perfect sense, somehow. As a woman fascinated with murder and death, Glessner Lee must have frequently felt as though her talents and passion were stymied by the misogynistic mores of the time. After her miniatures were incorporated into the curricula for trainee detectives at the Harvard Association of Police Science, she was awarded the position of honorary police captain by the New Hampshire State Police in 1943. Press gave attention to her otherness, such as the magazine cover emblazoned with "Grandma: Sleuth at Sixty-Nine."

Glessner Lee kept the answers secret to preserve the dioramas' utility as training tools. Either way, the mysteries her dioramas reproduced weren't meant to be solved without impossible-to-obtain supplemental information like medical examinations or suspect interrogations.[1] Murder is messy and complicated, just like life—even if it's rendered in twee miniature.

(1) When the dioramas were exhibited in 2018 at the Smithsonian American Art Museum, at the height of the country's true crime fever, visitors keen to play amateur detective often found themselves outwitted. "I think people do come here expecting that they're going to be able to look at these cases and solve them like some Agatha Christie novel," curator Nora Atkinson told NPR at the time. "And when you look at them you realize how complicated a real crime scene is."

DIRECTORY

CAT POWER

Words:
Poppy Beale-Collins

Musician CHAN MARSHALL opens the door to a different dimension.

Chan Marshall has been performing as Cat Power for over 30 years, having first emerged as a breakout name of the '90s New York indie rock scene. She's been steadily adding to her cult back catalog ever since. In January 2022, the self-produced *Covers* joined her seminal repertoire of cover albums (see also 2000's *The Covers Record* and 2008's *Jukebox*). In conversation from her home in Miami Beach as she approaches the milestone of turning 50, Marshall is contemplative, but hopeful. This capacity to hold the light and dark shades of life—to let in the bittersweet or troubling while always looking forward—is perhaps the defining feature of a Cat Power song, and what makes Marshall's musical invention so singular and enduring.

POPPY BEALE-COLLINS: As an art form, the cover song can take us back to the revelation of getting into music for the first time—a cover of or by an artist you love often leads to discovery, or rediscovery. Do you feel that sense of exploration when you're covering songs, too?

CHAN MARSHALL: Absolutely. [I'd start] not knowing what song I was going to sing. I'd go into the vocal booth, and I'd just think to myself, *Okay Chan, what song, what song?* The first song we did for *Covers* was because I'd had an episode with a friend of mine that summer, where he'd suffered a big loss, and I turned on "Against the Wind," because I knew he loved that song.

It helped him. So, in the vocal booth, I pulled up the lyrics to "Against the Wind," with the band already playing, and just recorded the first take. Then I was like *Fuck it, how about "I Had a Dream, Joe"*—a song I would never in a thousand years ever think to cover. The third song, same thing; composed the music, jumped back in the vocal booth not knowing what to do, and was like, *Man I gotta do "Endless Sea," because it's so moody and wobbly and cool*. For the last song that day, I said "Hey everybody, grab a guitar," and we're all on acoustic guitars playing these two notes, over and over—that became "You Got The Silver." That was the first day, the first four songs.

PBC: Is that improvisational approach distinct from the process of writing your own songs?

CM: It's exactly the same dynamic. When I sit at the piano, or the guitar, I don't sit down to write, I just sit down to create space. To spend time in a different dimension. And whatever words come out, if I remember them and I play it again, that becomes a song, and that's how it's always been for me. It's organic, like a stream of consciousness. Like a dimension where there's movement of colors and shapes, and memories.

PBC: Did the pandemic feel like a creative time for you?

CM: I was getting in touch with the things that, when you're rushing around

being a single parent, you don't have time to sit with. All that was, I feel, actually very creative because it is an essential part of my heart. One thing the pandemic allowed me to do was to see things I hadn't before. I found growth in my personal life. And I don't know if that's more important than writing a song, but I feel like they're kind of similar in a way. I wasn't able to make music, but I was able to go over some things that were really important for me, and for my son, too. Essential things that needed looking at.

PBC: Do you still like living in Miami?

CM: It's beautiful. It's strange, I like it. When I first started coming here, a lot of the hotels on South Beach were abandoned. There were boarded-up buildings, empty lots, less cars on the streets. Now all the lots are huge, there's 30-story buildings, the streets are redone. On the beach there used to be shells, now there's cigarette butts and bottle caps. Before the pandemic, I was kind of ready to go, but I'm really thankful I was here. After spending so much time in New York, I loved it here because it reminded me of Manhattan, but after a nuclear war. Every time I get off the plane, it's always the same. When I come home, it just feels like I'm closer to the earth. I feel grounded, and it feels good. I get so calm. The doors open, and everything just falls away.

THIS IS YOUR BRAIN ON DRUGS

Crossword: Mark Halpin

ACROSS

1. Certain set of academic subjects that sound like part of a plant
5. Words of denial
9. Part on a rosary or abacus
13. "Hmmmm... I don't think so."
14. Modern Persia
15. Like fairytale stepsisters
16. Google co-founder Sergey
17. 255, to Caesar
18. Hitchcock film or a weapon in Clue
19. Making noises like old floorboards / (taking drugs) Belief system at its highest point?
22. Column's counterpart
23. The Big Apple, for short
24. Like unnaturally formal conversation
28. Dancer Duncan and namesakes
31. Shakespearean stage direction for a departing group
32. Spill the beans / (taking drugs) Vessel for preparing some Mexican snacks?
34. Streets or highways: abbr.
35. Employ
36. So-so grade
37. Stimpy's cartoon companion
39. Pub or tavern centerpiece

41. One not playing by the rules / (taking drugs) Aquatic mammal who never picks up the check?
45. Opulent or extravagant
48. Instruction from an automated phone help-line
49. Ancient Greek tragedian whose name gives us a synonym for actors
51. Prague to Stockholm direction
52. Railroad stop, in brief
53. Ensued or pursued / (taking drugs) "Ship of the Desert" is more harebrained?
56. With 61 Across, some decorative carpets
59. Cole Porter's "Well, Did You ____?"
60. Former Jordanian Queen
61. See 56 Across
62. Nevada gambling site
63. Taboo
64. Shoelace mishap
65. All over again
66. Paradisical spot

DOWN
1. Secretly; in confidence (literally, under a certain flower)
2. Did something surprising to outwit someone
3. Oklahoma city
4. Titular princess in a Studio Ghibli film
5. Compliment to a center fielder, perhaps
6. Killer whale
7. Chews the fat
8. One on the guest list
9. Enter with an intent to steal
10. Sense of self
11. The Matterhorn, for one
12. Coloring substance
19. Lit ____ (univ. course)
20. Funereal flames
21. Veto
25. Fall victim to Medusa or a basilisk
26. Finish
27. Rehab affliction, for short
29. Parties or hairstyles
30. Expensive
33. Acquired the skills to do something
37. Comedian with a self-titled sitcom
38. UFO pilots, maybe
39. Cousin of a club sandwich
40. Comment to a dentist
41. Mythical monster, or an impossible dream
42. Remain undecided
43. Begin, as an adventure or enterprise
44. Hindquarters
46. "Alea iacta est!" ("The die __ ____")
47. Attraction in Baden-Baden or Bath
50. A-swimming swans count
54. Swimming pool or racetrack division
55. Alton Brown's passion
56. Biblical boat
57. Compete in a marathon or election
58. A megalomaniac's is much too big

CORRECTION: EFFORTLESSNESS IS IMPOSSIBLE

Words:
Allyssia Alleyne

On the labor of looking carefree.

In her 2016 book, *Thought in Action: Expertise and the Conscious Mind*, Barbara Gail Montero, a professor of philosophy at the City University of New York Graduate Center, observed that, "Although we praise effort, we prize effortlessness." A former professional ballet dancer, Montero was referring to the feats of athletes and dancers, as well as musicians and other artists. But the sentiment applies neatly to the way we evaluate beauty

and style: In magazine articles, on social media and in countless SEO-friendly blog posts, insouciance is always in fashion.

"Effortless style" is Jane Birkin in jeans and a men's shirt, with a straw pannier on her arm; Carolyn Bessette-Kennedy's '90s minimalism; and virtually every photo of Zoë Kravitz. It's Glossier's paradoxical no-makeup makeup and the aspirational realness of Reformation apparel.[1] It's also a beautiful, profitable lie.

Like the execution of a jump shot or the performance of a concerto, effortless style has less to do with actual effort exerted than the perceived ease with which it's achieved. Beauty and a cultivated sense of style, for those who value it, take work: There are garments to be chosen, tailored, broken in and laundered; skincare regimens to be purchased and adhered to; unruly bodies to be disciplined into submission. To be called "effortless" is merely to be told that labor was so masterfully executed as to be rendered invisible.

As in athletics and music, the pursuit of effortlessness privileges those with natural ability and financial resources—the winners of the genetic lottery, for whom glowing skin and a conventional, easily dressable physique are borderline accidental; and the winners of the actual lottery, who can invest time and money to affect it, an exercise in inconspicuous consumption. They stand in contrast to the contemptible try-hard, the woman whose hard work is written all over her face.

Not everyone is able to pull off the illusion; perhaps the standard is too much of a deviation, or they lack the right tools to pretend it comes naturally. But maybe it's just as well: The quickest way to have your work devalued is to let everyone think it's easy. Besides, there's something to be, if not prized, then admired in those who own the process as much as the outcome. It doesn't matter if people can see the lines if your appearance is a labor of love.

(1) Glossier has been criticized for selling users a vision of dewy perfection that functions to enhance the features of young people genetically blessed with good skin. While this was largely accepted when the brand only sold makeup, it riled users when they branched out into skincare. The skincare range was ineffective or, as one Twitter user put it, designed "for people who wash their face with water and have picture perfect skin."

LAST NIGHT

Words:
Bella Gladman

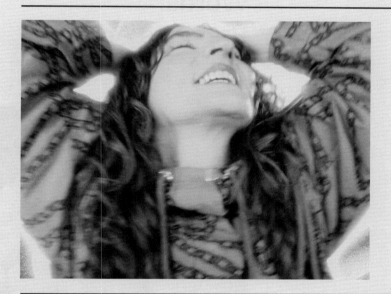

What did PLANNINGTOROCK do with their evening?

Jam Rahuoja Rostron, better known as Planningtorock, is a dance music icon to those in the know, having collaborated with The Knife, toured with Peaches, remixed Lady Gaga and Robyn, soundtracked the Chanel Autumn/Winter 2020 show and produced four studio albums. After spending 20 years in Berlin's thriving night scene, Rostron recently relocated to Tallinn, Estonia, their wife, Riinu's, home city.

BELLA GLADMAN: What did find yourself doing last night?

JAM RAHUOJA ROSTRON: I worked on a remix in the day, took a break to refresh my brain, and then I revisited it. The remix is for a friend, an emerging artist based in Paris called Yannis. The song is amazing, their voice is very beautiful! I try as much as possible to do remixes for artists who are just starting out, especially queer artists. Often they're making music about themselves, their queerness, their identity. My own work is about my story, and it's a great pleasure to facilitate someone else's.

BG: How do Tallinn nights compare to those in Berlin?

JRR: The biggest change is living with my wife, having a real sense of "home." For a long time I lived in shared apartments with friends, which was lovely, but I'm so happy to have reached this new point in my life. We have two cats and a dog, and we love downtime, watching TV, reading, everybody together on the sofa.

BG: I thought late nights were standard for the DJ/producer lifestyle?

JRR: I'm a bit unusual because I'm really a day person! In Berlin, I shared a studio with three other music producers. They'd work until 4 or 5 a.m., and I would come in at 8! I always used to ask to DJ earlier. It never works, because they'd say: "No, you're the headliner, you have to be last." Having said that, it's nice to party, and if you're DJing with other friends, it's really fun. I don't really drink so I love playing Berghain and Panorama Bar, because they serve coffee. I make it work!

BAD IDEA:
P-HACKING

Words:
Precious Adesina

What happens when researchers go fishing.

"P-hacking" sounds like some sort of dark-web-cryptocurrency-type activity. But, in fact, it's a shady practice from a different sphere: the pseudoscientific manipulation of a study to produce a desirable result. Coined by psychologists Uri Simonsohn, Joseph Simmons and Leif Nelson almost a decade ago, the "p" comes from "p-value," a number given to research to show how likely the results could have come about by chance.

A value lower than 0.05 (5%) allows researchers to declare their findings as "statistically significant," thus considerably increasing the likelihood of their work being published. Rather than setting out to prove a hypothesis, p-hacking means looking at

Photograph: Lamberto Teotino

the data and working backward to find out what hypothesis it could possibly prove.[1] If a researcher is disappointed by the lack of findings from a particular study (on the benefit of eating breakfast for weight loss, for instance), they might trawl back through all information collected and look for a random quirk (say, that participants who use stove-top coffee makers lost more weight) and turn that finding into the study.

"It's easy to find a p < .05 comparison even if nothing is going on, if you look hard enough," wrote Andrew Gelman and Eric Loken in a 2013 paper, "and good scientists are skilled at looking hard enough." In 2013, for example, Brian Wansink, then head of Cornell University's Food and Brand Lab, pushed a junior academic to trawl through all available data from a study on buffets that hadn't initially turned up much of interest, and reverse engineer four studies with catchy, press-friendly headlines such as "men eat more in the company of women."

But it's wrong to assume that p-hacking is always Machiavellian. It can be sensible for researchers to examine data they've gathered: Many scientific breakthroughs in other fields have been achieved by people who set out to do something entirely different. Consequently, even Gelman and Loken regret the popularity of the term: "It invokes an image of a researcher trying out comparison after comparison, throwing the line into the lake repeatedly until a fish is snagged. We have no reason to think that researchers regularly do that." What it really seems to be describing is the fact that, if you go searching for something deeply enough, you may be able to find what you're looking for without even noticing that you've distorted the truth to get there.

(1) To illustrate the problem of p-hacking in economics, the stats-heavy politics outlet *FiveThirtyEight* maintains a website where users can manipulate various data points regarding the US economy to try and "prove" that it is affected by whether Republicans or Democrats are in power. Depending on which variables you choose to include, you can use the data to make the case one way or another.

GOOD IDEA: REPLICATION

Words:
Harriet Fitch Little

P-hacking forms part of a wider set of issues in research known as the "replicability crisis." The phrase refers to the uncomfortable fact that many important studies, particularly into human behavior, fail to produce the same results when repeated by new researchers, even if they try to mimic the conditions perfectly. An initiative called Project Pipeline has sought to address this challenge by recruiting volunteer research departments to try and reproduce studies *before* they are published. "The idea was to see if findings are robust before they find their way into the media and into everyone's lectures," Eric Luis Uhlmann, associate professor of organisational behaviour at INSEAD, told *The Atlantic* in 2016.

Uhlmann used his own research papers as guinea pigs. While several studies stood up to replication, some fell apart. For example, while Uhlmann found that a company that doesn't respond to accusations of misconduct is judged equally harshly to one that's found guilty, his replicators found that the silent party is judged five times more harshly—a wildly divergent result.

Although there is hurt pride involved in having a study invalidated, Uhlmann told *The Atlantic* that he believes it is better for everyone in the long run. "It's less sensitive when something fails before publication. No one's even heard of the effect yet. My reputation isn't riding on it. There's less defensiveness."

CREDITS

FRESH STEMS:	PHOTOGRAPHER	Mar+Vin at SDMGMT
	CREATIVE DIRECTION	Mar+Vin at SDMGMT
	ART DIRECTION & SET DESIGN	Josephine Cho at Groupart
	STYLIST	Maika Mano at Thinkers
	FLORAL STYLING	Flower Bar
	MODELS	Bruna Di at Another Agency, Vivica Ifeoma at Way Model, Peter Silva at Joy Model
	MAKEUP	Suyane Abreu at HA Management
	HAIR	Stefany Silva
	PROPS	David Martins
	FASHION PRODUCER	Danilo Micke
	EXECUTIVE PRODUCER	Diego Domingos at SDCP
	PHOTO ASSISTANTS	Renato Toso
		Franklin Almeida
	SET ASSISTANT	Gabriel Tardoque
	STYLING ASSISTANT	Lucas Rodrigues
	MAKEUP ASSISTANT	Carolina Felicio
	PRODUCTION ASSISTANT	André Gonçalves
	RETOUCHER	Bruno Rezende
SPRING TRANCE:	PHOTO ASSISTANTS	Yuanling Wang
		Yinghan Wang
		Sherry Liu
	STYLING ASSISTANT	Li Kuan Zhen
	HAIR & MAKEUP ASSISTANT	Ke Rong Chen
MIND GAMES:	PHOTO ASSISTANT	Matt Marsh
	STYLING ASSISTANT	Noah Chahid
	RETOUCHER	Wetouch
SPECIAL THANKS		Thinkers Studio, São Paulo

STOCKISTS:
A — Z

A	AHLEM	ahlemeyewear.com
	ALEX WOLFE	alex-wolfe.com
	ATELIE MÃO DE MÃE	ateliemaodemae.com.br
B	BALENCIAGA	balenciaga.com
	BERLUTI	berluti.com
C	CALZEDONIA	calzedonia.com
	COS	cosstores.com
	CRAIG GREEN	craig-green.com
E	EMILIA WICKSTEAD	emiliawickstead.com
F	FENG CHEN WANG	fengchenwang.com
G	GIGI BURRIS	gigiburris.com
	GIORGIO ARMANI	armani.com
H	HERMÈS	hermes.com
	HOUSE OF FINN JUHL	finnjuhl.com
J	JEROME VINTAGE	@jerome_vintage
	JIL SANDER	jilsander.com
K	KRUG	krug.com
L	LEANDRO CASTRO	@leandrocastrum
	LOEWE	loewe.com
M	MADAME SHER	madamesher.com
	MAGDA BUTRYM	magdabutrym.com
	MAISON MARGIELA	maisonmargiela.com
	MAISON RABIH KAYROUZ	maisonrabihkayrouz.com
	MARGARET HOWELL	margarethowell.co.uk
	MARINE SERRE	marineserre.com
	MARK JEN HSU STUDIO	@markjenhsu
	MARK KENLY DOMINO TAN	mkdtstudio.com
	MARSET	marset.com
N	NAU	@naubikinis
	NORMANDO	normando.co
O	OMEGA	omegawatches.com
P	PAUL SMITH	paulsmith.com
	PAULA RAIA	paularaia.com
	PRONOUNCE	@_pronounce
R	REJINA PYO	rejinapyo.com
S	SALVATORE FERRAGAMO	ferragamo.com
	STRING	stringfurniture.com
	STUDIO NICHOLSON	studionicholson.com
	STUDIO OLIVER GUSTAV	olivergustav.com
T	TERRENCE ZHOU	badbinch.com
U	URSULA NISTRUP	nistrup.com
V	VIBE HARSLØF	vibeharsloef.com
	VINCENT WONG	@vincent_wcw_
	VTMNTS	vtmnts.website
W	WARDROBE.NYC	wardrobe.nyc
	WEIDER SILVEIRO	@weidersilveiro
	WILLY CHAVARRIA	willychavarria.com
	3N3O	3n3ostudio.com

MY FAVORITE THING

Words:
Tom Faber

DAVID ERRITZOE, interviewed on page 114, shares the vial that sparked psychedelic thinking.

This vial is from our 2015 trial, which was the first study since the 1950s of using psychedelics to treat depression. It's psilocybin that we received from a lab, rather than just being a compound that exists in a psychedelic mushroom that I could go out and find with my friends. This is actually a safe, very pure and controlled version of the same molecule that we can therefore give to people who are really unwell and in a fragile state.

So it symbolizes a reframing of how psychedelics are viewed, that they can reenter science and therapeutic testing for people who are suffering. We conducted the trial with the appropriate Home Office licenses, so it also represents the fact that we're allowed to do this in the UK—it's a validation that it's legal, approved and safe enough to test as a kind of medicine.

I like the brown color of these old medicine bottles compared to the plastic ones. I think I was supposed to have it destroyed, but I kept it because it's a pretty little object.